Photo SPEAK

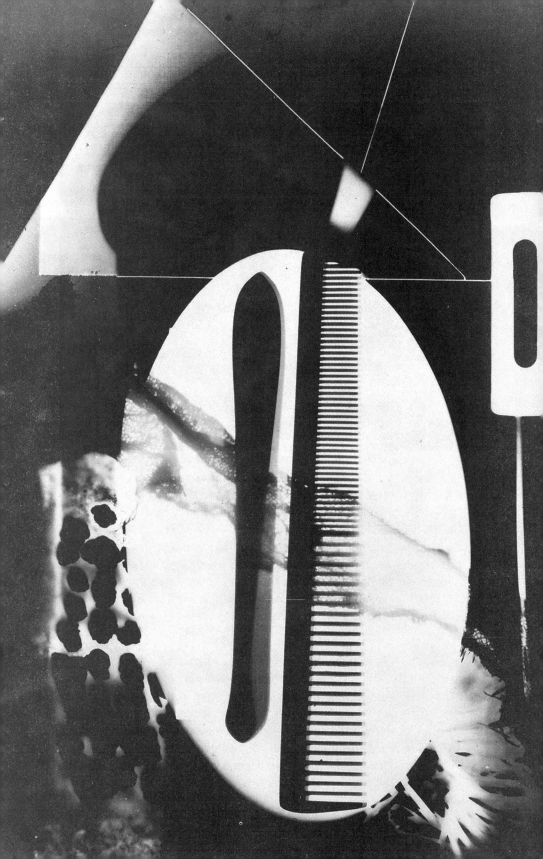

Photo SPEAK

A Guide to the Ideas, Movements,

and Techniques of Photography

1839 to the Present

Gilles MORA

Abbeville Press Publishers New York London Paris

CONTENTS

	1840	1860	1880	1900	1920	1940	1960	1980	1997

	
DAGUERREOTYPE	(1839–1870)
SALT-PAPER PROCESS	(1840–1860)
CALOTYPE	(1841–1850)
COLLODION PROCESSES	(1848–1880)
ALBUMEN PRINT	(1850–1893)
PHOTOJOURNALISM	(1850–1997)
CLICHÉ VERRE	(1851–1930)
AMBROTYPE	(1854–1865)
CARTE-DE-VISITE	(1854–1870)
CARBON PROCESS	(1855–1910)
TINTYPE	(1856–1910)
GUM BICHROMATE PROCESS	(1858–1920)
WOODBURYTYPE	(1864–1900)
GELATIN SILVER PROCESS	(1871–1997)
PLATINUM PRINT	(1873–1914)
NATURALISTIC PHOTOGRAPHY	(1886–1900)
PICTORIALISM	(1886–1923)
SYMBOLISM	(1890–1914)
PHOTO-SECESSION	(1902–1917)
STRAIGHT PHOTOGRAPHY	(1902–1970)
AUTOCHROME	(1904–1940)
FUTURISM	(1909–1929)
VORTOGRAPH	(1914–1917)
CLARENCE H. WHITE SCHOOL OF PHOTOGRAPHY	(1914–1942)
BAUHAUS	(1919–1933)
NEW VISION	(1920–1949)
NEUE SACHLICHKEIT	(1923–1930)
SURREALISM	(1924–1963)
HUMANIST PHOTOGRAPHY	(1930–1963)
GROUP f/64	(1932–1935)
FARM SECURITY ADMINISTRATION	(1935–1943)
PHOTO LEAGUE	(1936–1951)
NEW YORK SCHOOL	(1936–1963)
POLAROID	(1947–1997)
SUBJEKTIVE FOTOGRAFIE	(1950–1958)
POP ART	(1957–1969)
PHOTO-REALISM	(1965–1975)
LUMINISM	(1970–1979)
NEW TOPOGRAPHICS	(1970–1983)
NUEVA LENTE	(1971–1983)
POSTMODERNISM	(1977–1990s)
STAGED PHOTOGRAPHY	(1980s–1990s)
DIGITAL CAMERAS	(1985–1990s)

	1840	1860	1880	1900	1920	1940	1960	1980	1997

Photography has become a familiar part of daily life, yet many of us remain unfamiliar with numerous aspects of its complex history, aesthetics, and processes. The primary purpose of this compact guide is to distill into user-friendly entries the most essential information about photography while at the same time revealing new facets of its richly eclectic history.

Some entries offer precise descriptions of techniques both old and new, from daguerreotype and platinum print to digital imaging; these will be of particular usefulness to collectors. Some entries are devoted to the diverse styles and movements that have punctuated the history of photography, including Photo-Secession, New York School, and Nueva Lente. Some entries investigate the role that certain subjects, applications, and approaches have played in photography, such as advertising, fashion, metaphor, photojournalism, and war. And, finally, several entries—collections, gallery, photo agencies, semiology, and so on—address issues related to the interpretation, acquisition, and display of photography.

The entries dealing with movements are divided into the journalistic categories of **WHO**, **WHEN**, **WHERE**, and **WHAT**.

WHO is a list of the principal photographers involved with a movement or style. Capitalized names indicate the pioneers or virtuosos of that approach. Certain individuals appear in multiple entries; this is the case for the powerful Alfred Stieglitz, for example, who loomed large in the Photo-Secession, Pictorialism, and straight photography. Dates and nationalities for the photographers are provided in the index.

WHEN signifies the moment of greatest vitality for a particular attitude toward, or method of, photography. Straight photography, for example, did not disappear at the end of the 1960s, but by then its significance had greatly diminished.

WHERE identifies the cities, countries, or continents in which a movement was centered.

WHAT defines the nature, origins, and implications of the movement, style, and technique. Cross-references to other entries are CAPITALIZED.

PhotoSpeak is addressed to a broad audience: students, collectors, curators, scholars, and those simply curious to know more about photography. The best way to use this volume will vary with the user. The expert can employ it to find specific facts—say, the year that the Clarence H. White School of Photography was founded or who patented the ambrotype process. The more casual user will find it helpful to read the book from beginning to end and then consult it as needed, when confronted with unfamiliar terms, concepts, or images in photography.

PHOTOGENIC DRAWING

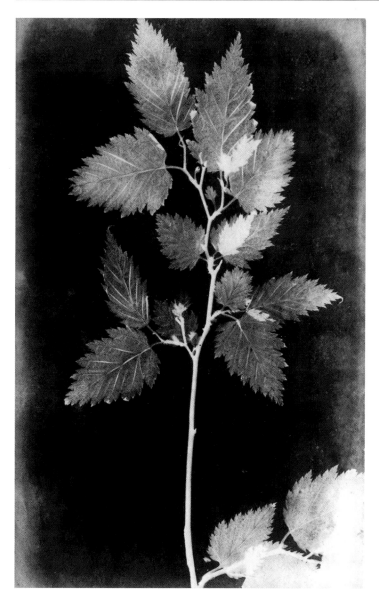

WILLIAM HENRY FOX TALBOT (1800–1877).
Botanical Specimen, c. 1838. Photogenic drawing, 7 x 4³/₈ in. (17.9 x 11.1 cm). The Royal Photographic Society Collection, Bath, England.

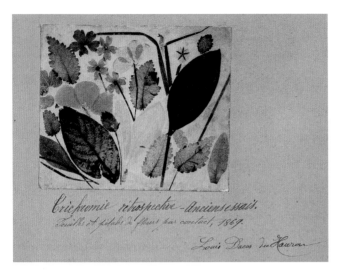

LOUIS DUCOS DU HAURON (1837–1920).
Tricolor Retrospective, Previous Attempts, 1869. Three-color carbon print from an 1869 negative, 3⅝ x 4½ in. (9.6 x 11.5 cm). Société Française de Photographie, Paris.

CARBON PROCESS

1855–1910

BERNARD PLOSSU (b. 1945).
Taos in the Winter, 1977. Color photograph (Fresson carbon process), 7 x 11 in. (18 x 28 cm). Eaton Fine Art, Inc., West Palm Beach, Florida.

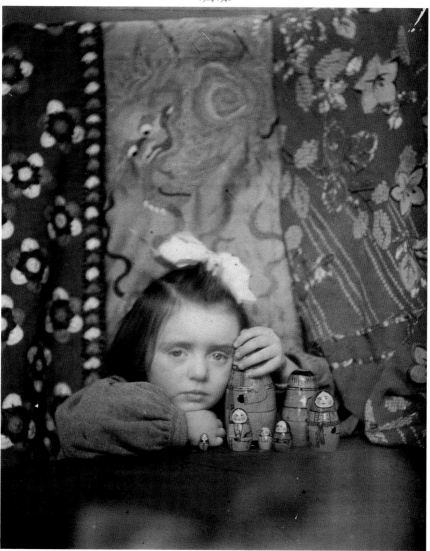

EDWARD STEICHEN (1879–1973).
Portrait of Mary Steichen with Set of Russian Nesting Dolls (assigned title),
c. 1910. Autochrome, 4⁷/₈ x 3³/₄ in. (12.5 x 9.9 cm). George Eastman House,
Rochester, New York. Reprinted with permission of Joanna T. Steichen.

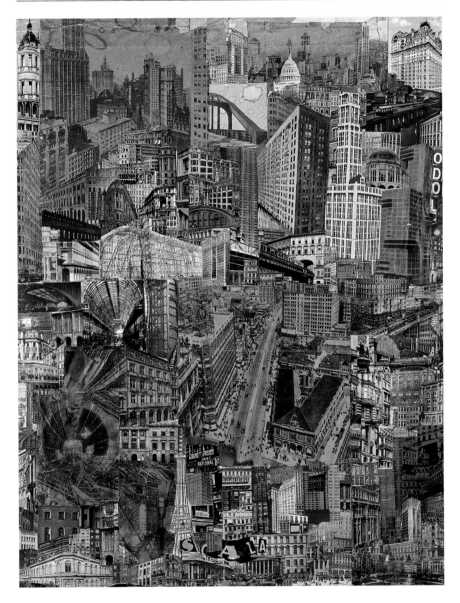

PAUL CITROEN (1896–1983).
Metropolis, 1923. Collage, 29⅞ x 23¼ in. (76 x 59 cm). Prentenkabinet der Rijksuniversiteit, Leiden, the Netherlands. © 1997 Paul Citroen/Licensed by VAGA, New York.

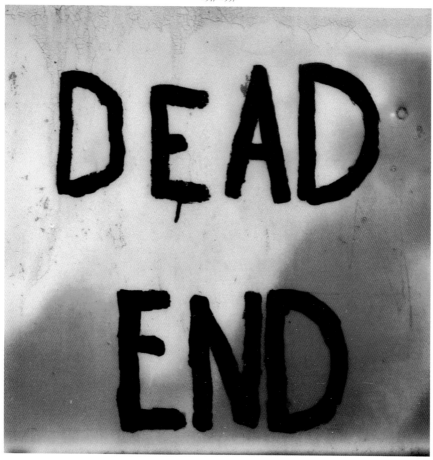

WALKER EVANS (1903–1975).
Graffiti: "Dead End," c. 1973–74. Polaroid SX-70 print, 4¹/₄ x 3¹/₂ in.
(10.8 x 8.9 cm). J. Paul Getty Museum, Los Angeles.

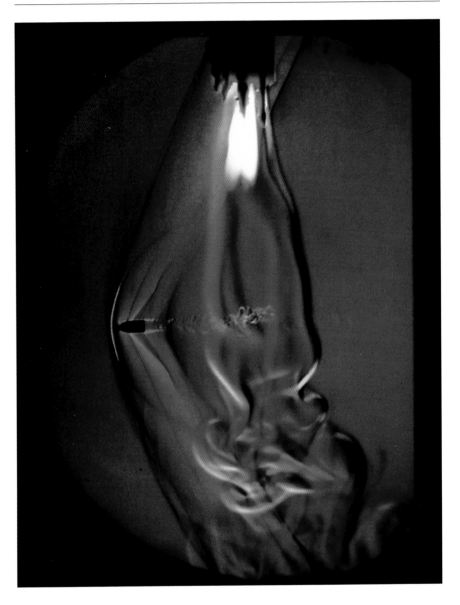

HAROLD E. EDGERTON (1903–1990).
Bullet Thru Flame, 1973. Dye-transfer print, 18¼ x 12¼ in. (46.3 x 31 cm).
Palm Press, Inc., Concord, Massachusetts.

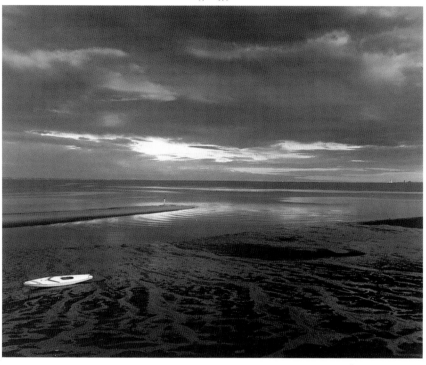

JOEL MEYEROWITZ (b. 1938).
Bay/Sky, Desk, 1977. Dye-coupler print, 7⅝ x 9⅝ in. (18 x 23.1 cm).
Bonnie Benrubi Gallery, New York.

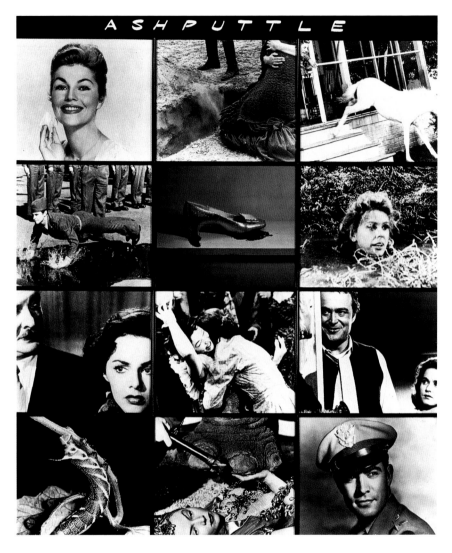

JOHN BALDESSARI (b. 1931).
Ashputtle, 1982. Eleven black-and-white photographs, one color photograph, and one text panel, 84 x 72 in. (213.4 x 182.9 cm), overall. Whitney Museum of American Art, New York; Purchase with funds from the Painting and Sculpture Committee.

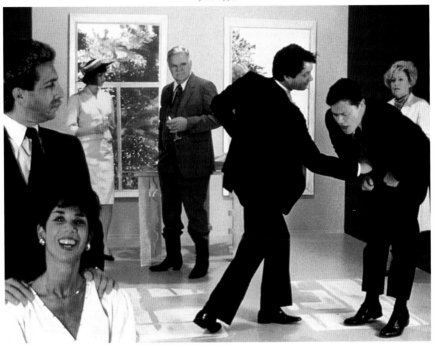

NIC NICOSIA (b. 1951).

Violence, 1986. Cibachrome print, 48 x 58 in. (121.9 x 147.3 cm).

P.P.O.W. Gallery, New York.

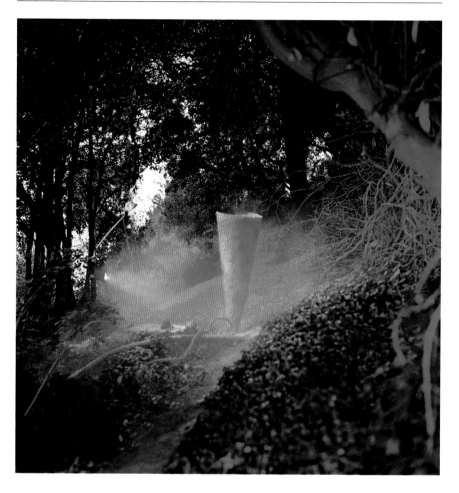

JOHN DIVOLA (b. 1949).
Cyclone, 1986. Dye-transfer print, 18⅝ x 18⅝ in. (45 x 45 cm).
Collection of the photographer.

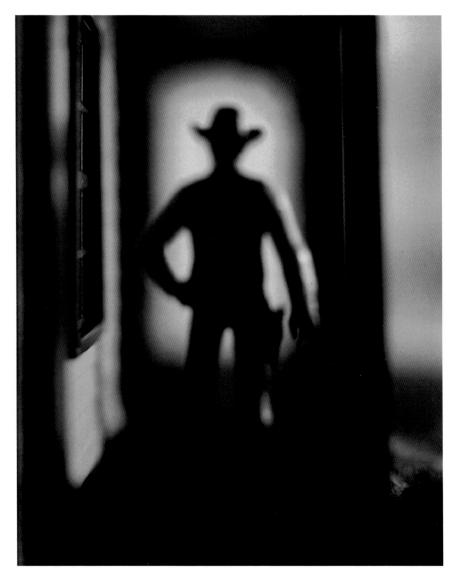

DAVID LEVINTHAL (b. 1949).
Untitled (Sheriff Silhouette), from the series The Wild West, 1987–89.
Polaroid using Polacolor ER 20 24 Land film, 24 x 20 in. (60.9 x 50.8 cm).
Janet Borden, Inc., New York.

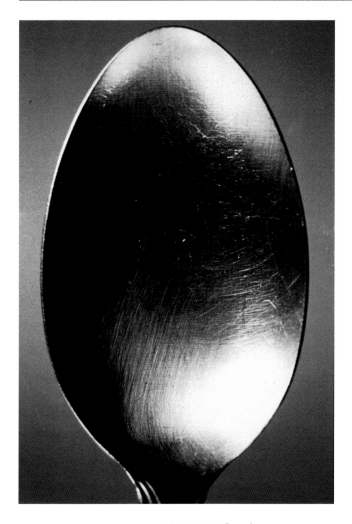

PASCAL TOSANI (b. 1954).
"D," from the series Spoons, 1988. Cibachrome (silver-dye bleach print),
71⅝ x 47¼ in. (182 x 120 cm). Liliane & Michel Durand-Dessert, Paris.

Words in CAPITALS are defined in the entries (pages 39–204).

1839

THE WORLD

Carlist War ends in Spain.

U.S. inventor Charles Goodyear makes rubber usable with "vulcanization" process; Scottish inventor Robert Davidson develops an electric motor.

Abolitionists establish Liberty party in the U.S.

French novelist Stendhal publishes *The Charterhouse of Parma.*

PHOTOGRAPHY

French physicist François Arago announces French painter Louis-Jacques-Mandé Daguerre's discovery of the DAGUERREOTYPE to the Académie des Sciences, Paris.

French inventor Hippolyte Bayard produces the first direct-positive print.

British physicist William Henry Fox Talbot announces to the British Royal Society his process for recording images on light-sensitive paper.

1840–49

1840

THE WORLD

First Opium War begins in China (ends 1842).

U.S. writer Edgar Allan Poe publishes *Tales of the Grotesque and Arabesque.*

PHOTOGRAPHY

U.S. scientist John William Draper produces DAGUERREO-TYPES of the moon.

The first portrait studios are opened in New York, first by Alexander S. Wolcott and John R. Johnson, then by Draper and Samuel F. B. Morse.

French physicist Armand-Hippolyte-Louis Fizeau invents a method of toning DAGUERREOTYPES with gold, improving their visibility.

1841

THE WORLD

French law prohibits children under age twelve from working more than eight hours a day in factories.

British miners unionize.

PHOTOGRAPHY

Talbot takes out his first patent for the CALOTYPE.

1843

THE WORLD

German physicist Georg Simon Ohm formulates his law of acoustics.

German composer Richard Wagner's opera *The Flying Dutchman* premieres in Berlin.

Danish philosopher Søren Kierkegaard publishes *Fear and Trembling.*

PHOTOGRAPHY

David Octavius Hill and Robert Adamson produce series of CALOTYPE portraits of founders of the Scottish Free Church.

1844

THE WORLD

Morse installs a telegraph line between Baltimore and Washington, D.C.

PHOTOGRAPHY

Talbot begins to publish his book promoting the potential of photography, *The Pencil of Nature* (1844–46).

1845

THE WORLD

Jews are given the right to vote in Britain.

Rotary printing presses are introduced in Britain.

PHOTOGRAPHY

William and Frederick Langenheim make PANORAMIC DAGUERREOTYPE of Niagara Falls.

1846

THE WORLD

Mexican-American War begins (ends 1848).

German astronomer Johann Galle discovers Neptune.

PHOTOGRAPHY

German manufacturer Carl Zeiss opens the first factory for optical instruments, including lenses, in Jena, Germany.

1847

THE WORLD

European economic crisis is worsened by famine and a cholera epidemic.

Labor laws protecting women are passed in Britain.

Algerian leader Abdelkader surrenders to French forces in Algeria.

PHOTOGRAPHY

The Photographic Club is founded in London.

1848

THE WORLD

Gold is discovered in California.

Revolution in France is followed by abdication of Louis-Philippe and election of Louis-Napoléon as president of the Second French Republic.

Popular uprisings take place across Europe.

Serfdom in central Europe and slavery in the French colonies are abolished.

German philosophers Karl Marx and Friedrich Engels publish *The Communist Manifesto.*

First women's rights convention is held at Seneca Falls, New York.

PHOTOGRAPHY

Color images of the solar spectrum are produced by French physicist Alexandre-Edmond Becquerel.

British sculptor Frederick Scott Archer invents the wet-COLLODION PROCESS.

1849

THE WORLD

Fizeau measures speed of light.

British novelist Charles Dickens publishes *David Copperfield.*

First Pre-Raphaelite painting is exhibited in London.

PHOTOGRAPHY

Scottish physicist David Brewster develops successful stereoscopic viewer.

1850–1859

1850

THE WORLD

California becomes the thirty-first state; since 1820 the U.S. population has grown from 9.6 to 23 million.

PHOTOGRAPHY

French inventor and amateur photographer Louis-Désiré Blanquart-Evrard invents a method for making ALBUMEN PRINTS.

U.S. photographer Mathew Brady publishes his *Gallery of Illustrious Americans.*

First photograph of stars is taken at Harvard University observatory.

1851

THE WORLD

First reliable undersea cable is laid, between Dover, England, and Calais, France.

U.S. novelist Herman Melville publishes *Moby Dick.*

First international exposition is held, at the Crystal Palace, London.

Reuters News Agency is established in London.

PHOTOGRAPHY

Société *Héliographique* is created by the French government to record the country's architectural monuments.

Blanquart-Evrard opens his photographic printing plant in Lille, France.

1852

THE WORLD

Louis-Napoléon proclaims himself Emperor Napoléon III in France (the Second Empire continues to 1870).

French philosopher Auguste Comte publishes *Catechism of Positive Religion.*

PHOTOGRAPHY

First exhibition consisting solely of photographs is held in London.

French photographer Maxime Du Camp publishes *Egypt, Nubia, Palestine, and Syria.*

1853

THE WORLD

Crimean War begins between Russia and the Ottoman Turks (allied with France and England); ends in 1856.

French administrator Georges-Eugène Haussmann begins to reconfigure the streets of Paris.

PHOTOGRAPHY

French engraver François Lemaître and French chemist Abel Niepce de Saint-Victor produce steel engravings from photographs—an early form of photogravure.

Photographic Society of London is established (renamed Royal Photographic Society in 1894).

1854

THE WORLD

Japan is opened to trade with the West.

PHOTOGRAPHY

Société Française de Photographie is established.

French photographer André-Adolphe-Eugène Disdéri patents the CARTE-DE-VISITE.

AMBROTYPES are introduced in the U.S.

1855

THE WORLD

Czar Nicholas I of Russia dies and is succeeded by Alexander II.

International exposition, which includes a photography section, is held in Paris.

U.S. poet Walt Whitman publishes first edition of *Leaves of Grass.*

PHOTOGRAPHY

Roger Fenton, James Robertson, and others photograph the Crimean War.

French chemist Alphonse-Louis Poitevin patents a CARBON PROCESS.

The Mayer and Pierson photography studio opens in Paris (closes 1864).

1857

THE WORLD

Indian Mutiny (Sepoy Rebellion) against the British begins (ends 1858).

French poet and critic Charles Baudelaire publishes *The Flowers of Evil.*

PHOTOGRAPHY

Swedish photographer Oscar Gustav Rejlander makes *Two Ways of Life,* an early composite photograph.

British publisher Francis Frith starts to photograph in Egypt.

1858

PHOTOGRAPHY

French photographer Nadar makes the first AERIAL PHOTOGRAPHS, from his balloon over Paris.

British photographer Henry Peach Robinson makes *Fading Away,* a STAGED PHOTOGRAPH combining five negatives.

French photographer Désiré Charnay takes photographs of Mayan ruins.

John Pouncy improves the CARBON PROCESS.

1859

THE WORLD

British naturalist Charles Darwin publishes *The Origin of Species.*

1860–1869

1860

THE WORLD

British and French troops occupy Beijing.

Abraham Lincoln is elected U.S. president.

PHOTOGRAPHY

The Bisson brothers make a series of photographs of Mont Blanc, France.

Brady produces *Abraham Lincoln,* a photographic ALBUM.

1861

THE WORLD

U.S. Civil War begins (ends 1864).

Alexander II emancipates the serfs in Russia.

French artist Gustave Doré illustrates Dante's *Inferno.*

PHOTOGRAPHY

First Brady, then Alexander Gardner, Timothy O'Sullivan, and Andrew Russell record the Civil War in a DOCUMENTARY mode that proves immensely influential in U.S. photography.

Nadar uses artificial LIGHT to photograph the catacombs and sewers of Paris.

1862

THE WORLD

Otto von Bismarck becomes prime minister of Prussia.

Japanese arts and crafts are presented to the Western public for the first time at the international exhibition in London.

PHOTOGRAPHY

A group of French painters issues a manifesto against photography.

Disdéri publishes *The Aesthetic of Photography.*

French physicist Louis Ducos du Hauron lays technical groundwork for color photography.

1863

THE WORLD

French painter Edouard Manet's *Luncheon on the Grass* provokes a scandal in Paris.

PHOTOGRAPHY

The first photographic magazines are published in Spain *(El propagador de la fotografía)* and Italy *(La camera obscura).*

Etienne Carjat makes photographic portrait of Baudelaire.

Julia Margaret Cameron photographs her family and friends in a Pre-Raphaelite style (until 1875).

1864

THE WORLD

In London, Marx and others establish the International Workingmen's Association.

After capturing Mexico City, the French proclaim Archduke Maximilian of Austria emperor of Mexico; he is executed in 1867, after French support is withdrawn.

Steamship service is introduced between Le Havre, France, and New York.

PHOTOGRAPHY

British inventor Walter B. Woodbury patents the WOODBURYTYPE.

1865

THE WORLD

President Lincoln is assassinated.

British writer and mathematician Lewis Carroll publishes *Alice's Adventures in Wonderland.*

1866

THE WORLD

Russian novelist Fyodor Dostoyevsky publishes *Crime and Punishment.*

PHOTOGRAPHY

Gardner's Photographic Sketch Book of the Civil War is published.

1868

THE WORLD

The shogunate collapses in Japan; the capital is moved from Kyoto to Edo (now Tokyo).

1869

THE WORLD

Suez Canal opens in Egypt.

First transcontinental railroad line in the U.S. is completed.

French inventor Charles Cros and Ducos du Hauron publish, independently, processes for making photographic images in color.

1870-1879

1870

THE WORLD

Metropolitan Museum of Art is founded in New York.

PHOTOGRAPHY

William Henry Jackson photographs the American West as part of the U.S. Geological and Geographical Survey of the Territories (through 1878).

1871

THE WORLD

France is defeated in the Franco-Prussian War after a devastating siege of Paris; the Commune seizes control of Paris but is quickly crushed.

The German Empire, or Reich, is established.

German archaeologist Heinrich Schliemann begins to excavate what he believes to be ancient Troy.

U.S. artist James McNeill Whistler paints *Arrangement in Grey and Black, No. 1: Portrait of the Artist's Mother.*

Richard Leach Maddox invents the first dry plates coated with GELATIN SILVER bromide.

Police use photography in their efforts to arrest the Paris Communards.

1872

THE WORLD

German philosopher Friedrich Nietzsche publishes *The Birth of Tragedy.*

PHOTOGRAPHY

In the U.S., production of celluloid begins.

First stop-action photographs of a galloping horse are taken, by U.S. photographer Eadweard Muybridge.

1873

THE WORLD

Remington factory starts producing typewriters in the U.S.

International exposition is held in Vienna.

French writer Jules Verne publishes *Around the World in Eighty Days.*

PHOTOGRAPHY

British inventor William Willis patents the PLATINUM PRINT process; Peter Mawdsley invents GELATIN SILVER-bromide paper.

1874

THE WORLD

Benjamin Disraeli becomes prime minister of Britain.

The Impressionists present their first exhibition, at Nadar's photography studio in Paris.

1875-77

THE WORLD

Russian writer Leo Tolstoy publishes *Anna Karenina.*

1876

THE WORLD

Scottish-American inventor Alexander Graham Bell patents the telephone.

1877

THE WORLD

U.S. inventor Thomas Edison and French inventor Charles Cros invent the phonograph, independently.

PHOTOGRAPHY

John Thomson publishes *Street Life in London,* illustrated with woodcuts made from his photographs—the first great example of photographic social documentation.

1879

THE WORLD

Norwegian playwright Henrik Ibsen's *A Doll's House* premieres.

Muybridge designs an early version of the movie projector, which he calls a "zoopraxiscope."

1880-1889

1880

THE WORLD

French sculptor Auguste Rodin begins work on *The Gates of Hell*.

French writer Emile Zola publishes *Nana*.

PHOTOGRAPHY

In Lyons, France, the Lumière brothers open their photographic factory.

First halftone reproduction of a photograph appears in a New York newspaper.

1881

THE WORLD

U.S. novelist Henry James publishes *The Portrait of a Lady*.

1882

THE WORLD

U.S. Congress legislates the Chinese Exclusion Act, a ten-year prohibition against Chinese workers entering the country.

In France, Jules Ferry makes primary education obligatory and independent of church control.

PHOTOGRAPHY

French physiologist Etienne-Jules Marey perfects the *fusil photographique* ("photographic gun") and uses it to take chronophotographs, which record sequential MOVEMENT.

French criminologist Alphonse Bertillon invents the first photographic identification file for police use.

1884

THE WORLD

In Chicago, William Le Baron Jenney uses first steel frame in a commercial building.

French industrialists Albert de Dion and Georges Bouton develop first steam automobile.

The Circle line, the first underground public transport system, opens in London.

1885

THE WORLD

Conference of Berlin formalizes Western powers' colonial rule in Africa; Congo Free State is established under the rule of Leopold II of Belgium.

PHOTOGRAPHY

French officer S. Moëssard invents the panoramic camera.

In Paris, Léon Gaumont establishes the Comptoir Général de Photographie.

U.S. inventor Frederic E. Ives perfects a halftone process that makes it possible to print text and photographs in a single operation.

1886

THE WORLD

American Federation of Labor is established.

The Statue of Liberty, a gift from the people of France to the U.S., is dedicated in New York Harbor.

PHOTOGRAPHY

Nadar's photographs of and interview with the one-hundred-year-old chemist Michel-Eugène Chevreul appear in *Le Journal illustré*.

British photographer Peter Henry Emerson coins the term PICTORIALISM.

1887

THE WORLD

German engineer Gottlieb Daimler patents first high-speed internal-combustion engine.

German scientist Heinrich Hertz discovers and analyzes electromagnetic waves.

PHOTOGRAPHY

Muybridge publishes *Animal Locomotion*.

New York Camera Club is established.

1888

THE WORLD

Scottish inventor John B. Dunlop patents the rubber tire.

International expositions are held in Brussels, Buffalo, Glasgow, and Melbourne.

Austrian composer Gustav Mahler completes his First Symphony.

PHOTOGRAPHY

U.S. inventor and industrialist George Eastman introduces the small-format Kodak camera using roll film. Hereafter, amateurs can send their SNAPSHOTS to a factory to be developed—a new ease of use encouraged by Kodak's famous slogan, "You press the button we do the rest."

1889

THE WORLD

The Eiffel Tower is completed for the international exposition in Paris.

PHOTOGRAPHY

Peter Henry Emerson publishes *Naturalistic Photography*.

1890–1899

1890

THE WORLD

Bismarck falls from power in Germany.

Sherman Antitrust Act is passed in U.S.

The first edition of poems by Emily Dickinson is published, posthumously.

PHOTOGRAPHY

German scientist Paul Rudolph produces the first anastigmatic LENS.

U.S. journalist Jacob Riis publishes his photographic exposé of New York slums, *How the Other Half Lives*.

1891

THE WORLD

Construction of the Trans-Siberian Railroad begins (completed 1916).

Dutch anatomist and paleontologist Eugène Dubois discovers *Pithecanthropus erectus*, or Java man.

PHOTOGRAPHY

The Wiener Kamera Klub is founded in Vienna and organizes the first international photography exhibition to be held in a German-speaking country.

1892

THE WORLD

The Secession, a group of young dissident artists, is established in Munich.

PHOTOGRAPHY

The first successful underwater photographs are taken by French scientist Louis Boutan.

The first American edition of *Vogue* is published.

In London, the Linked Ring is established to promote "artistic" photography.

1893

THE WORLD

French diplomat and engineer Ferdinand de Lesseps is convicted for his part in the Panama Canal bankruptcy scandal.

German physicists Julius Elster and Hans Friedrich Geitel invent the photoelectric cell.

PHOTOGRAPHY

Edison perfects 35 mm film.

First public exhibition of amateur photographs is held, in Hamburg's Kunsthalle.

1894

THE WORLD

Sino-Japanese War begins (ends 1895).

1895

THE WORLD

Italian inventor Guglielmo Marconi experiments with wireless telegraphy.

First Venice Biennale is held.

PHOTOGRAPHY

French film pioneers Auguste and Louis Lumière present first public screening of a movie.

German physicist Wilhelm Conrad Roentgen discovers the X ray.

1896

THE WORLD

The will of Alfred Nobel, Swedish inventor of dynamite, establishes the Nobel Prizes.

Russian playwright Anton Chekhov's *The Seagull* premieres.

PHOTOGRAPHY

French astronomer Victor Puiseux publishes *Photographic Atlas of the Moon.*

1897

THE WORLD

English physicist Joseph John Thomson discovers the electron.

Rudolph Dirks's comic strip, *The Katzenjammer Kids,* debuts in the *New York Sunday Journal.*

Viennese painter Gustav Klimt establishes the Vienna Secession.

PHOTOGRAPHY

Under auspices of the New York Camera Club, U.S. photographer Alfred Stieglitz establishes *Camera Notes,* a journal with PICTORIALIST allegiances intended to promote artistic photography.

1898

THE WORLD

The U.S. defeats Spain in the Spanish-American War and acquires Puerto Rico, Guam, and the Philippines.

Zola publishes *"J'accuse"*— a public letter calling for reversal of Captain Alfred Dreyfus's conviction for treason.

French scientists Pierre and Marie Curie discover radium.

PHOTOGRAPHY

French photographer Eugène Atget starts taking pictures of Paris (continues until 1927).

1899

THE WORLD

The Boer War begins in South Africa (ends 1902).

1900–1909

1900

THE WORLD

The Boxers rebel against foreign influence in China.

German physicist Max Planck formulates quantum theory.

Austrian psychoanalyst Sigmund Freud publishes *The Interpretation of Dreams.*

1901

THE WORLD

Queen Victoria dies.

1902

THE WORLD

Italian philosopher Benedetto Croce publishes first volume of *Philosophy of the Spirit.*

PHOTOGRAPHY

Stieglitz resigns from *Camera Notes* and, with Edward Steichen, founds the PHOTO-SECESSION.

1903

THE WORLD

The Wright brothers complete a brief flight in their motor-driven airplane at Kitty Hawk, North Carolina.

Austrian composer Arnold Schoenberg's *Pelleas and Melisande* premieres.

PHOTOGRAPHY

Stieglitz publishes first issue of *Camera Work* in New York.

Photo-Club de Paris founds *La Revue de photographie* in Paris.

1904

THE WORLD

Russo-Japanese War begins (ends 1905).

PHOTOGRAPHY

Louis Lumière patents AUTOCHROME, the first viable process for making color plates (manufactured in quantity starting 1907).

International Society of Pictorialist Photographers is established.

1905

THE WORLD

German physicist Albert Einstein publishes his special theory of relativity.

The Fauve painters make their debut at the Salon d'Automne in Paris.

PHOTOGRAPHY

Stieglitz opens Little Galleries of the Photo-Secession (known as 291) in New York.

1907

THE WORLD

Britain, France, Russia, and Japan claim spheres of influence in Asia.

Spanish artist Pablo Picasso completes *Les Demoiselles d'Avignon.*

PHOTOGRAPHY

Royal Photographic Society, London, presents exhibition by French PICTORIALIST Robert Demachy.

U.S. photographer Edward S. Curtis begins publishing his twenty-volume series, *The North American Indian* (completed 1930).

1908

THE WORLD

French critic Louis Vauxcelles coins the term *Cubism.*

1909

THE WORLD

Italian writer Filippo Tommaso Marinetti publishes manifesto of FUTURISM.

1910–1919

1911

THE WORLD

The Manchu dynasty is overthrown in China; Sun Yat-sen is elected president of the new republic.

Norwegian explorer Roald Amundsen is first to reach the South Pole.

PHOTOGRAPHY

The young Jacques-Henri Lartigue begins to photograph the Bois de Boulogne in Paris.

In Italy, Anton Giulio and Arturo Bragaglia experiment with FUTURIST-related "photo-dynamism."

1912

THE WORLD

Russian painter Wassily Kandinsky publishes *Concerning the Spiritual in Art.*

Swiss psychoanalyst Carl Jung publishes *Psychology of the Unconscious.*

1913

THE WORLD

In U.S., assembly-line production begins in Ford automobile plants.

The International Exhibition of Modern Art (known as the Armory Show) introduces European modern art to U.S.

Russian composer Igor Stravinsky's *Rite of Spring* premieres, riotously, in Paris.

PHOTOGRAPHY

German engineer Oskar Barnack designs prototype of Leica camera.

E. J. Bellocq photographs prostitutes in New Orleans.

1914

THE WORLD

World War I begins (ends 1918).

Panama Canal opens.

PHOTOGRAPHY

CLARENCE H. WHITE SCHOOL OF PHOTOGRAPHY opens in New York.

1916

THE WORLD

The name *Dada* is coined for an avant-garde group of artists in Zürich.

Swiss philosopher Ferdinand de Saussure publishes *Course in General Linguistics.*

Paul Strand exhibition at 291 in New York marks the beginning of American photographic MODERNISM.

1917

THE WORLD

Czar Nicholas II abdicates; the Bolsheviks, led by Lenin, later seize control.

U.S. enters World War I.

1918

THE WORLD

Influenza pandemic kills 20 million people.

League of Nations is established; convenes in Geneva in 1920.

1919

THE WORLD

Bauhaus opens in Weimar, Germany.

1920–1929

1920

THE WORLD

Amendments to the U.S. Constitution give women the right to vote and establish Prohibition (the latter repealed in 1933).

PHOTOGRAPHY

Keystone PHOTO AGENCY is founded in Paris.

Dadaists start to experiment with photography, making COLLAGES and PHOTOMONTAGES.

1921

THE WORLD

Italian Communist Party is founded.

Irish Free State is granted independence from Britain.

PHOTOGRAPHY

U.S. photographer Man Ray makes his first RAYOGRAMS, in Paris.

The journal *Camera* is established in Lucerne, Switzerland.

The Constructivist photographic aesthetic begins to emerge.

1922

THE WORLD

Benito Mussolini becomes prime minister of Italy.

Irish writer James Joyce publishes *Ulysses* in Paris; the U.S. bans it.

1923

THE WORLD

Adolf Hitler leads unsuccessful putsch in Germany.

PHOTOGRAPHY

First wirephoto transmission is made.

Agfa produces the first reversible EMULSION.

U.S. photographer Edward Weston and Italian photographer Tina Modotti move to Mexico.

1924

THE WORLD

First nonstop flight from Paris to Tokyo is made.

French writer André Breton publishes *The Surrealist Manifesto*.

German filmmaker Erich von Stroheim's *Greed* premieres.

PHOTOGRAPHY

Ermanox and Leica 35 mm cameras are introduced.

1925

THE WORLD

The Schutzstaffel (SS) is established in Germany.

Mahatma Gandhi becomes president of Indian National Congress.

John Scopes is convicted of teaching the theory of evolution in a Tennessee high school.

U.S. novelist John Dos Passos publishes *Manhattan Transfer*.

PHOTOGRAPHY

Hungarian photographer László Moholy-Nagy publishes *Painting, Photography, Film*.

The electronic flash is invented in Germany by Paul Vierkötter.

1926

THE WORLD

Early experiments with television take place; Scottish inventor John Baird televises an image.

Austrian filmmaker Fritz Lang's *Metropolis* premieres.

PHOTOGRAPHY

Museum of Modern Art in New York (which will open to the public in 1929) begins to collect photographs (Photography Department established there in 1940).

1927

THE WORLD

Joseph Stalin takes control of Communist Party in USSR; exiles Leon Trotsky (in 1928).

U.S. aviator Charles Lindbergh flies from New York to Paris in 33 1/2 hours.

1928

THE WORLD

Chiang Kai-shek becomes president of the Chinese republic.

First radio link between Paris and New York is established.

Threepenny Opera, by Germans Kurt Weill (music) and Bertolt Brecht (lyrics), premieres.

British novelist D. H. Lawrence publishes *Lady Chatterley's Lover*.

PHOTOGRAPHY

Dephot PHOTO AGENCY opens in Berlin; the magazine *Vu* is established in France.

German photographer Albert Renger-Patzsch publishes his book *The World Is Beautiful.*

The Rolleiflex is introduced and helps popularize the twin-lens reflex camera.

Walker Evans begins to photograph on the streets of New York.

1929

THE WORLD

The stock market collapses in New York, eventually triggering worldwide economic depression.

PHOTOGRAPHY

Film und Foto exhibition is held in Stuttgart, Germany.

1930-1939

1930

THE WORLD

Austrian novelist Robert Musil begins to publish *The Man Without Qualities.*

L'Age d'or, SURREALIST film by the Spaniards Luis Buñuel and Salvador Dalí, premieres.

PHOTOGRAPHY

The journal *Photographie, arts et métiers graphiques* is established in Paris.

Lewis Hine photographs construction of Empire State Building in New York.

1931

THE WORLD

Japan invades Manchuria.

In Spain, Second Republic is established.

PHOTOGRAPHY

Julien Levy Gallery opens in New York, originally devoted to showing only photography.

1932

PHOTOGRAPHY

Photoelectric-cell light meter is introduced.

1933

THE WORLD

Nazi Party wins a majority in the Reichstag and takes control in Germany.

BAUHAUS is closed; several of its teachers emigrate to U.S.

Mexican painter Diego Rivera's mural for New York's Rockefeller Center is destroyed after public outcry over his inclusion of a portrait of Lenin.

PHOTOGRAPHY

Hungarian photographer Brassaï publishes *Paris by Night.*

The Rapho PHOTO AGENCY is established in Paris.

Evans works in Havana.

1935

THE WORLD

France and USSR sign a pact of alliance.

PHOTOGRAPHY

Resettlement Administration is established in U.S.; in 1937 it becomes the FARM SECURITY ADMINISTRATION.

Kodachrome FILM is introduced; infrared film is perfected.

1936

THE WORLD

Spanish Civil War begins (ends 1939).

Charlie Chaplin's film *Modern Times* premieres.

PHOTOGRAPHY

U.S. publisher Henry Luce establishes *Life* magazine.

PHOTO LEAGUE is founded in New York.

1937

THE WORLD

Picasso paints *Guernica* following the Nazi bombing of the Basque town of Guernica, Spain.

Japan invades China.

PHOTOGRAPHY

Beaumont Newhall organizes *Photography 1839–1937* at the Museum of Modern Art, New York.

1938

THE WORLD

Germany annexes Austria and Sudetenland; Italy, Britain, and France sign the Munich Pact ratifying the annexation.

Orson Welles's radio production of H. G. Wells's science-fiction *War of the Worlds* (1898) inadvertently causes widespread panic in U.S.

PHOTOGRAPHY

First photographic grant is awarded by Guggenheim Foundation, to Weston.

1939

THE WORLD

World War II begins (ends 1945).

1940–1949

1940

THE WORLD

Winston Churchill becomes prime minister of Britain.

Trotsky is assassinated in Mexico.

Prehistoric paintings are discovered in Lascaux caves in Dordogne, France.

PHOTOGRAPHY

New types of color FILM and papers are marketed by Agfa, Kodak, and Ansco.

1941

THE WORLD

Japanese forces bomb Pearl Harbor, in Hawaii; U.S. enters World War II.

Orson Welles's film *Citizen Kane* premieres.

PHOTOGRAPHY

Let Us Now Praise Famous Men is published by James Agee (text) and Walker Evans (photographs).

1942

THE WORLD

French existentialist Albert Camus publishes *The Stranger* and *The Myth of Sisyphus*.

1944

THE WORLD

Franklin Roosevelt is elected to unprecedented fourth term as U.S. president.

1945

THE WORLD

World War II ends in Europe. U.S. drops first atomic bombs on Hiroshima and Nagasaki; Japan surrenders and World War II ends.

Henri Matisse retrospective is held in Paris.

Italian filmmaker Roberto Rossellini's *Open City* premieres.

PHOTOGRAPHY

Groupe des XV is founded in Paris.

U.S. photographer Weegee publishes *Naked City.*

1946

THE WORLD

Nuremberg trials end in conviction of nineteen Nazi war criminals.

French Indochina War begins (ends 1954).

PHOTOGRAPHY

Museum of Modern Art, New York, presents "posthumous" Henri Cartier-Bresson exhibition (Cartier-Bresson had been sentenced to death at a prison camp during World War II but survived).

1947

THE WORLD

India establishes independence from Britain and is partitioned into India and Pakistan.

British writer Malcolm Lowry publishes *Under the Volcano.*

PHOTOGRAPHY

Robert Capa, Henri Cartier-Bresson, George Rodger, David Seymour, and Bill Vandivert found the Magnum PHOTO AGENCY in Paris.

Bussola group publishes manifesto in Italy against Neo-Realism.

1948

THE WORLD

U.S. Marshall Plan begins providing more than $12 billion for European economic recovery (ends 1951).

State of Israel is founded.

U.S. engineer Peter Goldmark invents the long-playing record.

First exhibition of the CoBrA group of artists (Asger Jorn, Karel Appel, Corneille, Jean Atlan, and Pierre Alechinsky) is held, in Copenhagen.

PHOTOGRAPHY

U.S. inventor and physicist Edwin H. Land demonstrates the Polaroid Land Camera.

1949

THE WORLD

North Atlantic Treaty Organization (NATO) is established.

Mao Tse-tung proclaims People's Republic of China.

French writer Simone de Beauvoir publishes *The Second Sex.*

1950-1959

1950

THE WORLD

Korean War begins (ends 1953).

1951

THE WORLD

Churchill becomes prime minister of Britain again.

PHOTOGRAPHY

W. Eugene Smith's "Spanish Village" PHOTO-ESSAY appears in *Life.*

1952

THE WORLD

U.S. explodes first hydrogen bomb.

Elizabeth II becomes queen of Britain.

The term *Action painting* is coined in U.S.

Twentieth Century-Fox introduces Cinemascope.

PHOTOGRAPHY

Minor White, with Dorothea Lange, Ansel Adams, and Beaumont Newhall, establishes the U.S. journal *Aperture.*

Cartier-Bresson publishes *The Decisive Moment.*

1953

THE WORLD

Stalin dies; Nikita Khrushchev becomes first secretary of the Communist Party.

Waiting for Godot, by Irish writer Samuel Beckett, premieres.

1954

THE WORLD

Algerian War of Independence begins (ends 1962).

1955

THE WORLD

Warsaw Treaty Organization is established by Albania, Bulgaria, Czechoslovakia, East Germany, Hungary, Poland, Rumania, and the USSR to counter NATO.

Bus boycott in Montgomery, Alabama, marks the start of the U.S. civil rights movement.

The first *Documenta* exhibition of contemporary art is held in Kassel, Germany.

U.S. biologist Gregory Pincus invents the birth-control pill.

PHOTOGRAPHY

Steichen organizes the phenomenally successful *Family of Man* exhibition at the Museum of Modern Art, New York.

1956

THE WORLD

President Gamal Abdal Nasser of Egypt nationalizes the Suez Canal, triggering armed intervention by Britain, France, and Israel.

USSR crushes insurrections in Hungary and Poland.

U.S. singer Elvis Presley has his first big success, with "Heartbreak Hotel."

1957

THE WORLD

Treaty of Rome establishes European Economic Community (Common Market).

1958

THE WORLD

Charles de Gaulle is elected president of the French Fifth Republic.

Claude Lévi-Strauss publishes *Structural Anthropology.*

U.S. establishes National Aeronautics and Space Administration (NASA).

Russian writer Vladimir Nabokov publishes *Lolita.*

PHOTOGRAPHY

Swiss photographer Robert Frank publishes *The Americans* in Paris (published in U.S. in 1959).

Museum of Modern Art, New York, presents *Abstraction in Photography.*

1959

THE WORLD

Fidel Castro overthrows dictator Fulgencio Batista in Cuba.

1960–1969

1960

THE WORLD

John F. Kennedy is elected president of U.S.

U.S. engineer Theodore H. Maiman builds first laser.

Italian filmmaker Federico Fellini's *La Dolce Vita* premieres.

PHOTOGRAPHY

U.S. photographer William Klein publishes *Rome in Paris.*

1961

THE WORLD

Soviet cosmonaut Yuri Gargarin makes first manned orbital spaceflight.

Berlin Wall is erected.

1963

THE WORLD

USSR, U.S., and Britain sign first nuclear test ban treaty.

Kennedy is assassinated.

Jean-Luc Godard's film *Contempt* premieres.

PHOTOGRAPHY

Museum of Modern Art, New York, presents the first large-scale exhibition of work by Lartigue.

Cibachrome process is introduced.

Kodak introduces the Instamatic camera.

1964

THE WORLD

United Nations troops are sent to Cyprus.

Roland Barthes publishes *Elements of Semiology.*

PHOTOGRAPHY

Musée de la Photographie opens in Bièvres, France.

Museum of Modern Art, New York, presents *The Photographer's Eye.*

Free Speech movement begins in Berkeley, California.

1965

THE WORLD

U.S. begins bombing North Vietnam.

1966

THE WORLD

Indira Gandhi becomes prime minister of India.

Cultural Revolution begins in China (ends 1969).

PHOTOGRAPHY

International Center of Photography opens in New York.

George Eastman House, Rochester, New York, presents *Towards a Social Landscape.*

1967

THE WORLD

Six-Day War is fought between Israel and Arab states.

Cuban revolutionary Ernesto "Che" Guevara is executed by Bolivian troops.

Antiwar demonstrations and race riots take place across U.S.

The term *Conceptual art* comes into use.

PHOTOGRAPHY

The journal *Photo* is established in Paris.

1968

THE WORLD

USSR invades Czechoslovakia.

Student uprisings take place in Europe and U.S.; general strike paralyzes Paris.

U.S. linguist Noam Chomsky publishes *Language and Mind.*

1969

THE WORLD

First commercial flight of the Concorde—supersonic jet developed by France and Britain.

U.S. astronauts are first to walk on the moon.

PHOTOGRAPHY

The journals *Afterimage* (U.S.) and *Creative Camera* (Britain) are established.

Lee Witkin Gallery opens in New York.

1970–1979

1970

THE WORLD

Marxist Salvador Allende is elected president of Chile (overthrown in military coup and dies, 1973).

PHOTOGRAPHY

First *International Conference on Photography* is held in Arles, France.

U.S. photographer Ralph Gibson publishes *The Somnambulist,* part one of a trilogy.

Sylvania introduces Flash-Cube X for amateurs.

1971

THE WORLD

In Washington, D.C., 200,000 protestors demand end of Vietnam War.

1972

THE WORLD

Watergate scandal erupts in U.S., eventually causing President Richard M. Nixon to resign (in 1974).

PHOTOGRAPHY

Italian photographer Ugo Mulas produces his series *Verifiche.*

Diane Arbus retrospective is held at the Museum of Modern Art, New York.

1973

Provisional peace treaty concludes U.S. involvement in Vietnam War.

1975

THE WORLD

Generalissimo Francisco Franco dies in Spain.

Civil wars begin in Lebanon, Angola, and Ethiopia.

Artists Space presents first exhibition of graffiti art in New York.

PHOTOGRAPHY

Claude Nori launches his journal *Contrejour* and his gallery in Paris.

U.S. photographers W. Eugene Smith and Aileen Smith publish *Minamata*.

1977

PHOTOGRAPHY

U.S. writer Susan Sontag publishes *On Photography*.

1979

THE WORLD

Islamic fundamentalists depose shah of Iran.

1980–1989

1980

THE WORLD

Green Party is established in Germany.

The first videoconferences are held.

Venice Biennale features major exhibition of POSTMODERN architecture.

PHOTOGRAPHY

Musée d'Art Moderne de la Ville de Paris presents *They Call Themselves Painters, They Call Themselves Photographers*.

U.S. photographer Lewis Baltz publishes *Park City*.

The first Month of Photography is organized in Paris, inaugurating an annual tradition of citywide exhibitions.

Canon introduces the autofocus AF 35M camera.

1981

THE WORLD

François Mitterrand is elected president of France.

Egyptian president Anwar Sadat is assassinated.

MTV music video channel is introduced in U.S.

IBM introduces its personal computer.

PHOTOGRAPHY

The journal *Les Cahiers de la photographie* is established in Paris.

1982

THE WORLD

Israel returns the Sinai Peninsula to Egypt.

Falklands War is fought between Britain and Argentina.

PHOTOGRAPHY

Ecole Nationale de la Photographie opens in Arles, France.

Masterpieces of Anonymous Nineteenth-Century Photography is held at the Centre Pompidou, Paris.

Sony introduces the DIGITAL camera in Japan.

1983

THE WORLD

Lech Walesa wins the Nobel Peace Prize.

The AIDS virus is identified by Luc Montagnier, France, and Robert Gallo, U.S.

PHOTOGRAPHY

Fotogramm exhibition is organized in Kassel, Germany, by German photographer Floris Neussüs.

Museum of Modern Art, New York, presents Frank Gohlke retrospective.

1984

THE WORLD

Indira Gandhi is assassinated.

German filmmaker Wim Wenders's *Paris, Texas* premieres.

PHOTOGRAPHY

Centre de la Photographie opens in Geneva.

Henri Van Lier publishes *The Philosophy of Photography*.

1985

THE WORLD

Mikhail Gorbachev is elected secretary general of the Communist Party, USSR.

The Musée Picasso opens in Paris.

PHOTOGRAPHY

Friends of Photography is established in Carmel, California.

Photography and Surrealism exhibition is held at the Centre Pompidou, Paris.

1987

THE WORLD

The Intifada (the Palestinian insurrection movement) begins.

Andy Warhol dies.

Philips (Holland) introduces the video compact disk.

PHOTOGRAPHY

In France, the exhibition *Body to Body* by the group Noir Limite provokes scandal and is censored.

U.S. photographer Nicholas Nixon takes portraits of dying AIDS patients.

1988

THE WORLD

The Iran-Iraq War ends.

The Palestine Liberation Organization proclaims an independent Palestinian state.

PHOTOGRAPHY

Christian Boltanski: Lessons of Darkness exhibition tours U.S. and Canada.

1989

THE WORLD

Student prodemocracy demonstrations are violently repressed at Tian An Men Square in Beijing.

The Berlin Wall comes down, marking the end of Communist domination of Eastern Europe.

PHOTOGRAPHY

Corcoran Gallery of Art in Washington, D.C., cancels the Robert Mapplethorpe retrospective because of controversy over his sexually explicit photographs.

The 150th anniversary of the invention of photography is celebrated worldwide with numerous important exhibitions.

1990–1997

1990

THE WORLD

Germany is reunified.

Iraqi troops invade Kuwait, triggering the Gulf War (1991).

Lech Walesa is elected president of Poland.

PHOTOGRAPHY

In Paris, the Month of Photography sponsors extensive exhibitions of Japanese photography.

1991

THE WORLD

Civil War begins in Yugoslavia.

Gorbachev resigns.

Museum für Moderne Kunst opens in Frankfurt, Germany.

PHOTOGRAPHY

Italian photographer Oliviero Toscani devises publicity campaign for the Benetton clothing company focusing on AIDS themes in particular; his photographs are prohibited in the U.S.

1992

THE WORLD

Riots are triggered in Los Angeles by the acquittal of policemen accused of beating black motorist Rodney King.

The Communist regime falls in Afghanistan.

PHOTOGRAPHY

The first exhibition of Andy Warhol's Polaroid portraits is held at Galerie Durand Dessert, Paris.

U.S. photographer Andres Serrano produces his Morgue series.

Kodak introduces the Photo CD.

Whitney Museum of American Art, New York, presents Richard Avedon retrospective.

1993

THE WORLD

Maastricht Treaty on European unification takes effect.

The telescope at the Keck Observatory in Hawaii, the largest in the world (32 feet 10 inches [10 meters] in diameter), begins functioning.

PHOTOGRAPHY

Centre National de la Photographie, Paris, presents *Vanities: Nineteenth-Century Fashion Photography.*

Fundacio Antoni Tàpies, Barcelona, presents Brassaï retrospective.

U.S. photography historian Beaumont Newhall dies.

1994

THE WORLD

Massacres begin in Rwanda.

Russian military intervention in Chechnya begins.

PHOTOGRAPHY

French photographer Robert Doisneau dies.

Musée d'Orsay, Paris, presents Nadar retrospective.

National Gallery of Art, Washington, D.C., presents *Robert Frank: Moving Out.*

Michel Frizot, editor, publishes *Nouvelle Histoire de la photographie.*

1995

THE WORLD

Jacques Chirac is elected president of France.

Yitzhak Rabin, prime minister of Israel, is assassinated.

Dayton peace accord on Bosnia-Herzegovina is signed.

PHOTOGRAPHY

Edward Weston retrospective is held at the Hôtel de Sully, Paris.

Tokyo Metropolitan Museum of Photography presents *The Age of Modernism.*

1996

THE WORLD

Teatro de la Fenice, Venice, is destroyed by fire.

First Palestinian elections are held.

PHOTOGRAPHY

Maison Européenne de la Photographie opens in Paris.

Museum of Modern Art, New York, presents Roy DeCarava retrospective.

Twenty-seventh photography festival in Arles, France, is devoted, in part, to DIGITAL images.

A History of Women Photographers opens at the New York Public Library.

1997

THE WORLD

Pathfinder takes detailed photographs on the planet Mars.

Diana, princess of Wales, is killed in a car accident in Paris; some blame the paparazzi for her death.

Mother Teresa dies in Calcutta.

PHOTOGRAPHY

Helen Anderson's remarkable photographic collection is auctioned in London for the record-setting price of 1.8 million pounds.

The International Center of Photography, New York, presents a major retrospective of the photojournalist Weegee.

ABSTRACTION

The conventional definition of pictorial abstraction ("a work of art with no recognizable subject") seems totally at odds with the nature of photography, which is essentially realistic and figurative. Basically, two approaches to photographic abstraction have been explored: exaggeration of a single characteristic (for example, the subject's form or texture) and the use of extreme close-ups, distortion, lighting effects, and so on to transform the subject so completely that it becomes unidentifiable and hence abstract.

From the moment Cubism emerged in Europe, around 1907–8, its radically stylized geometric shapes prompted photographers—who were also influenced by JAPONISME, Constructivism, and Wassily Kandinsky's theories of abstraction (1913)—to imitate what then seemed the essence of MODERNISM. It was Alvin Langdon Coburn who created the first intentionally abstract photographs, with his 1912 series New York from Its Pinnacles, in which the city was photographed using plunging perspectives (see, for example, *The Octopus, New York*). His interest in Cubist abstraction led Coburn, in 1916, to make VORTOGRAPHS, in which light was reflected and refracted by mirrors and prisms to produce an art of optical effects. Also in 1916, and equally influenced by the Cubists, Paul Strand made abstract photographs such as *Porch Shadows*. These inspired many other photographers, such as Francis Bruguière and members of the Japanese Camera Pictorialists of America, all of whom were eager to link their photography to avant-garde European painting. This tendency toward abstraction quickly evolved into a figurative formalism, in which the human body was often reduced to geometric shapes, as in Cubist paintings—an approach associated with the CLARENCE H. WHITE SCHOOL OF PHOTOGRAPHY. There, beginning in 1914, many professors and students (Laura Gilpin, Paul Outerbridge Jr., Karl Struss, and above all Bernard S. Horne) developed a photography marked by experimental abstraction; their efforts were often reproduced in the magazine *Photo=Graphic Art.*

European photographers of the NEW VISION group (nourished by the BAUHAUS aesthetic of László Moholy-Nagy and El Lissitzky) and French avant-garde photographers such as André Kertész and Florence Henri produced especially innovative images that treated forms and volumes in novel ways. Kertész often used vertiginous views that suppressed the horizon and intensified the two-dimensional effect of the photographed scene, as in *Shadow of the Eiffel Tower, Paris, 1929*. Henri used mirrors to multiply lines and volumes (*Window*, 1928–29), as did some Czech photographers—for example, Jaromír Funke in his series Photographic Construcions (1923). The

ABSTRACTION

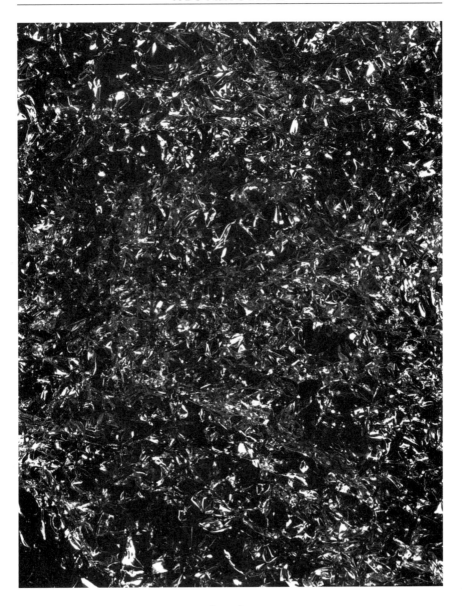

JAMES WELLING (b. 1951).
Untitled (42), 1980, from *October Portfolio One,* 1993. Gelatin silver print, 5 1/2 x 4 1/4 in. (13.9 x 10.7 cm). Museum of Fine Arts, Boston; Contemporary Curator's Fund.

PHOTOGRAMS that Moholy-Nagy, Man Ray, and Christian Schad produced without using a camera influenced the photographic abstractions made into the 1950s by members of the SUBJEKTIVE FOTOGRAFIE group in Europe as well as by American photographers such as Arthur Siegel and Henry Holmes Smith.

After World War II photographic abstraction, influenced by the New Bauhaus in Chicago, was quite prominent in the United States, where it evolved into the use of METAPHOR—most notably by Harry Callahan, Aaron Siskind, Frederick Sommer, and Minor White. In 1958 the Museum of Modern Art in New York presented the international exhibition *Abstraction in Photography*, which marked the culmination of the formalist investigations that had originated with photographic modernism and coincided with the development of Abstract Expressionism in American postwar painting.

ADVERTISING PHOTOGRAPHY

The strong links between photography and advertising were established in the period between the two world wars, when photographers began to participate actively in the promotion of the new products that proliferated in the West's rapidly growing consumer culture. The persuasive realism of photographs was perfectly suited to describing consumer goods and hence to promoting them. In 1927 Edward Steichen devised an advertisement for Camel cigarettes, and two years later, in Paris, Florence Henri did likewise for Lanvin perfume. Advertising assimilated the look of modern art, including new effects associated with avant-garde movements, such as François Kollar's use of SOLARIZATION and DOUBLE EXPOSURE for haute couture advertising images in 1930.

Many fine-art photographers specialized in advertising photography during this interwar period and worked for advertising agencies—Paul Outerbridge Jr. and Steichen in the United States; Kollar, Man Ray, Maurice Tabard, and René Zuber in France. Some of these photographers (perhaps most notably Outerbridge) were the first to make systematic use of color in their commissioned work; the widespread use of commercially viable color processes after World War II further vitalized advertising photography. A return to black-and-white photography can be seen in current advertising photography, which often uses subjects from movies, literature, and even the history of photography itself—as in the American campaign for the Gap's khakis, which featured vintage images of khaki-clad celebrities such as Jack Kerouac and Sarah Vaughan.

Sarah Vaughan in an ad from the Gap's khakis campaign.

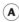

The interactions between creative photography and advertising photography have been extensive. (The commercial rates paid for advertising photography make it a lucrative endeavor that has helped underwrite more personal work by many photographers.) Even the resolutely noncommercial photographer Robert Frank participated, in 1991, in the creation of an advertising campaign for the clothing line by the Italian designer Romeo Gigli. The POST-MODERN aesthetic evident in Barbara Kruger's PHOTOMONTAGES, with their distinctive typography and narrative drive, has been used in many advertising campaigns. Pierre et Gilles have created record and CD covers featuring their quirky visual world of popular myth staged in kitschy settings filled with allusions to Hollywood stars.

AERIAL PHOTOGRAPHY

The first experiments with aerial photography occurred early in the medium's history. Nadar photographed from his balloon over Paris in 1858, and James Wallace Black did likewise over Boston two years later. Edward Steichen took aerial reconnaissance photographs during World War I, and the documentary aspect of that experience helped convince him to abandon the purely aesthetic approach of PICTORIALISM. Influenced by FUTURISM, the Italian aviator Masoero produced aerial views between 1930 and 1935 that he intended to create "a sensation of speed in its pure form." After World War II, William Garnett produced curiously abstract aerial views of the American landscape, some of which recall the dust accumulations that Man Ray made in 1920. Aerial photographs taken by Emmet Gowin in the late 1980s have an apocalyptic aura related to pervasive fears about the destruction of the environment.

Aerial photography, especially since the perfection of infrared film in 1935, has been most useful for scientific purposes: archaeological surveys, map making, military reconnaissance, the search for water or oil, the study of forestation patterns, and so on. Photography taken from space—the most technologically sophisticated form of aerial photography—began in 1946; the first exposures were made from an altitude of 81 miles (130 kilometers), by a 35 mm camera mounted on a captured German V-2 rocket launched by the United States. In 1959 the first image of Earth was recorded from a satellite. Photographs of the planet, which continued to be made on the Apollo missions throughout the 1960s, culminated in the famous *Earthrise* (December 24, 1968). Rapidly disseminated through calendars, magazines, and books as well as films such as Stanley Kubrick's *2001: A Space Odyssey* (1968), space photographs had considerable impact, transforming Earth-bound visions of

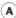
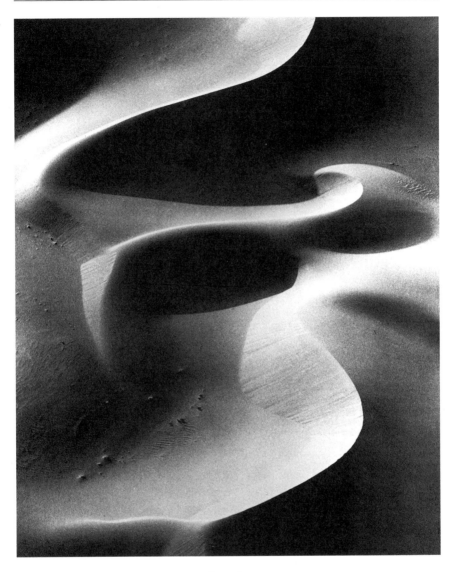

JEAN DIEUZAIDE (b. 1921).
Dunes in the Sahara, 1964. Gelatin silver print, 8⁵/8 x 7 in. (22 x 18 cm).
Collection of the photographer.

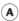

the world into a new consciousness of the planet's relative tininess and isolation within the vastness of the universe. Contemporary space photography is made by satellites like France's *Spot* (launched in 1986), which can transmit digital images of objects as small as 33 feet (10 meters) across, from an altitude of 520 miles (830 kilometers). Their long-distance precision has helped draw attention to ecological problems such as the air pollution that is now visible on a global scale.

ALBUM

Starting in the mid-1840s, the availability of the CALOTYPE process (which made it possible to produce multiple positive prints from a single negative) encouraged the mass production of photographs, many of which ended up in photographic albums. In 1851 Louis-Désiré Blanquart-Evrard issued the first photographic album—a collection of architectural and landscape prints carefully mounted on high-quality paper—thereby inaugurating a type of publication that was the forerunner of today's often lavish photography books. Three years later André-Adolphe-Eugène Disdéri devised a multilens camera that could produce up to ten prints from a single exposure. Used primarily for portraiture but also for landscapes, this invention made possible the production of inexpensive CARTES-DE-VISITE; customers glued these into family albums (introduced commercially in 1860), which became portable museums that could contain as many as five hundred portraits of family members or contemporary celebrities. Often richly decorated leatherbound volumes with metal locks, these albums were owned in many cases by wealthy English or European amateurs, who filled them with photographs they had taken themselves.

The photo historian William Welling has divided nineteenth-century albums into three categories:

Albums for private use, into which *cartes-de-visite,* TINTYPES, and other photos could be easily inserted using a system of slots. These albums are of great historical significance because they often contain the only surviving prints of destroyed negatives.

Special albums commemorating particular events. In 1876, for example, *Mora's Centennial Album,* with a cover encrusted with Tiffany silver, was illustrated with photographs of "the most prominent belles of New York society," taken by the photographer José Mora.

ALBUM

CHRISTIAN BOLTANSKI (b. 1944).
Photo Album of Family D., 1939-64, 1971. 150 black-and-white
photographs in tin frames with glass, 7⅝ x 7⅝ in. (20 x 20 cm), each.
Collection of Liliane and Michel Durand-Dessert, Paris.

Official albums, published by official or private patrons. In the 1850s the French government commissioned sets of photographs (mostly calotypes) documenting French architecture and monuments, and soon there were analogous private undertakings. In 1855 Baron Rothschild commissioned Edouard Baldus to photograph French railroads under construction; in 1860 the Bisson brothers photographed Mont Blanc to commemorate the ascent of that mountain by Emperor Napoleon III and his wife, Eugénie.

Some contemporary artists have reworked the family-album concept to suit their needs. To prepare his *Photo Album of Family D., 1939–64* (1971), Christian Boltanski borrowed several boxes and albums of family photographs from a friend, then rephotographed them and attempted to put them in chronological order. When the work was first exhibited, Boltanski wrote: "Knowing nothing of these people, I set out to reconstitute their lives on the basis of photos taken at all the important moments of their existence, which would remain as testimonial to their lives after their deaths." In the same spirit, he devised an accompanying fictional chronology intended to "send us back to our own past."

ALBUMEN PRINT

Invented in 1850 by Louis-Désiré Blanquart-Evrard, albumen paper remained the most popular support for photographic prints throughout much of the nineteenth century. A sheet of paper was immersed in a solution made of egg whites and salts. (The *British Quarterly Review* of October 1866 estimated that 6 million egg whites were used annually in England to supply albumen for coating paper.) After drying, the albumenized sheet was sensitized to light by being immersed in or brushed with a silver nitrate solution. The paper was then exposed to sunlight through a negative for several minutes, or in some cases for several hours. The resulting image was rinsed, almost always TONED with gold, fixed (see DEVELOPMENT), and then rinsed again. The toning usually produced a warm brown cast with yellow and cream highlights and smooth, bright surfaces, which gave albumen prints a distinctive appearance. Photographs on albumen paper are somewhat more stable than those produced by the SALT-PAPER PROCESS, because the coating of albumen protects the silver salts from the corrosive effects of the air.

Used with COLLODION negatives, albumen paper was widely employed in Europe and the United States. Nadar skillfully exploited its rich tonal range, and photographers like Edouard Baldus and Roger Fenton found its crisp definition ideal for architectural photography. Until the beginning of the 1890s

most photographs printed on paper used the albumen process; it was thereafter replaced by the GELATIN SILVER PROCESS.

AMBROTYPE

Based on the COLLODION process, the ambrotype was immensely popular (especially with modest commercial studios in the United States) through the 1850s and the first half of the 1860s, when it was supplanted by the TINTYPE. Patented by James Ambrose Cutting in 1854, the ambrotype somewhat resembled a DAGUERREOTYPE but could be more rapidly, and hence more cheaply, produced.

A collodion-covered glass negative was immersed in a ferric developer, then the image was whitened by chemical treatment to obtain an exposure that, when placed against a black ground, became a one-of-a-kind positive image. An ambrotype looks like a daguerreotype with a grayish surface, and the two types of exposure were often presented similarly—behind glass in decorated frames—which has made it easy to confuse them. But the ambrotype's gray and lusterless quality as well as its lack of detail sets it apart from daguerreotypes, which are notable for their crisp definition.

ANONYMOUS PHOTOGRAPHY

The accessibility of photography had led to the production and circulation of images by makers whose identities are unknown, especially in the realm of amateur photography. (Beginning in the nineteenth century, laws prohibiting pornographic photography also fostered anonymity.) Although of little commercial value, such anonymous works frequently have considerable documentary interest.

Photographers themselves have often been fascinated with anonymous images. Walker Evans, for example, collected postcards and even used anonymous press photographs in his illustrations for Carleton Beales's book *The Crime of Cuba* (1933). POP artists like Robert Rauschenberg, James Rosenquist, and Andy Warhol have appropriated anonymous photographs by amateurs as well as from advertisements for use in their compositions. The recycling of anonymous photographs is crucial to the work of many contemporary artists, including Robert Heineken, Annette Messager, and Gerhard Richter.

APPROPRIATION

▷ **WHO** John BALDESSARI, Victor Burgin, Alain Fleischer, Joan Fontcuberta, Gilbert and George, Jeff Koons, Barbara KRUGER, Sherrie LEVINE, Richard PRINCE, Robert RAUSCHENBERG, James ROSENQUIST, David Salle, Charlie Samuels, Andy WARHOL

▷ **WHEN** 1960s to the present

▷ **WHERE** Primarily the United States, but also Europe

▷ **WHAT** Any image can be removed from its original context and put to a different use. This approach has come to be known as "appropriation." In photography, appropriation was first used to make COLLAGES and PHOTOMON-TAGES out of preexisting images. In the 1960s POP artists began to incorporate photographs from the mass media (photojournalism, advertisements, and so on) into their work. With the advent of POSTMODERNISM, appropriation acquired a new allure as a method well suited to cultural critique. Barbara Kruger has deconstructed the underlying codes of meaning in media imagery; Jeff Koons and Joan Fontcuberta recycle pornographic images; and Sherrie Levine has undermined the notion of the creator by reshooting images by important photographers—Walker Evans, Edward Weston—and exhibiting the results as her own work.

ARCHITECTURE AND PHOTOGRAPHY

Architecture has been an important photographic subject from the beginning, and photographs have played an important role in architectural history and theory. The clarity and potential objectivity of photography (which can also be used to interpret buildings subjectively) has made it an ideal medium for representing architecture. And the fact that buildings are motionless made them an ideal subject for early photography, which could not capture movement without blurring.

In 1838 Charles Nègre began work on a large monograph about Chartres Cathedral, and in 1858 he produced a series of photographs of the government's insane asylum at Vincennes, France. DAGUERREOTYPE expeditions to Egypt were undertaken beginning in 1840, headed by Maxime Du Camp. This archaeological project allowed him to make photographic studies of Egyptian and Nubian monuments. France's Commission des Monuments Historiques sponsored the Mission Héliographique (1851), whose participants included

Hippolyte Bayard, Gustave Le Gray, Henri Le Secq, O. Mestral, and Edouard Baldus; it used the best French photographers to record monuments threatened with demolition, vandalism, or neglect. In England, Philip Henry Delamotte published an ALBUM (1855) documenting the reconstruction of the Crystal Palace near London.

The invention of photography coincided with the transformation of many European cities—for example, the reconfiguration of Paris by Baron Georges Haussmann beginning in 1850, which was recorded by Charles Marville in an important series, of which more than nine hundred exposures survive. Eugène Atget undertook a poetic architectural inventory of "old" Paris early in the twentieth century, while Frederick H. Evans concentrated on the architecture of England's past. Throughout the century, cities have provided an inexhaustible supply of architectural subjects well suited to the PICTORIAL-IST and PHOTO-SECESSION aesthetics (see THE CITY AND PHOTOGRAPHY).

In the 1920s, as photography in both the United States and Europe came to be dominated by the MODERNIST aesthetic, architecture began to figure in audaciously framed shots of industrial, urban, and rural environments. Notable in this regard are photographs by Charles Sheeler (particularly his Doylestown House series, 1927, and his *Chartres Cathedral*, 1929) and Edward Weston (*Armco Steel, Ohio*, 1922). In France, interior views by André Kertész, François Kollar, Alphonse Mucha, and others were published in the popular magazine *L'Illustration*. The Russians El Lissitzky, Kazimir Malevich, and Alexander Rodchenko as well as Germany's BAUHAUS photographers undertook visual explorations in the form of interior and exterior architectural shots with innovative points of view, especially plunging ones or a compression of planes accentuating the absence of depth. These characteristics appear in Lucia Moholy's series of detailed photographs (1925–26) of the buildings designed by Walter Gropius for the Bauhaus in Dessau, Germany.

During the 1930s architectural photography acquired new social significance in the United States, where it was used to reveal the living conditions of different social strata. Walker Evans, in his images of Victorian houses (1931) as well as his views of churches and other buildings in the American South produced under the auspices of the FARM SECURITY ADMINISTRATION, developed a serial approach that was to influence later artists as diverse as Ed Ruscha (in his book *Twentysix Gasoline Stations*, 1963) and Lee Friedlander (in his book *American Monuments*, 1975). Lewis Baltz has also produced photographic series (Mitsubishi Vitré, 1991; Ronde de Nuit, 1992) and installations documenting the pervasiveness of bland industrial structures in the modern world.

ARCHITECTURE AND PHOTOGRAPHY

FREDERICK H. EVANS (1853–1943).
Kelmscott Manor: In the Attics (No. 1), 1896. Platinum print,
6 1/8 x 7 7/8 in. (15.5 x 20.2 cm). J. Paul Getty Museum, Los Angeles.

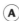

The architectural photography now being made by photographers such as Gabriele Basilico, Luigi Ghirri, and Joel Meyerowitz is better understood as a contribution to ongoing critical reflection on environmental issues than as an exercise in nostalgia. Nostalgia sometimes is a motivating factor, however—as in the work of William Christenberry, who has retraced Walker Evans's footsteps in the Deep South. By providing abundant documentation, which facilitates comparisons between the present and the past, architectural photography helps make possible the classification of building types, thus contributing to a better understanding of urban and suburban ecologies.

ART AND PHOTOGRAPHY

From the beginning, the mechanical nature of taking a picture seemed to set photography apart from traditional fine arts like painting, which required manual skill and painstakingly acquired expertise. The poet and critic Charles Baudelaire, comparing painting and photography, described the latter as a "material science" and dismissed its means as "foreign to art" ("The Modern Public and Photography," in *The Salon of 1859*).

Nonetheless, it was not long before photographers began to claim the status of artist. They did this initially by incorporating a growing number of references to paintings in their work, an approach that emerged first in Victorian England (for example, in still lifes by Roger Fenton, c. 1858) and then quickly spread throughout Europe. It was Oscar Gustav Rejlander, a Swedish photographer working in England, who first created what he dubbed the "photographic tableau" by combining several negatives to produce allegorical images, as in *The Two Ways of Life* (1857). Henry Peach Robinson followed his lead, producing composite prints of narrative scenes in the British tradition of genre paintings such as William Hogarth's series Industry and Idleness (1747). In the mid-1860s Julia Margaret Cameron, influenced by Christian symbolism and the Pre-Raphaelite painters, began to produce soft-focus allegorical scenes and illustrations of Alfred, Lord Tennyson's epic poem *The Idylls of the King* (1859–85).

NATURALIST photographs taken by Peter Henry Emerson and Frank M. Sutcliffe toward the end of the century introduced a newly personal response to nature. Their use of photography to convey the impressions left by their contemplation of the landscape was closer to the subjectivity of the Impressionist painters than to the matter-of-fact realism previously associated with photography. This approach opened the way for PICTORIALISM, which

fostered the use of visual effects inspired by painting and encouraged the development in both American and European photography of an aesthetic often colored by SYMBOLISM, as in the work of Edward Steichen. Alfred Stieglitz's establishment of the PHOTO-SECESSION group in 1902 furthered the cause of artistic photography by imposing more exacting standards and hence justifying comparisons between photography and the fine arts.

By liberating painting from its imitative responsibilities, photography became a force in art's abandonment of realism for ABSTRACTION and played an innovative role central to the European avant-garde movements (Dada, NEW VISION, SURREALISM). As the twentieth century advanced, photography was increasingly recognized as an autonomous practice distinct from painting and the other traditional pictorial arts—a medium with its own laws and language. This independent status was accepted more readily in America than in Europe. In the United States beginning in the early 1960s, when photographic MODERNISM gave way to a freer exploration of the medium, artists such as David Hockney, Robert Rauschenberg, Ed Ruscha, and Andy Warhol began to use photography in POP ART. Photography has also played a part in Conceptual art, as in the work of Joseph Kosuth, who juxtaposes a photograph with a word or its definition in order to question the notion of representation. Photographs have also been used to direct attention to the process of making or perceiving an image rather than to the image itself, as in works by John Baldessari, Marcel Broodthaers, Victor Burgin, and Bruce Nauman. From the perspective of POSTMODERNIST artists, photography is just one of the many ways of producing images in a consumer-oriented culture.

Photography's ties to art are also apparent in its frequent use by artists, sometimes as preliminary studies (used by Jean-François Millet and others) but more often as a source of subjects; Eugène Delacroix and Gustave Courbet both took inspiration for their nudes from DAGUERREOTYPES. Camille Corot's way of painting landscapes owed much to the pictures taken by his photographer friends Constant Dutilleux and Adalbert Cuvelier. The increasing availability of instantaneous photography from the 1860s on resulted in new and innovative urban scenes that inspired Impressionist painters like Claude Monet (see, for example, his *Boulevard des Capucines*, 1873). Eadweard Muybridge's explorations of chronophotography (see MOVEMENT AND PHOTOGRAPHY) made it possible for Edgar Degas to depict his horses and jockeys correctly. In the United States, the artist Thomas Eakins took nude photographs to serve as anatomical studies for his paintings, and he collaborated with Muybridge on photographic studies of movement, which were crucial to several of his paintings of horses and athletes.

In painting *Garden on the Champs-de-Mars* (1922), Robert Delaunay relied very heavily on an aerial photograph taken by André Schecher and André Omer-Decugis, *The Eiffel Tower* (1908). Pablo Picasso explored throughout his career all the possibilities offered by photography (CLICHÉ-VERRES, COLLAGES, PHOTOMONTAGES, SELF-PORTRAITS, the combination of original photographs with original prints, and so on). The British painter Francis Bacon found some of his most important inspiration in photography, often working from news photos and even claiming that photography inspired him more than reality.

The creation of photographic archives of works of art—an essential project for the sculptor Constantin Brancusi, for example—has also proved a vital means of documenting certain perishable art forms, such as land art: Richard Long photographs his excursions into the landscape as well as the stone configurations that result from them; Christo has extensively recorded each of his otherwise ephemeral projects. Performance artists often use photographs as records of past actions, including *Leap into the Void* (1960) by the painter Yves Klein and Gina Pane's mutilations of her own body during the 1970s. Photography has also helped record the process of artistic creation, as with Hans Namuth's photos of Jackson Pollock painting in his studio and Ugo Mulas's portraits of New York School painters at work.

AUTOCHROME

▷ **WHO** James Craig Annan, Alvin Langdon Coburn, Baron Adolph de Meyer, Louis DUCOS DU HAURON, Frank Eugene, Léon Gimpel, Heinrich KÜHN, Jacques-Henri LARTIGUE, the LUMIÈRE BROTHERS, Charles Martin, George Bernard Shaw, Edward STEICHEN, Alfred Stieglitz, Karl Struss

▷ **WHEN** 1904 through 1930s

▷ **WHERE** Europe and the United States

▷ **WHAT** The first popular color photographic process, autochrome was invented and patented in 1904 by Louis Lumière. It became commercially available three years later and, despite the fragility of its support, remained in widespread use through the 1930s.

An autochrome is a unique, transparent image made on a glass plate (pliable supports for the process did not become available until 1932). Potato starch particles dyed red-orange, blue-violet, and green were sifted and bound onto the glass plate. The plate was then covered with black powder, varnished, coated with a light-sensitive gelatin-bromide emulsion, exposed

in a camera, and developed into a negative. After a chemical bath and exposure to white light, the negative was developed, yielding the positive image on the original glass plate. Autochrome plates were available in several formats, from 1⅞ x 2⅜ inches to 5⅛ x 7⅛ inches (4.5 x 6 cm to 13 x 18 cm), including stereoscopic ones. Despite the difficulty of fabricating them, the impossibility of duplicating them, and their high cost, which restricted their use to moneyed amateurs, autochromes long dominated the market for color photography.

Alfred Stieglitz made some autochrome portraits of his daughter, Kitty, in Paris shortly after the process became available, and he saluted it as "a process which in history will rank with the startling and wonderful invention of those two other Frenchmen, Daguerre and Niepce." Autochromes were also made by photographers in the PHOTO-SECESSION, some practitioners of a modern brand of PICTORIALISM (including Alvin Langdon Coburn and Baron Adolph de Meyer), amateurs like Jacques-Henri Lartigue, and even the underwater photographer Charles Martin. (The Pictorialists soon abandoned the practice, which did not permit any MANIPULATION.) The most impressive collection of autochromes, consisting of more than seventy thousand plates, was assembled by the French millionaire Albert Kahn; a selection of these now belongs to the Musée d'Orsay in Paris.

BAUHAUS

▷ **WHO** Herbert BAYER, Paul Citroen, Erich Consemüller, Horacio Coppola, Andreas Feininger, T. Lux Feininger, Werner Graeff, Toni von Haken-Schrammen, Florence HENRI, Lucia MOHOLY, László MOHOLY-NAGY, Moï Ver, Walter PETERHANS, Ellen Rosenberg (later Auerbach), Hannes Schmidt, Grete Stern, Elsa Thiemann, Umbo

▷ **WHEN** and **WHERE** Germany: Weimar (1919–25), Dessau (1925–32), and Berlin (1932–33, when the school was closed by the Nazis)

▷ **WHAT** The Bauhaus was an art school founded by the architect Walter Gropius. Its classes and its communal spirit were intended to reconcile craft traditions and industrial technology, which at the time were widely understood to be antithetical. Practitioners of all kinds (painters, sculptors, architects, weavers, and so on) were encouraged to collaborate on projects conceived with an eye to eventual mass production. The Bauhaus faculty boasted a prestigious group of European masters—notably, Wassily Kandinsky, Paul Klee, and László Moholy-Nagy—all of whom were affiliated

with avant-garde circles. Building on this unique constellation of talent in three different venues and under various directors (Gropius until 1923, then the architect Hannes Mayer, and finally the architect Ludwig Mies van der Rohe), the Bauhaus developed a curriculum and a style that have had immense influence throughout the West.

Photography initially played a relatively minor role at the Bauhaus, but this changed in 1923 with the appointment of Moholy-Nagy as director of the metal workshop and later of the foundation course, or *Vorkurs*. He had begun his career as a painter, but during his tenure at the Bauhaus photography's unique potential to challenge established patterns of visual communication became one of his primary interests. (His enthusiasm for photography was not reflected in the school's curriculum until Walter Peterhans opened his photography studio there in 1929.) Moholy-Nagy's 1925 book *Malerei, Fotografie, Film (Painting, Photography, Film)*, illustrated with photographs taken by himself and his wife, Lucia Moholy, summarized the full range of possibilities offered by the medium, but the key to his thinking was the primary structural role of LIGHT. For Moholy-Nagy, light was simultaneously a physical agent and a spiritual element.

Photography became an essential part of the artistic investigations undertaken at the Bauhaus and helped shape the NEW VISION. Moholy-Nagy influenced the students through his experiments, which tested the limits of STRAIGHT PHOTOGRAPHY by making effective use of new techniques (such as PHOTOGRAMS) and formal strategies that he considered central to the "objective vision of our time": surprising points of view (angled, looking up, plunging down), "counter-composition" (the deliberate use of oblique lines rather than the verticals and horizontals that predominate in classical composition), distortion, prominent shadows, high contrast, positive-negative effects (i.e., retaining the reversed values of the negative in the positive print), close-ups, PHOTOMACROGRAPHY and PHOTOMICROGRAPHY, and the use of concave or convex mirrors. These practices of deconditioning the gaze—changing the usual way of seeing—were supplemented by COLLAGE, DOUBLE EXPOSURE, and PHOTOMONTAGE.

As a result of the diversity of approaches to photography at the Bauhaus, and largely due to Moholy-Nagy's and Peterhans's teachings, the school left its mark on the study of experimental materials, ARCHITECTURAL and OBJECT photography, typography and graphic design (especially in advertising; Bauhaus students collaborated with large companies like Bayer), and even reportage and theatrical photography. In 1937, at the urging of a group of manufacturers, Moholy-Nagy opened the New Bauhaus in Chicago with the

T. LUX FEININGER (b. 1910) (photo)
and **JOOST SCHMIDT** (1893–1948) (design).
Front page from the magazine *Bauhaus*, April–June 1929.
Museum für Gestaltung, Berlin; Bauhaus-Archive.

intention of training American designers along Bauhaus lines. It closed in 1938 but was reborn in 1939 as the Chicago School of Design, and five years later it became the Institute of Design. The first director of the school's photography department, Henry Holmes Smith, was succeeded in 1946 by Harry Callahan, then by Aaron Siskind. Their work and teaching continued to encourage the spirit of photographic experimentation associated with the Bauhaus.

BLURRING

A blur is a lack of sharpness in an image resulting from incorrect focus, either on exposure or during ENLARGEMENT. It can be accidental, but it also can be used deliberately for aesthetic effect.

The PICTORIALISTS employed blurring to achieve an atmospheric softness characteristic of some painting (the work of James McNeill Whistler was a favored model). In the 1950s NEW YORK SCHOOL photographers such as Robert Frank and Louis Faurer—who were influenced by the painter Ben Shahn (an amateur photographer working for the FARM SECURITY ADMINISTRATION) as well as by the freewheeling style of Beat Generation writers like Jack Kerouac— made frequent use of out-of-focus imagery to convey the spontaneity and energy of urban and small-town America. In the work of other photographers, most of them European (Bernard Plossu of France and Jorge Molder of Portugal, but also the American Ralph Eugene Meatyard), blurring is used deliberately to create an effect of mystery and poetry.

THE BODY

The very first photograph pictured not a body but a LANDSCAPE (Nicéphore Niepce, *View from His Window at Le Gras,* 1826[?]), but it was PORTRAITURE that determined the commercial success of the DAGUERREOTYPE in the 1840s. Influenced by contemporary psychological theories that the body reflected the soul within it, throughout the nineteenth century members of the middle class turned to portrait studios to record both their existence and their appearance.

Early on, photographers showed an interest in the body, exemplified by erotic nudes, ethnographic studies (linked to TRAVEL PHOTOGRAPHY and the celebration of colonialism), medical images, and JUDICIAL documentation. Pornography and the artistic nude (inspired by painting) often merged during this period in photographs of the female body; there are also a few

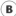
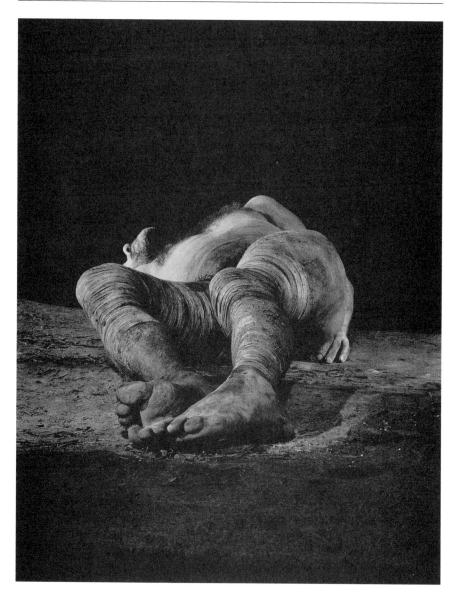

DIETER APPELT (b. 1935).
From *Memory's Trace,* 1977–79. Gelatin silver print, 15⅝ x 11¾ in.
(40 x 30 cm). Galerie Rudolf Kicken, Cologne, Germany.

cases, such as photographs by the American painter and photographer Thomas Eakins, in which the male body was pictured erotically. The photographs of New Orleans prostitutes taken by E. J. Bellocq around 1912 are early examples of an aestheticized sexuality.

Beginning in the late nineteenth century, photographers exploited the aesthetic potential of the body, first by treating it as a PICTORIALIST subject, then by using it for formal or poetic experimentation, as in NEW VISION and SURREALIST work. Photographers ranging from Imogen Cunningham to Frantisek Drtikol set out to show the body in unconventional ways. During the interwar period the male body became the icon of a cult of strength and virility, as in the Nazi-era photographs by Leni Riefenstahl glorifying German athletes.

The two world wars and the expansion of PHOTOJOURNALISM, which documented social crises as well as urban squalor of all kinds, led to a proliferation of disturbing images of human bodies wracked by misery, crime, and violence, as in Lee Miller's 1944 photographs of the concentration camps. The implicit prohibitions against photographing and publishing images of death were gradually lifted as its presence in modern life became inescapable. In the same way, the relaxation of Western sexual mores that began in the 1960s led to a popularization of sexual imagery, in FASHION and ADVERTISING photography as well as in frankly erotic publications like *Playboy*.

The body has been a major preoccupation in photography since the 1980s. Sex and death, once off-limits to photographic representations of the body, now pervade current work, especially in the context of the AIDS crisis. Nan Goldin's *Ballad of Sexual Dependency* (1986) became a model for this taboo-breaking approach to photographic documentation, which had originated almost a generation earlier in Larry Clark's book *Tulsa* (1971). Recent images of the body have been varied and often deliberately disturbing, characterized by an intentionally shocking exploration of same-sex sexuality (Robert Mapplethorpe), baroque or grotesque variants of eroticism (Jan Saudek, Joel-Peter Witkin), social critique (Cindy Sherman), and the aestheticizing of death (the German Rudolf Schafer, the French group Noir Limite [Black limit], and Andres Serrano's Morgue series of 1992). Growing interest in SELF-PORTRAITURE has also led to increased concentration on the body by Dieter Appelt, John Coplans, Gilbert and George, and others.

CALOTYPE (TALBOTYPE)

This early photographic process was patented in 1841 by William Henry Fox Talbot (hence its alternative name, the Talbotype). A calotype (from the Greek word *kalos,* "beautiful") was made by brushing a sheet of paper with a silver nitrate solution, drying it, and then floating it on a solution of potassium iodide. Shortly before exposure, the sheet was further sensitized by application of a mixed solution of gallic acid, acetic acid, and silver nitrate. This treated paper was then inserted, while still damp, into the camera and the exposure was made. Initially, Talbot fixed the resulting negative image by rinsing the exposed paper in water and then bathing it in a bromide-of-potassium solution. Later, following a suggestion by John Herschel, a hyposulfite of soda solution, called "hypo," was used instead.

The calotype was most notable as an advance in photographic technique because it could be used to produce multiple positive prints; these were usually SALT-PAPER prints, which have a granulated surface that makes them appear more tonal than linear. The calotype process was most successfully used by David Octavius Hill and Robert Adamson in a series of portraits set in landscapes (1843–47). The process remained popular until the 1850s, when it was supplanted by the ALBUMEN PRINT. The tonal quality of calotypes made the process especially appealing to the PICTORIALISTS, who revived it in the 1890s.

CAMERA

Basically, a camera consists of a light-proof box; a LENS equipped with a light-regulating shutter (through which an image is projected, upside-down, into the box); and a viewfinder. Over the years many refinements have been added that facilitate greater technical control (including adjustable apertures, telemeters, mirrored viewfinders, motors, and light meters) or serve specialized needs (underwater cameras, architectural cameras with special tilted or wide-angle lenses). Cameras vary in size, from those designed to make large-scale negatives (view or field cameras) to small, lightweight cameras, which first appeared in the 1920s and revolutionized PHOTOJOURNALISM.

CAMERA OBSCURA/CAMERA LUCIDA

The camera obscura ("dark room") was the optical model for the modern camera. Its basic principle had been known since antiquity, but it was given

new currency in the Renaissance by the Italian scientist Giovanni Battista della Porta, who designed a portable version. Intended to simplify the process of copying from nature, it consisted of a box pierced by a single opening with a convergent lens and fitted at the back with a mirror pitched at a forty-five-degree angle. Light penetrating the opening produced an image on the mirror, which reflected it onto a screen of ground glass, upon which tracing paper was placed. Nicéphore Niepce, in his experiments in 1826–27, introduced a light-sensitive surface into this setup—thereby obtaining a durable image and initiating the invention of photography.

The camera lucida ("light room") is one of an array of "drawing machines" that, prior to the invention of photography in 1839, allowed painters to trace the contours of a subject. It was perfected in the early nineteenth century by the Englishman William Hyde Wollaston. More portable than a camera obscura, though still cumbersome, it consisted of a prism fitted with a viewfinder through which an image was cast onto a sheet of drawing paper; the artist could then trace it with relative ease.

CARBON PROCESS

In 1855 Adolphe-Louis Poitevin patented the carbon process, the first photographic process to yield prints that remained stable over time. First a sheet of paper was coated with a gelatin solution containing a pigment composed primarily of carbon black. Once dry, the paper was floated on a solution of potassium bichromate, which sensitized it to light. The paper was then exposed to the sun through a negative for an indeterminate period, usually several minutes. The paper was then rinsed, and while it was still in the water a sheet of gelatin-treated paper was put, face down, on top of it. The joined sheets were removed from the water and placed on a glass plate, which in turn was positioned between two blotters that were pressed between two glass plates for about twenty minutes. The two sheets, still joined, were then submerged in warm water, which dissolved the excess gelatin and carbon pigment. The sheets were then separated, revealing the image, which had been transferred, in reverse, to the gelatin-treated paper, making what was called a "carbon print."

Popular from the 1870s to the beginning of the twentieth century, carbon prints are notable for their clear definition, dense shadows, lack of grain, and deep blacks. By using a pigment other than carbon black, various colors could be obtained, though each print was monochromatic. Thomas Annan and Julia Margaret Cameron were among the period's most fervent users of

the carbon process. Carbon prints are still being produced today, in particular by the patented Fresson process, which yields color prints by using a complex process that has been kept secret by the descendants of its inventor, Théodore-Henri Fresson.

CARTE-DE-VISITE

In 1854 André-Adolphe-Eugène Disdéri patented the *carte-de-visite:* a portrait glued to a piece of cardboard the size of a traditional visiting card (roughly 4½ x 2½ inches [11.4 x 6.4 cm]). The model's name and address were often printed on the back of the card. Disdéri devised a multilens camera capable of exposing four to ten different portraits on one wet-COLLODION plate during a single sitting, thereby expediting the process and making it commercially viable. The 1870s saw the introduction of cabinet cards, which were slightly larger (about 6¼ x 4¼ inches [15.9 x 10.8 cm]), more durable, and more elaborately decorated. The immense success of the *carte-de-visite* contributed much to the popularity of photography in general and photographic portraits in particular.

CHRONOPHOTOGRAPHY—*see* MOVEMENT AND PHOTOGRAPHY

THE CITY AND PHOTOGRAPHY

Starting in the second half of the nineteenth century, the documentation of cities by photographers made it possible for the authorities and historians to track the changes being effected by the new urban-development campaigns that were profoundly transforming the large European cities. The rapid development of the urban landscape between about 1850 and World War I became the subject of many important photographic projects: architectural inventories (such as those made in Second Empire Paris by Charles Marville and Edouard Baldus), the record of urban catastrophe (for example, Arnold Genthe's photographs of the destruction wrought by the San Francisco earthquake and fire in 1906), and the devoted documentation of vestiges of a rapidly disappearing past (Eugène Atget's images of Paris). At the turn of the century, NATURALISM and PICTORIALISM redirected many photographers to nature, and as a result there was a momentary lull in urban photography, until it again became an important activity under the influence of the PHOTO-SECESSION (exemplified by Alvin Langdon Coburn's studies of London,

1909). Both Alfred Stieglitz and Paul Strand produced countless images of New York, as did Charles Sheeler in the early 1920s and Berenice Abbott in the 1930s.

The European avant-garde movements, from FUTURISM to SURREALISM, saw the city as a field of visual experiences in ceaseless motion (as in Alexander Rodchenko's innovative images of Moscow), a flux characteristic of modern life (as in Charles Sheeler's series Manhatta, 1920), or a theater of potential encounters and fortuitous poetry (see, for example, Brassaï's book *Paris by Night*, 1932). The success of Fritz Lang's film *Metropolis* (1926) encouraged an expressionistic strain of urban photography, exemplified by László Moholy-Nagy's images of Marseilles, André Kertész's of Paris, and Kineo Kuwabara's of Tokyo.

Street life—passersby, billboards, the accoutrements of urban leisure—began to preoccupy Walker Evans as early as 1933, when he embarked on a typological documentation of neighborhoods of all kinds in the great American cities, and it retained a fascination for him into the 1950s, when he was working for *Fortune* magazine. W. Eugene Smith created an extraordinary photographic portrait of Pittsburgh in 1955–57, supported by a Guggenheim fellowship. Weegee produced unflinching images of New York (*Naked City*, 1945), in which sensational events, crimes, and amusements intermingle. These photographers were not the only ones who attempted to construct, by different photographic means, portraits of big cities. From the end of the 1940s, under the influence of the New Bauhaus in Chicago, Harry Callahan and Ray Metzker used multiple exposures, COLLAGE, and PHOTOMONTAGE in their attempts to produce visual equivalents of the large postwar American cities of Chicago (Callahan) and Philadelphia (Metzker).

Increasingly, the city has been viewed as a place of alienation, in photographs by Diane Arbus, Bruce Davidson, William Klein, and, in the 1990s, Eugene Richards. Coldly clinical, the contemporary vision of the city can reiterate the cool and distant approach of the NEW TOPOGRAPHICS. However, it is the physical presence of the city that still interests photographers the most, as seen in the elegant images by Gabriele Basilico, the meditative views by Jun Shiraoka, and Thomas Struth's large-format photographs of the most diverse physical elements of urban space, such as chimneys and electric lines, without any human presence.

LEON LEVINSTEIN (1913–1988).
Three Boys in Brooklyn, 1957. Gelatin silver print, 14 x 11 in.
(35.5 x 27.9 cm). Howard Greenberg Gallery, New York.

CLARENCE H. WHITE SCHOOL OF PHOTOGRAPHY

▷ **WHO** Paul Lewis Anderson, Anton Bruehl, Arthur Chapman, Alfred Cohn, Edward R. Dickson, Laura Gilpin, Bernard S. Horne, Dorothea Lange, Ira W. Martin, Paul OUTERBRIDGE JR., Clara Sipprell, Ralph Steiner, Karl STRUSS, Doris Ulmann, Margaret Watkins, Clarence H. WHITE

▷ **WHEN** 1914 to 1942

▷ **WHERE** New York

▷ **WHAT** Clarence H. White—PICTORIALIST, SYMBOLIST, and original member of the PHOTO-SECESSION—founded his photography school in 1914, after he broke with Alfred Stieglitz, who thought him too wed to the past. White's teaching was pragmatic, for he believed in the utilitarian value of photography. Some of his students—women as well as men—intended to pursue commercial photography as a career; others approached the medium simply as a pastime. The school's curriculum included design, the history of art, and photographic techniques, making it possible for a student to obtain both technical and artistic instruction there. Thirty hours of class were offered each week, half of them devoted to "art" photography, taught by White himself. The critics Paul Lewis Anderson and Max Weber were also on the school's faculty, as was the advertising photographer Margaret Watkins.

White advocated an elegant formalism based on a harmonious balance between form and light. Although there was no emphasis on subject or style,the school's approach encouraged ABSTRACTION and even a mystical sense of formal relationships (Weber stressed a Zen-like approach to the filling of pictorial space). White believed that photography could integrate aspects of modern art without completely rejecting Pictorialist devices— notably, the use of BLURRING. As a result, the school subtly fostered MODERNIST photographic tendencies but avoided the more brutal ruptures with the past evident in the STRAIGHT PHOTOGRAPHY being championed by Alfred Stieglitz and Paul Strand.

CLARITY

In technical language, *clarity* designates the precision with which the subject of a negative or photographic print is rendered. The medium's ability to capture minute detail has been apparent since the invention of the DAGUERREO-TYPE in 1839. This clarity was regarded by adherents of the aestheticizing

movements of the late nineteenth century (PICTORIALISM, SYMBOLISM) as a hand-icap to be overcome. In reaction, members of the European and the American MODERNIST movements of the 1920s (NEUE SACHLICHKEIT, GROUP F/64) embraced clarity as one of the medium's most distinctive and valued features.

CLICHÉ VERRE

This process, invented by Constant Dutilleux and Eugène Cuvelier in 1851, uses as a negative a glass plate on which an image has been scratched; the plate is then CONTACT PRINTED onto a SENSITIZED sheet of paper. During the second half of the nineteenth century, painters including Camille Corot, Jean-François Millet, and Eugène Delacroix successfully used this hybrid "photographic-drawing" technique. It was later taken up and modified in various ways by several modern artists, notably Brassaï, Pablo Picasso, and Man Ray.

COLLAGE

In a collage (the word comes from the French *coller,* "to glue"), various mate-rials—paper, fabric, photos—are attached to a single support. Long used in the decorative arts, collage entered the realm of fine art when Pablo Picasso pasted a piece of oilcloth onto his 1912 painting *Still Life with Chair Caning.* In a collage, the diverse materials are deliberately allowed to retain their indi-vidual identities, although they may be unified into a coherent composition by the addition of inscriptions and painted elements of various kinds. Photographs, which are readily available from a multitude of sources, includ-ing the daily newspaper, and which can easily be applied to various types of support, are particularly well suited for inclusion in collages. Collage is close in form and spirit to PHOTOMONTAGE—a composite made of photographic frag-ments from diverse sources, which are often reprinted in order to create the effect of a seamless whole.

The abstract compositions and the impression of simultaneity that are often characteristic of collage link it to the MODERNIST art of the 1920s and 1930s. The collage technique gained new currency in the postwar period, when it was taken up by artists and photographers working in diverse styles. Robert Rauschenberg combines photographic images of all varieties, mostly from the mass media, in his large-scale montages. David Hockney conveys the absence of a fixed point of view in imposing panoramas constructed from juxtaposed Polaroids—for example, more than seven hundred individual

prints are used in his *Pearblossom Highway* (1982–86). Robert Frank's *Mute/Blind* (1989) is a tableau composed of photographic stills of blind dogs and statues of deer taken from his film *Hunter.*

COLLECTIONS

The act of collecting photographs seems to have begun almost simultaneously with the medium's invention. The earliest public collections were established in France, the first being the Société Héliographique (1851), which was renamed the Société Française de Photographie three years later. The Bibliothèque Nationale in Paris had long required printmakers to submit at least two copies of each of their prints (the system known as *dépot légal*), and starting in 1851, photographers began doing the same with their photographs—a practice that continues today. The photographic collections established in France during the nineteenth century (Bibliothèque Historique de la Ville de Paris, 1872; Musée Carnavalet, 1881) constitute an incomparable source of documentation. In 1853 the Royal Photographic Society of London was founded and began by collecting photographic ALBUMS; three years later the Victoria and Albert Museum was established, also in London, and immediately began acquiring photographs. In all these cases, the photograph was collected as a document, not a work of art. In 1854 the Alinari brothers in Florence founded an archive of photographic reproductions of art that constituted a veritable anthology of Italian art, but these, too, were considered documents rather than works of art in their own right.

It was not until photography gained recognition as an art form in the United States at the beginning of the twentieth century, thanks to Alfred Stieglitz, that museums became interested in photography as aesthetic objects. The Museum of Fine Arts, Boston, acquired twenty-seven photographs by Stieglitz in 1924; the Metropolitan Museum of Art in New York added his work to their collection four years later. The first institution to set up an independent photography collection parallel to those of the other visual arts was the Museum of Modern Art, New York (which opened in 1929), under the direction of Alfred Barr Jr. The first photographer to enter the collection was Walker Evans, with thirty-two images, in 1930. During the first six years of its operation, the Museum of Modern Art enriched its collection with 105 images by Evans, 13 by Edward Weston, and 4 by Man Ray. Nonetheless, it was not until 1940 that Beaumont Newhall became the museum's first curator of photography.

Other American museums soon began to assemble important photographic collections—notably the International Museum of Photography in Rochester, New York (1947), and the Art Institute of Chicago, which started collecting photography in 1951. Corporations such as Hallmark Cards (starting in 1964) and the Gilman Paper Company (starting in the 1970s, under the direction of Pierre Apraxine) have put together important photographic collections, which have been regularly exhibited at major museums throughout the United States.

In Europe, the Agfa Foto-Historama collection was established by the photographic materials manufacturer Agfa and then given to the Ludwig Museum in Cologne in 1986. European museums have been somewhat slower to originate their own photographic collections. The Musée d'Orsay, which opened in Paris in 1986, was the first European museum to collect photographs on a large scale. However, the Bibliothèque Nationale had set an example as early as 1941 by establishing within its Print Department an office specifically devoted to photography and by systematically acquiring the archives from photographers' studios; for example, fifty thousand prints were purchased from the Nadar studio in 1949. Since the 1970s, under the impetus of the library's photography curator, Jean-Claude Lemagny, works by both established and promising photographers have been added to the collection.

Private collectors have been the most active agents in forming photographic collections ever since the nineteenth century. The duc d'Aumale and Prince Roland Bonaparte, for example, established magnificent holdings in the 1860s, with an emphasis on ethnographic images. Stieglitz (at the beginning of the twentieth century) and Julien Levy (in the 1930s) assembled important collections of American and European MODERNIST photography, often in connection with their own galleries. Other American (David McAlpin, Alden Scott Boyer) and European (Gabriel Cromer) collectors, as well as photographic historians (André Jammes, Helmut and Alison Gernsheim), collected photographs seriously before the photography market really began to develop. In 1964 the Gernsheims donated their personal collection to the University of Texas at Austin, which included the first photograph in the world, taken by Nicéphore Niepce (*View from His Window at Le Gras*, 1826[?]).

Starting in the late 1960s, a new interest in photography, served by a rapid proliferation of galleries and an expanding market for prints, first in the United States and then in Europe, accelerated the passion for private collecting. Samuel Wagstaff, for example, assembled nineteenth- and twentieth-century photographs with an enlightened eclecticism. In the same period,

the lawyer Arnold Crane acquired one of the most handsome private collections, dominated by the work of Walker Evans. Harry Lunn Jr., a collector and dealer in photographs, is as interested in French nineteenth-century photography as he is in contemporary artists such as Robert Mapplethorpe, Andres Serrano, and Joel-Peter Witkin. Many of these collectors have donated or sold their collections to institutions; Crane's and Wagstaff's were acquired in 1984 by the J. Paul Getty Museum in Los Angeles; the photographic collection of William H. Lane, which includes Edward Weston's and Charles Sheeler's best prints, is overseen by the Museum of Fine Arts, Boston.

The flourishing market for and increasing value of prints (Man Ray's *Black and White*, 1926, was sold for $400,000 in 1994) has contributed, over the last twenty-five years, to making photography collecting an increasingly expensive proposition. In 1997 Helen Anderson's collection of photographs from the 1920s was sold in London for the extraordinary price of 1.8 million pounds.

COLLODION PROCESSES

Invented in 1848 by the British sculptor Frederick Scott Archer, the wet-collodion process quickly became the predominant means of producing glass negatives; after about 1860, it gradually displaced the DAGUERREOTYPE and the CALOTYPE.

The essential element in the wet-collodion process was a thick liquid produced by mixing guncotton (ordinary cotton soaked in nitric and sulfuric acid, then dried) with ether and alcohol. This sticky substance—called "collodion"—was poured over a clean glass plate, which was then made light sensitive by bathing it in a solution of silver nitrate. (These preparations had to be carried out in total darkness.) The wet plate was then inserted into the camera, exposed, and developed immediately (if developing was delayed, the image became all but invisible).

This procedure was complicated and unwieldy, for it required the photographer to take his cumbersome laboratory equipment into the studio or field with him. To make matters worse, the fragile glass plates were often quite large and awkward to handle (some measured 18 x 21 inches [46 x 53 cm]). Compensating for these inconveniences were the shorter exposure times and the richness of detail in the resulting negatives. Nadar's most beautiful portraits, for example, were produced from collodion glass negatives. For

landscapes, however, there was another drawback: collodion-sensitized plates were hypersensitive to the color blue, and as a result, skies developed into a blank white. This necessitated either the use of shorter exposure times for images in which sky predominated or the combination of two negatives to produce a single print—a method used with notable success by Gustave Le Gray in his seascapes.

The dry-collodion process, which entered widespread use beginning in the 1870s, eliminated the need to treat the glass plate immediately prior to exposure by coating it with a mixture of honey, albumen, gelatin, or other substances that kept the collodion from drying. This process was unreliable, however, and required prolonged exposures. Even so, William Henry Jackson, Timothy H. O'Sullivan, and Carleton E. Watkins used it with great skill to capture the monumental landscapes of the American West. Around 1880 both collodion processes were replaced by the simpler and more dependable GELATIN SILVER PROCESS.

COLOR

Color photography—which exploits the capacity of the human eye to perceive all colors through combinations of the three primary colors of light (blue, red, and green)—was essentially invented in France between 1867 and 1869 by Charles Cros and by Louis Ducos du Hauron, although earlier attempts had been made. In 1907 a glass-plate process was commercialized as AUTOCHROME by Louis Lumière. It was not until the marketing of the Kodachrome process (invented by L. D. Mannes and Leopold Godowsky) in the United States in 1935 that the subtractive process of color photography became commercially viable. In the subtractive three-color process, colors are produced by the precise superimposition of three images in yellow, magenta, and cyan. These colors selectively screen out the complementary blues, greens, and reds present in the white light of the photographed scene. In the Kodachrome process, the three hues are present in a single multilayer emulsion; since they produce color automatically at the development stage, only one exposure is required, as in monochrome photography. There are several types of multilayer-emulsion film—the most common categories are color positive film (which produces transparencies) and color negative film. Currently, the four most popular processes are those offered by Kodak, Agfa, Polaroid, and Cibachrome.

The advent of color photography posed a number of questions. Was it a means to new artistic ends, as in the autochromes made early on by

PICTORIALISTS and PHOTO-SECESSIONISTS such as Heinrich Kühn and Alfred Stieglitz? Or was it primarily a documentary tool that made it possible to publish more realistic and more eye-catching images in popular magazines like *National Geographic?* The availability of the comparatively easy-to-use Kodachrome process and its derivatives in the 1930s benefited both amateur photographers and professionals. Gisèle Freund, for example, took color portraits of many writers in the years between the wars, which made her a pioneer of this process.

Once the new printing technologies made it possible for magazines to include color layouts in the late 1930s, FASHION photographers such as Cecil Beaton and Louise Dahl-Wolfe exploited the full potential of color. They constituted the first generation of color photographers, and they were largely dependent on the publishers of commercial books and magazines for their livelihood. In 1951 Alexander Liberman, art director of the Condé Nast group (*House and Garden, Vogue, Glamour*), published *The Art and Technics of Color Photography,* in which he stressed that the problems with using color in fashion and advertising photography (largely due to the extended exposure times that color required) could be solved only in a controlled studio environment. Ernst Haas (who was influenced by Abstract Expressionism) published *Life* magazine's first spread of color photographs, on New York City, in 1952.

Purists ranging from Edward Weston to Henri Cartier-Bresson condemned the use of color, despite experimenting with it themselves. Until the end of the 1960s photographers and critics continued to regard color with the suspicion that it augmented realism at the expense of expressiveness. Nonetheless, nature photographers like Eliot Porter and photojournalists like Haas mastered the use of color, integrating its distinctive qualities into their personal vision. In 1958 the Cibachrome process was patented, which makes it possible to obtain richly colored prints from positive transparencies without an intermediary negative. Cibachrome prints are both stable and finely detailed, for their support is not paper but a translucent plastic film. In 1969 development-inhibitor-releasing color couplers (DIRs) were developed, which prevent the unwanted diffusion of colorants from one coating to another during development. The colors are better separated and the details are sharper, making possible enlargements on a grand scale. These technical advances opened up new aesthetic possibilities, first in the United States in the work of William Eggleston, Joel Meyerowitz, Stephen Shore, and others, then in Europe with work by photographers including John Batho, Franco Fontana, and Luigi Ghirri.

Since the 1980s it has seemed that photographers are no longer seeking to develop an aesthetic language specific to color. Instead, they make more pragmatic use of it. In the context of documentary projects, color can serve a descriptive or satirical role, as in the urban landscapes by Lewis Baltz and those, more formal, by Jean-Louis Garnell, in portraits by Thomas Ruff, and in social reportage by Martin Parr and Nick Waplington. Color can also supply links to the history of art, as in Gilbert and George's monumental color montages, which relate to the visual tradition of posters and stained glass; in portraits by Clegg & Guttmann that address the relationship between photography and codes of representation by using Renaissance paintings as a source; and in the wall-size transparencies by Jeff Wall, whose compositions are often based on familiar icons of art history.

CONSERVATION

The potential physical instability of photographs has been a source of worry ever since the medium was invented. All of the organic materials used as photographic supports are fragile, under constant threat of deterioration caused by exposure to physical or chemical agents (light, heat and humidity, atmospheric pollutants) as well as biological ones (fungus, bacteria, insects, rodents). Concern is now growing over the perishability of resin-coated (RC) paper as well. The poor quality and limited longevity of other photographic materials—nitrate FILM, celluloid film, glass plates, COLLODION papers—has also been a troublesome issue.

Various means have been used to restore photographs ever since the first such efforts by the Kodak company, which began to explore conservation methods for its products as early as 1912. Since the 1970s the American National Standards Institute (ANSI) and the International Organization for Standardization (ISO) have established standards for the fabrication and conservation of photographs. Conservators affiliated with large public collections now have at their disposal any number of aids with which to supplement careful handling. Most notable among these are chemical and mechanical methods of restoring photographic materials, fluorescence X spectrometers (which use X rays to provide information about photographic processes and hence determine the appropriate treatment), and data obtained from studies of long-term stability and the impact of various conditions of archival storage.

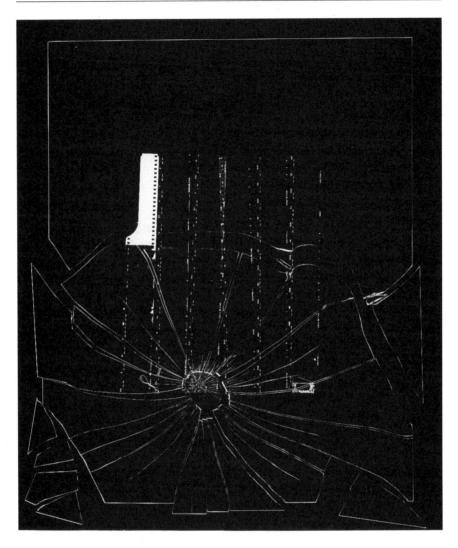

UGO MULAS (1928–1973).
Verification No. 13: "Homage to Marcel Duchamp," 1972. Silver print
on aluminum, 23⅝ x 19⅝ in. (60 x 50 cm). Archivio Ugo Mulas, Milan.

CONTACT PRINT/CONTACT SHEET

A contact print results when a NEGATIVE (whether on glass or film) is placed in direct contact with SENSITIZED paper and exposed to light; the resulting image is the same size as the negative, without any loss or softening of detail. The advent in the 1920s of small cameras, with commensurately small negatives, led to the abandonment of contact printing in favor of ENLARGEMENT.

A contact sheet is a contact print of an entire roll of exposed film. Necessitated by the advent of small-format film rolls, contact sheets provide an essential intermediate step between exposure and utilization, enabling the photographer to determine which pictures should be printed in a larger format. Although they primarily serve as working tools for the photographer, contact sheets also make it possible for curators and scholars to study a photographer's working and selection processes. Henri Cartier-Bresson found them to be without aesthetic interest, dismissing them as mere *épluchures* (peelings). Others—including Robert Frank, William Klein, and Denis Roche—have opted to make contact sheets into works in their own right, printing enlargements of entire sequences and presenting them as graphic or narrative ensembles. And some have put them to more conceptual use, as in the Verification series (1971–72) by Ugo Mulas. In this series of thirteen images, Mulas took photography itself as his theme, breaking it down into its constituent physical elements (sensitized emulsion, exposure time, and so on). The first of these Verifications shows a contact sheet that has been developed and contact printed from a blank roll of 35 mm film, resulting in thirty-six black frames. Dedicated to Nicéphore Niepce, it represents, according to Mulas, "thirty-six lost photographic occasions."

CRITICISM AND PHOTOGRAPHY

The first critical text dealing with photography was written by the French poet and critic Charles Baudelaire, as part of his review of the 1859 Salon. He denounced photography as a "vulgar" art, which must be excluded from the domain of artistic creation because of its mechanical nature. With the establishment of PICTORIALISM (the first aesthetic movement in photography) in the late nineteenth century, discussion as to whether photography was an art became widespread and often contradicted Baudelaire's negative judgment. The foundations of critical evaluation of the medium as an art were laid in the United States. The establishment of the magazine *Camera Work* by Alfred Stieglitz in 1903 marked the beginning of a concerted attempt to determine the aesthetic nature of photography, with thoughtful articles by Marius de

Zayas, Benjamin De Casseres, Sadakichi Hartmann, and even the photographer Paul Strand, who initially defended the PHOTO-SECESSION but gradually became an advocate of STRAIGHT PHOTOGRAPHY.

After the birth of the MODERNIST avant-garde on the eve of World War I, the approach to photography became more theoretical and experimental, especially in Europe. Adherents of the NEW VISION and the NEUE SACHLICHKEIT (László Moholy-Nagy, Albert Renger-Patzsch, Alexander Rodchenko, the historian Franz Roh, and others) sought, through their writings as well as their work, to shed light on the rapidly changing forms and uses of photography. In 1928 Moholy-Nagy declared, "The illiterates of the future will not be those who are ignorant of literature but those who neglect photography." Many writers, like the philosopher Walter Benjamin, questioned the nature of the medium and analyzed its relation to such aspects of the modern world as urbanization and mechanization. In his major essay on the visual arts, "The Work of Art in the Age of Mechanical Reproduction" (1936), Benjamin defined photography as a mass medium that radically alters the function of art by destroying the experience of an art object's "aura" of uniqueness. In the United States during this same interwar period, the critic Lincoln Kirstein disseminated the experimental approach to photography in his Harvard-based journal, *Hound and Horn,* while also defending the work of Walker Evans and reviving interest in such nineteenth-century documentary photographers as Mathew Brady and Eugène Atget, who were praised for their ability to confound conventional ways of seeing through their fresh take on straight photography.

Since the late 1950s, European critics such as Roland Barthes and Umberto Eco have scrutinized the photographic image in terms of SEMIOLOGY. In the United States, Susan Sontag (in her book *On Photography,* 1973) and Rosalind Krauss (who cofounded the journal *October* in 1976) have investigated the role of photography in contemporary art and society. According to Krauss, it is misleading to analyze photography in terms of the classification systems and historical models developed for painting. She advocates instead the application of critical concepts to elements specific to photography—for example, its reproducibility and its "indexical" nature (as a particular kind of sign linked to its referent).

CROPPING—*see* FRAME

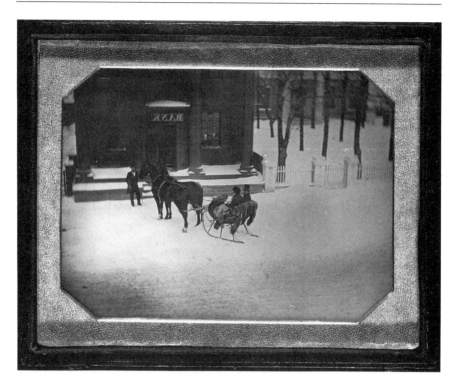

UNKNOWN PHOTOGRAPHER (mid-19th century).
Horses and Sleigh in Front of a Bank, c. 1845. Daguerreotype,
3³⁄₈ x 4⁵⁄₈ in. (8.8 x 11.8 cm). National Gallery of Canada, Ottawa.

DAGUERREOTYPE

In 1839 the Frenchman Louis-Jacques-Mandé Daguerre invented the first photographic process destined for commercial success, and his discovery spread rapidly throughout Europe and North America. Daguerreotypes were immensely popular during the 1850s and 1860s, especially in the United States as a medium for PORTRAITURE. These unique, nonreproducible images, with their distinctive metallic surfaces, are characterized by great richness of detail and tonal nuance. Fully visible only from a certain angle, the image appears either positive or negative according to how the light strikes it.

Producing a daguerreotype began with a carefully polished sheet of copper—usually ranging from 2 x 3⅜ inches (5 x 6 cm) to 6½ x 8½ inches (16.5 x 21.5 cm)—that was plated with a thin layer of silver, then suspended over iodine in a closed box. Vapors from the iodine fused with the silver to produce a light-sensitive layer of silver iodide on the plate, which was then placed in a camera and exposed for anywhere from a few seconds to several minutes. The result was a LATENT IMAGE that could be revealed by suspending the daguerreotype over heated mercury inside a closed container, which produced the image in a blend of silver and mercury. It was then fixed (see DEVELOPMENT), sometimes with gold, which resulted in a richer but still essentially monochromatic surface. To make portraits more lifelike, daguerreotypes were sometimes hand-colored with pigment suspended in resin. Being quite vulnerable to tarnishing and abrasion, daguerreotypes were always preserved behind glass in carefully sealed cases, some of which were elaborately decorated.

DECISIVE MOMENT

In 1952 the French photographer Henri Cartier-Bresson published a book entitled *Images à la sauvette* (roughly, "images on the run"), which opened with a preface entitled "L'Instant décisif" (translated as "The Decisive Moment," which also served as the book's American title). In it, Cartier-Bresson expounded on photography and PHOTOJOURNALISM. He wrote, "To me, photography is the simultaneous recognition, in a fraction of a second, of the significance of an event as well as of a precise organization of forms which give that event its proper expression." This instantaneous merging of meaning and form is characteristic of Cartier-Bresson's art, which is geometrically ordered in its visual composition.

HENRI CARTIER-BRESSON (b. 1908).
Siena, Italy, 1933. Contemporary gelatin silver print from a 35 mm
negative, 8¹/₂ x 5³/₄ in. (21.5 x 14.6 cm). Magnum Photos, New York.

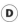

The "decisive moment" theory has been criticized for holding reportage in thrall to a formal academicism that was inevitably incompatible with documentary objectivity, especially in the years from 1950 to 1970. Robert Frank broke with this elegant aesthetic of selective, distanced reportage in his book *The Americans* (1958). In Frank's view, "Every moment is valuable."

DEVELOPMENT

Photographic images, whether negatives or positives, do not exist until they are developed, which is to say *revealed.* Development—the transformation of a LATENT IMAGE into a visible image by a chemical process—is at the very heart of photography.

First, the SENSITIZED SURFACE of the exposed FILM, plate, or paper is immersed in a chemical-based developing solution, which selectively removes the silver salts from the surface, thereby forming the visible image. The surface is then rinsed to eliminate any trace of the developing solution and "fixed" by immersion into a second chemical bath of sodium thiosulfate (commonly known as "hypo"), which makes any remaining silver salts insensitive to light and transforms them into soluble salts that are easily eliminated by another rinse of water.

The development of film negatives requires the use of solutions appropriate for each type of film, and increasingly it is done in mechanized laboratories, where many of the principal tasks are automated. The development of PRINTS has retained a more hands-on character, although it, too, is often carried out by professionals. It requires carefully regulated conditions—exact timing of how long the paper is exposed beneath the enlarger, the correct temperature of the developing solution, the use of special toning chemicals, proper rinsing technique, and so on—all of which affect the quality of the resulting image. Nonetheless, many amateurs still prefer to develop and print their photographs in their own darkrooms.

The amount of time intervening between exposure and development can vary considerably. In the nineteenth century, the wet-COLLODION process required development almost immediately after exposure. POLAROIDS have made the development stage automatic, reducing it to a few seconds. Some photographers accumulate images without developing them. Almost twenty-five hundred rolls of undeveloped film were discovered in Garry Winogrand's studio after his death in 1984, and the photographer Ralph Eugene Meatyard would develop his film only once a year.

Digital images, obtained with the aid of a computer, have two distinctly different manifestations: digitized images and virtual images.

The conversion of an analog photograph (which reproduces an image in continuous tones) to a digital image requires an electronic device such as a scanner, which analyzes the image and translates it into a video signal whose intensity varies in proportion to the light and dark tones of the image. A computer converts this data into binary language (assigning a value of 1 or 0 to each unit of visual information) and stores the numerical values thus obtained in the computer's memory. This stored information can be used to reconstitute the original image, which can be viewed on a computer screen (in the form of tiny squares known as "pixels") or reproduced on a support with the aid of a printer. Computer software, which is becoming increasingly sophisticated and widely available, makes it possible to retouch and manipulate the image—modifying its color, creating special effects, PHOTOMONTAGING it with other images, and so on.

Digital cameras, which appeared around 1985, are equipped with electronic scanners capable of distinguishing 600,000 to 6 million dots per image; they translate the subject directly into binary code during exposure, without passing through the intermediary stage of a silver-based image. The output generally can be read on a computer or television screen or transmitted to a printer; it is stored in a computer's memory or on compact or video disks. The results are defined more or less clearly, according to the camera's technical capabilities, with the quality of images obtained with inexpensive digital equipment being far inferior to that of silver-based images.

Virtual images bypass any source material, whether taken from reality or a silver-based photograph. Instead, the computer operator creates original images by using specially designed software to manipulate digital raw materials. Such images simulate a nonexistent, or "virtual," reality.

Digital imaging has facilitated both the manipulation of visual reality and the origination of virtual reality. For example, since 1979, Nancy Burson has created fantastic computer-generated faces: composite portraits, artificially aged portraits, digitally realized facial anomalies. Eva Sutton uses a computer to combine discarded photos scavenged from trash cans with her own images, producing electronic photomontages. Digital imaging has also facilitated the invention of seemingly true fictions, such as the architectural universe created by the Spaniards Jordi Guillumet and Mònica Rosello solely by

NANCY BURSON (b. 1948), with Richard Carling and David Kramlich. *Catwoman,* 1983. Gelatin silver print, 8⁷/8 x 10³/8 in. (22.5 x 26.2 cm). Collection of the photographer.

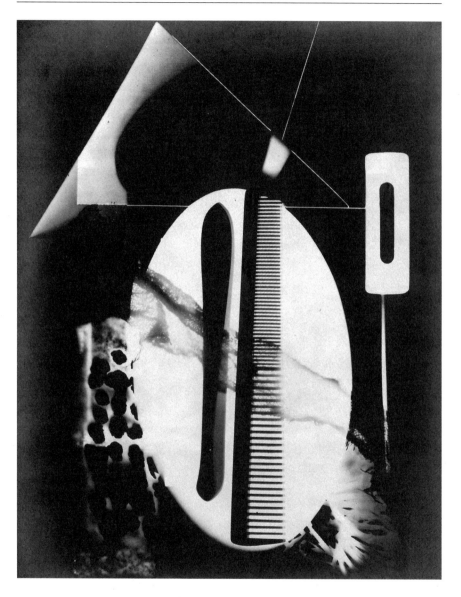

MAN RAY (1890–1976).
Rayograph, 1922. Gelatin silver print, 8¹³/₁₆ x 6⅞ in. (22.4 x 17.5 cm).
The Metropolitan Museum of Art, New York; Ford Motor Company
Collection, Gift of the Ford Motor Company and John C. Waddell, 1987.

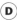

computer (1996). In the documentary fictions by the Mexican Pedro Meyer, his photographic images in the style of STREET PHOTOGRAPHY or PHOTOJOURNAL-ISM are modified by digital intervention. And the California-based team of Aziz+Cucher, with the help of digital technology, are cooking up unsettlingly ambiguous and provocative pictures, as in their Dystopia series (1994–95) of faces with all their orifices hermetically sealed. Such convincing manipulations have posed a host of new aesthetic and ethical problems, prompting a reevaluation of what constitutes a photograph and raising doubts about the medium's documentary reliability.

DIRECT PROCESSES

All photographic images produced without a separate negative, whether on a paper, glass, or metal support, are known as "direct photographic prints"; the term *direct positive print* is used when a positive image is produced. Each print is unique and can be reproduced only by rephotographing it. This technique has been used in processes such as the DAGUERREOTYPE, the AMBROTYPE, and, in the twentieth century, the POLAROID. Direct positive prints can also be made without the use of a camera, as in a CLICHÉ VERRE or PHOTOGENIC DRAWING. Direct processes were revived after World War I, first in Dada-related PHO-TOGRAMS (Christian Schad's Schadographs, Man Ray's Rayograms) and then in an experimental spirit by NEW VISION photographers, including László Moholy-Nagy and his students.

DIRECTORIAL PHOTOGRAPHY—*see* STAGED PHOTOGRAPHY

DOCUMENTARY PHOTOGRAPHY

The photograph's usefulness as visual evidence was valued from the beginning. Whether in the context of JUDICIAL PHOTOGRAPHY, medical photography, PHOTOJOURNALISM, SCIENTIFIC PHOTOGRAPHY, or TRAVEL PHOTOGRAPHY, the photographic document was long considered to be a reliable source of information. From the mid–nineteenth century on, governments as well as individuals sponsored photographic archives and expeditions. The Italian firm Alinari, established in 1854, has compiled an archive of close to 100,000 images of architecture and artworks, which is still in active use. In the United States between 1860 and 1885, photographers including William Henry Jackson, Timothy H. O'Sullivan, and Carleton E. Watkins were essential participants in government-sponsored expeditions that explored and recorded

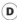

the unspoiled American West. At the beginning of this century, the French financier Albert Kahn sent photographers to the Middle and Far East to assemble an unprecedented visual record of those regions, for the use of scholars and students. In the 1910s in the United States, Lewis Hine worked for the National Child Labor Committee, photographing children at work in factories, mines, and fields in order to denounce and ultimately improve their circumstances.

But, also from the beginning, the possibilities of physical manipulation and ideological distortion have undermined photography's claims to reliable objectivity. After the fall of the Paris Commune in 1871, for example, the photographer Eugène Appert devised anti-Communard propaganda by carefully cutting the heads from photographs of prisoners and applying them to spurious depictions of Communard "atrocities" (in a series called Crimes of the Commune). Also questioned has been the objectivity of the social documentation that thrived during the interwar period as a response to economic and social crises in Europe—notably in August Sander's studies of Germany's various social classes—and in the United States in work by Berenice Abbott and the photographers working for the FARM SECURITY ADMINISTRATION. Doubts were voiced about the objectivity of these admittedly opinionated images, which some saw as advancing the government's ideological agenda. Similar concerns have haunted PHOTOJOURNALISM to this day. The use of DIGITAL IMAGING has cast additional suspicion on the documentary reliability of photographs because digital images look like real photographs yet can be manipulated in ways that leave no trace of deception.

In the 1960s a new documentary approach to reality began to emerge, one acknowledging that the photographer's own subjectivity influences the images that he or she produces. In March 1967 the curator John Szarkowski drew attention to this new tendency by presenting the exhibition *New Documents* at the Museum of Modern Art, New York, which brought together work by Diane Arbus, Lee Friedlander, and Garry Winogrand. These STREET PHOTOGRAPHERS incorporated into their sometimes visually violent work the same signs of urban American culture that were being used in POP ART. Dissecting the American dream with a sometimes cruel objectivity, this exhibition inspired a new generation of photographers to engage in more active criticism of contemporary society.

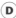

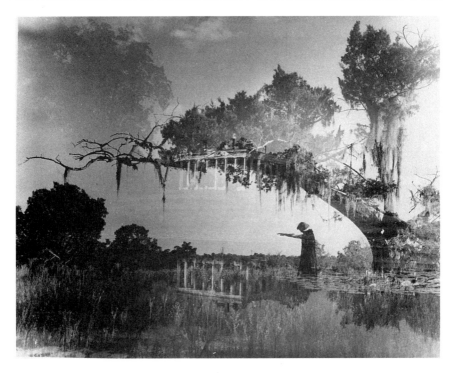

CLARENCE JOHN LAUGHLIN (1905–1985).
Elegy for Moss Land (Elizabeth Heintzen, Greenwood Plantation), 1940.
Gelatin silver print from two superimposed negatives, 11 x 14 in.
(27.9 x 35.5 cm). The Historic New Orleans Collection.

DOUBLE EXPOSURE

Double exposure, sometimes called "overprinting," is the superimposition of two or more exposures on the same negative. It can occur accidentally due to a faulty camera, but it is also a device that can be put to interesting intentional use. The BAUHAUS photographer Moï Ver, for example, captured the bustle and chaos of urban life by printing "sandwiches" of up to five negatives, as in *Paris: 80 Photographs* (1931). This technique also lends itself to METAPHORICAL modes of expression, as in Clarence John Laughlin's works that merge past and present by overprinting two separate negatives.

DYE-TRANSFER PROCESS

This process of producing color prints on paper (invented by the Kodak company) is so protracted and expensive that it is financially feasible only for an edition of at least a hundred prints. After three black-and-white negatives have been made, each through a blue, green, or red filter, these negatives are printed in the desired format on matrices (molds supplied by the manufacturer), which are then processed in a black-and-white developer containing a tanner to harden the exposed gelatin. A subsequent rinse in warm water eliminates certain parts of the gelatin, producing three relief matrices that are then soaked, respectively, in yellow, magenta, and cyan dyes (complements of the original filter colors). After each gelatin relief absorbs its dye, in proportion to the thickness of the gelatin, the three matrices are aligned successively on gelatin-coated paper, to which their color is transferred, producing a full-color image.

The dye-transfer process has the advantage of allowing the photographer or developer to adjust each color separately, allowing for precise control of the final effect. The resulting image is extremely stable.

EMULSION

The light-sensitive coating on modern photographic film, plates, and printing paper, emulsion consists of silver halide crystals suspended in gelatin or some other binding agent. Emulsion, which helps prolong the light sensitivity of silver halides, was a welcome improvement on nineteenth-century materials such as ALBUMEN papers and COLLODION plates. Because silver halide crystals were applied directly on those surfaces, rather than suspended in a protective gelatin, photographers had to expose and develop them within

ANN MANDELBAUM (b. 1945).
Untitled, 1992. Gelatin silver print, 15⁷/₈ x 20 in. (40.6 x 50.8 cm).
Collection of the photographer.

minutes; otherwise the silver halides would immediately absorb so much light that the photograph would be a blank.

ENLARGEMENT

Both the operation of increasing the size of an image obtained from a negative and the result of this operation, the enlarged print itself, are called *enlargement.* The process was made possible by the development in the 1870s of EMULSIONS sensitive to artificial light, which permitted prints to be made by using an optical enlarger with an artificial light source. The clarity of an enlargement is determined by how much it is being enlarged, the sharpness of the original negative, and the kind of paper used (glossy or resin-coated paper generally works best).

Some photographers have used enlargement to give details an unexpected scale, as with *Kiki's Lips* (1929), by Man Ray, and Patrick Tosani's giant Heels series of 1987. Many contemporary photographers—including Geneviève Cadieux, Thomas Florschuetz, and Eva Klasson—combine enlargement with extreme close-ups to produce a disturbing effect, as in Ann Mandelbaum's large-scale lip portraits (1992).

EQUIVALENTS

From 1922 to 1932 Alfred Stieglitz produced a series of cloud photographs (taken at Lake George in upstate New York), which he called Equivalents. Inspired by Charles Baudelaire's poem "Correspondences" and by SYMBOLIST theory, Stieglitz wanted these abstracted images of nature to establish the viability of using photographs to communicate diverse emotional states, much as music can do. He later decided to call all of his photographs, not just those in this series, Equivalents, as a way of indicating that their forms could evoke emotions through association (see METAPHOR).

As the critic Rosalind Krauss has noted, the Equivalents also exemplify the "cut effect" specific to photography—i.e., the way the medium isolates fragments of reality from the whole. This cut effect sets photographic composition apart from the traditional approach to composing a painting as a coherent whole.

FARM SECURITY ADMINISTRATION (FSA)

▷ **WHO** John Collier Jr., Jack Delano, Walker EVANS, Dorothea LANGE, Russell Lee, Carl Mydans, Gordon Parks, Arthur ROTHSTEIN, Ben SHAHN, John Vachon, Marion Post WOLCOTT

▷ **WHEN** 1935 to 1943

▷ **WHERE** United States

▷ **WHAT** The Great Depression prompted President Franklin D. Roosevelt to sponsor federal photographic campaigns that would make evident the full extent of the economic devastation in the United States, in the hope that these images would rally support for his aid to farmers. The most visible of these campaigns originated in 1935, when the Department of Agriculture hired Roy Stryker to set up the Historical Section of the Resettlement Administration; two years later the operation came to be known as the Farm Security Administration, or FSA (in 1942 it was transferred to the Office of War Information, or OWI). Stryker directed the photographic program until October 1943.

The participating photographers came from diverse backgrounds, ranging from the professional photographer Walker Evans to the painter Ben Shahn. Though much of their work was done in the Southeast, they worked all across the country, in both rural and urban settings. Their choice and handling of subjects were guided by precise instructions—veritable "scripts"— furnished by Stryker, who told them to "look for the significant detail. The kinds of things that a scholar a hundred years from now is going to wonder about." Each new assignment required the photographers to study the social and economic circumstances of their subjects, but they retained considerable freedom when it came to capturing them on film. The social photography that Lewis Hine had pioneered early in the century, which had revealed the potential impact of DOCUMENTARY PHOTOGRAPHY as a force for economic and social change, served as a model for the FSA.

With the exception of Walker Evans (who accepted the job mainly for economic reasons, taking advantage of it to pursue his own personal vision), all the FSA participants were imbued with a humanistic optimism, which helped inspire their contributions to what was the largest sociological investigation ever undertaken in photography. The FSA archives, which include 107,000 labeled prints as well as a multitude of negatives (180,000 black and white, 1,610 color slides), were given to the Library of Congress in 1944,

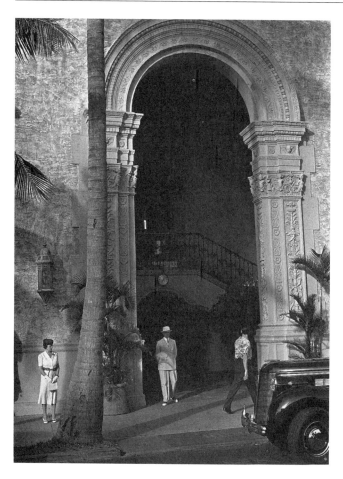

MARION POST WOLCOTT (1910–1990).
Entrance to Roney Plaza Hotel, Miami, 1939. Gelatin silver print,
negative: 4¼ x 3¼ in. (10.7 x 8.2 cm). Library of Congress,
Washington, D.C.; Courtesy Linda Wolcott-Moore Fine Art
Photography, Mill Valley, California.

where they remain. Stryker's archives are now at the University of Louisville in Kentucky.

·FASHION PHOTOGRAPHY

From the beginning of the century, fashion, photography, and the female image have evolved together. Fashion photography became an independent and profitable genre soon after its emergence in late-nineteenth-century Paris, when large studios, like those of Charles and Emile Reutlinger and Mayer and Pierson, specialized in portraits of fashionable women. Fashion magazines have played a key role in this ongoing evolution, especially the three most important American ones: *Vogue* (developed by Condé Nast), the original *Vanity Fair,* and *Harper's Bazaar.* They provided the facilities, support, and art directors (like Edward Steichen and the famed Alexey Brodovitch) required for effective fashion photography,

One especially interesting aspect of fashion photography is the way it tends to absorb aesthetic trends. Baron Adolph de Meyer produced PICTORIALIST images for *Vogue.* Steichen, who replaced him at the magazine in 1924, favored a MODERNIST approach inspired by Cubism and Art Deco. SURREALISM (Man Ray), experimental MANIPULATIONS (Erwin Blumenfeld, H. P. Horst), and the PHOTOJOURNALIST look (Toni Frissell) all left a vivid imprint on fashion imagery. The photographers who worked for Steichen at *Vogue* included Cecil Beaton, Horst, and George Hoyningen-Huene. All of them devised distinctive visual styles under his direction that were based on showcasing the day's celebrities and juxtaposing fashionable clothing with contemporary elements (skyscrapers, high-tech objects, sports themes, abstract paintings by Jackson Pollock).

In the 1950s Brodovitch liberated the genre at *Harper's Bazaar* by using non-conformist photographers like Brassaï, Henri Cartier-Bresson, and Man Ray to radically transform the magazine's look; Hiro and Richard Avedon are much indebted to Brodovitch. Along with Irving Penn, these were the most important figures of the 1950s. During this decade, fashion photography became more than simply an applied art, achieving an aesthetic autonomy and an inventiveness that it would scarcely ever match in later years.

Fashion in the 1960s was abandoning haute couture in favor of ready-to-wear lines better suited to popular and even countercultural values. In the "swinging London" of the 1960s, David Bailey (immortalized in Michelangelo Antonioni's film *Blow-Up,* 1966) personified the fashion photographer as a

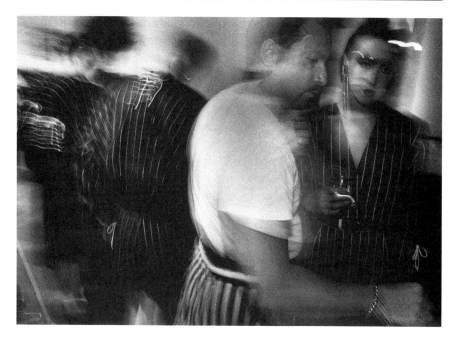

WILLIAM KLEIN (b. 1928).
Backstage J.R. Daumas, Paris, 1987. Gelatin silver print, dimensions variable. Collection of the photographer; courtesy Howard Greenberg Gallery, New York.

larger-than-life figure attuned to every current trend—a type represented a couple of decades later by the American photographer Annie Leibovitz. Photographers are often under contract to well-known designers—Avedon works for Versace, Sarah Moon for Cacharel. Fashion photography has now taken on just about every subject, and its content has become increasingly sexual, as in the work of Guy Bourdin, Helmut Newton, and Jeanloup Sieff. The Italian clothing company Benetton has caused scandals by broaching such taboo subjects as AIDS and racism in its controversial ad campaigns. Deborah Turbeville, by contrast, has created an idiosyncratic visual universe, posing figures in abandoned spaces empty of any contemporary reference.

The stylized black-and-white movies directed by Jim Jarmusch have influenced the German fashion photographer Peter Lindbergh, just as photonovels had influenced William Klein somewhat earlier. Many young European practitioners—Paolo Roversi, Martine Sitbon, and Javier Vallhonrat—have been inspired by the unbridled inventiveness of music videos, with their shocking colors, dreamlike scenes, and audacious cropping. On the other hand, Nick Knight has extended the tradition of Erwin Blumenfeld, experimenting with color and graphics to produce images of great formal perfection. In 1997 President Bill Clinton chastized fashion photographers and editors for glorifying the drug culture with their pictures in a style dubbed "heroin chic."

FERROTYPE—*see* TINTYPE

FILM

There are many kinds of film: achromatic film, for black-and-white positive paper prints made from a negative; negative color film and reversible color film (Agfachrome, Ektachrome, Fujichrome, Kodachrome, etc.), for positive transparencies. They all consist of a pliable support coated with a light-sensitive EMULSION, and they all can be used for still photography as well as for movies. A film is defined by its sensitivity to light, which determines the graininess and the contrast of the results. Film sensitivity is measured according to a formula established by the International Organization for Standardization: the higher the ISO number, the more sensitive (and hence faster) the film—ISO 400 film is twice as fast as ISO 200. The higher the sensitivity of the film, the more grains of silver salts it contains, which means that faster film will yield grainier images.

Kodak and Fuji collaborated on a new kind of film, introduced in 1996, known as Advanced Photo System (APS). Retaining the traditional silver-based support (though made of polyethelene naphthalate as opposed to the celluloid triacetate used in conventional film), it is also equipped with a small magnetic track that records the photographer's information about the materials used, identifying attributes (date, place, subject), instructions regarding film development and corrections needed for any future reprint-ings, and so on. More important, it makes it possible for a scanner to record exposures in DIGITAL form instantaneously. The new format is 40 percent smaller than conventional film—17 x 30 mm, as opposed to 24 x 36 mm.

FILM UND FOTO

Familiarly known as *Fifo,* the exhibition entitled *Film und Foto* was held in Stuttgart, Germany, between May 18 and July 7, 1929. It was conceived by the Deutscher Werkbund (a group of German architects and designers active since 1907 in promoting better design) as an international panorama of 1920s MODERNIST photography from Europe and the United States. Far-ranging in its selection, the show mixed avant-garde photography and PHOTOMONTAGE with publicity shots, film stills, scientific work ranging from radiographs to astro-nomical views, and industrial photography. The magazine *Kunstblatt* announced: "This exhibition will bring together for the first time work by those people, at home and abroad, who have broken new paths in photog-raphy as well as film....In addition are extraordinary productions of anonymous new photographers from all over the world and photographs from various areas of technology and science." Effectively the death knell of PICTORIALISM and other art-imitating approaches to the medium, *Fifo* was a manifesto in favor of what was called the New Photography, especially the two trends known as the NEW VISION and NEUE SACHLICHKEIT.

The exhibition was conceived by László Moholy-Nagy, who installed the introductory gallery and organized the other thirteen rooms according to the nationality, technique, or school affiliation of the participants. Three curators chose the works to be exhibited from groups selected by an inter-national committee, many of whose members were themselves eminent photographers: Edward Weston and Edward Steichen from the United States, probably Man Ray and Christian Zervos from France, and El Lissitzky from the USSR (the Soviet exhibitors included Gustav Klucis and Alexander Rodchenko).

In all, work by 150 photographers was exhibited. Some older work was included (for instance, views by Eugène Atget), but most of the participants were contemporary German photographers: Willi Baumeister, Aenne Biermann, Max Burchartz, Hugo Erfurth, George Grosz, John Heartfield, Albert Renger-Patzsch, and almost all of the BAUHAUS group. In addition to Steichen and Edward Weston, the American contingent included Berenice Abbott, Anton Bruehl, Imogen Cunningham, Paul Outerbridge Jr., Charles Sheeler, and Brett Weston. The French photographers were Florence Henri, George Hoyningen-Huene, André Kertész, Germaine Krull, Eli Lotar, Man Ray, Maurice Tabard, and Maximilien Vox. The sole English participant was Cecil Beaton. As the title indicates, *Film und Foto* also dealt with the movies. Under the direction of the avant-garde German filmmaker Hans Richter, sixty films were projected, by directors ranging from Charlie Chaplin to René Clair.

The exhibition was accompanied by a catalog including texts on photography and film, notably by Edward Weston and Richter, as well as twenty-three reproductions. The book *Foto-Auge/Oeil et photo/Photo-Eye,* by Franz Roh, was also published on the occasion of the exhibition. Versions of the show traveled to Zurich, Berlin, Vienna, Munich, and, in 1931, to Japan (Tokyo and Osaka), diffusing the new photographic style and facilitating its acceptance on an international scale.

FIXING—*see* DEVELOPMENT

FORMAT

Format is a term used primarily to designate the dimensions of photographic FILM. These are traditionally measured in millimeters (24 x 36 mm), though inches are sometimes used for large-format film (4 x 5 or 8 x 10 inches). The choice of a specific film format is often determined by aesthetic considerations; the precise definition that is characteristic of large-format film, for example, makes it ideal for static and descriptive images like those produced by members of GROUP F/64. By contrast, reportage and STREET PHOTOGRAPHY would have been impossible without the mobility offered by small-format film and cameras, which were introduced around 1920. Format also determines the shape of the image: there are rectangular formats (notably, 24 x 36 mm) as well as square ones (6 x 6 cm).

Since 1888, when George Eastman devised his simplified Kodak camera, the Eastman Company (later the Eastman Kodak Company) has repeatedly tried

to impose new industry standards: the Brownie (1900), the "126" (1961), the "110" (1972), the Disc (1982), and the Advanced Photo System (1996). The "135" (24 x 36 mm, introduced in 1923) is still the most widely used format.

Format is also used to designate the size and shape of prints. For most of this century, the prevailing "classical" aesthetic limited print dimensions to the maximum size of photographic paper—19³/₄ x 23⁵/₈ inches (50 x 60 cm). This limit has been breached in recent years by oversize work on a scale reminiscent of ambitious painting, made by photographers such as Jeff Wall and Jean-Marc Bustamante. The large collaged prints by Doug and Mike Starn also allude to the history of painting, invoking models ranging from Rembrandt to Kazimir Malevich; their *Blue and Yellow Louvre Four* (1985–88) measures 83⁷/₈ x 192¹/₈ inches (213 x 488 cm). Photographic prints can now be strikingly monumental in size, as in Pascal Kern's diptychs and triptychs of industrial molds photographed in rooms and printed life-size.

FRAME

In a CONTACT PRINT, the exact size and extent of the image recorded on the original negative are retained. With the introduction of ENLARGEMENT in about 1880, the practice of cropping the image became widespread. The term *frame* refers to the limit of what is recorded at the moment of exposure; it is established by the physical boundaries of the camera's image frame. *Cropping* refers to the operation, after exposure, of selectively cutting edges from the image as originally framed (see SELECTION).

In photography, *composition* designates the conscious organization of elements within the frame *prior* to exposure (the aesthetic of previsualization), *during* exposure (Henri Cartier-Bresson's DECISIVE MOMENT), or *after* exposure (through cropping, often condemned by purists). In determining a composition, the photographer considers issues such as symmetry versus asymmetry as well as visual traditions inherited from painting and drawing.

As MODERNISTS attempted to define the characteristics specific to STRAIGHT PHOTOGRAPHY, beginning in the 1920s, it became virtually a moral obligation for most photographers (Walker Evans was a notable exception) to honor the full extent of the image on their original negatives. As a result, "full-frame" photographic prints often feature rough black edges tracing the limits of the actual exposure. Cartier-Bresson made a point of including these edges in his prints, for he denounced cropping as a betrayal of the photographer's original experience.

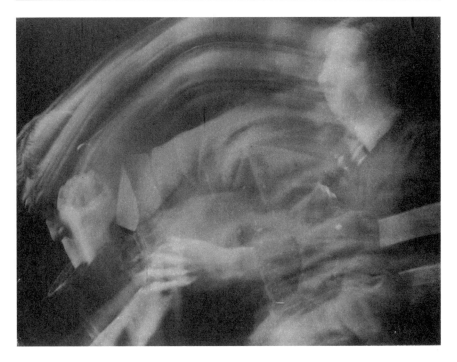

ANTON GIULIO BRAGAGLIA (1890–1960).
Change of Position, 1911. Gelatin silver print, 5 x 7 in. (12.8 x 17.9 cm).
Antonella Vigliani Bragaglia.

FUTURISM AND PHOTOGRAPHY

▷ **WHO** Anton Giulio BRAGAGLIA and Arturo BRAGAGLIA, Tullio D'Albisola, Masoero, Bruno Munari, Vinicio Paladini, Ivo PANNAGGI, Giulio Pariso, Tato

▷ **WHEN** 1909 to 1929

▷ **WHERE** Italy

▷ **WHAT** In 1909 the Italian poet Filippo Tommaso Marinetti published the first Futurist manifesto—a paean to speed and technological progress, in which the automobile was the dominant image. In 1910 a second manifesto, written by painters (including Umberto Boccioni), called for artists to depict speed and its effects, with reference to the chronophotography of Etienne-Jules Marey (see MOVEMENT AND PHOTOGRAPHY).

This desire to convey the sensations of movement was a defining characteristic of Futurism, which in 1913 acquired adherents among photographers—notably, the brothers Anton Giulio and especially Arturo Bragaglia (who was already familiar with chronophotography). That same year, Anton Giulio Bragaglia, in his manifesto *Fotodinamismo Futurista* (Futurist photodynamism), laid the foundation for an approach to "photodynamism" that, following Marey's example, broke movement down into its component instants, rendered in blurred forms. At the same time, the Futurist painters were portraying movement by using lines of force in a way adapted from Cubist painting. For the first time, painters and photographers were interested in answering the same formal questions: How could movement and speed be translated into visual equivalents? Did formal means exist that were specifically suited to the rendering of modern life? According to the Futurists, the convergence and fusion of all the arts—literature, photography, painting—offered one possible solution.

Not until the 1920s and the influence of NEW VISION photography did Futurist photographers take up the techniques of PHOTOMONTAGE (Ivo Pannaggi, Vinicio Paladini), DOUBLE EXPOSURE (Tato), OPTICAL DISTORTION (Giulio Pariso), and AERIAL PHOTOGRAPHY (Masoero). At the time, Futurist photography seemed like an attempt to subvert visual reality by presenting it in unconventional ways, and in this guise it influenced photographers working in very different contexts, ranging from BAUHAUS photographers like T. Lux Feininger to the New Vision photographers.

GALLERY

The idea of exhibiting photographs occurred quite early: in London they were displayed in the rooms of the Society of Art in 1852, and two years later, in Paris, at the Société Française de Photographie. The establishment of more exhibition societies—for example, the Photographic Society of Vienna (1861) and the Photographic Society of Philadelphia, (1862)—made it possible to present photographs to an expanding public. Advocates of NATURALISM, PICTORIALISM, and the PHOTO-SECESSION were determined to insert photography into the art world, and they sponsored exhibition spaces as a means to this end. In 1905 Alfred Stieglitz, for example, opened his Little Galleries of the Photo-Secession in New York, which soon came to be known as 291 (after its address at 291 Fifth Avenue). Julien Levy's gallery, also in New York, was the first in the world to be devoted exclusively to photography, although he subsequently mounted exhibitions of modern painting and sculpture. In Paris, Levy had discovered the work of Eugène Atget and the SURREALISTS, which he exhibited beginning in 1931 (the year the gallery opened), as well as that of Henri Cartier-Bresson, whose first one-man show he mounted in 1932. But such initiatives were isolated; there was still no gallery network and no art market for photography.

It was only in the late 1960s that such a network began to emerge, first in the United States (spearheaded by the Witkin Gallery in New York) and then in Europe. The new venues introduced "fine-art photography," selling vintage PRINTS by well-known photographers and thereby spurring individuals, museums, and other institutions to collect them. Galvanized by highly publicized auctions and rising prices, the photography market expanded rapidly; there was an almost 700 percent increase in the market between 1975 and 1991 (according to the fall 1991 *Journal of Art*). Galleries selling photographic prints began to appear in all the major cities of the West. Additional stimulus was provided by the osmosis between photographers and artists working in other media, a phenomenon that became increasingly prevalent beginning in the late 1980s. Many galleries specializing in painting seized the moment to ask—and receive—prices for photographic work comparable to those for painting.

GELATIN SILVER PROCESS

Gelatin, which became the essential binder for most photographic EMULSIONS, occupies a special place in the history of photography. William Henry Fox Talbot used it, beginning in 1839, to size his SALT PAPERS; Richard Leach

Maddox prepared the first gelatin–silver bromide emulsion in 1871. By 1880 gelatin silver had supplanted all other materials for the preparation of light-sensitive plates, especially negatives, and it has remained popular ever since. The gelatin silver process, using silver salt crystals suspended in gelatin, combines heightened sensitivity with unequaled simplicity of use.

Three types of supports have been used with this process: glass plates for negatives or positives, pliable supports for negatives (introduced by Kodak in 1889, with celluloid nitrate film), and papers for positive prints; they all can be stored for long periods without losing their effectiveness. Invented in 1873 by Peter Mawdsley, gelatin–silver bromide papers were used primarily for "developing-out," using chemical products such as a developer to reveal the LATENT IMAGE, rather than for "printing-out" (see PHOTOGRAPHIC PAPER). Gelatin silver prints are usually a neutral black (with variations specific to each brand), but their hue can be modified by TONING. The sensitivity of gelatin silver makes considerable ENLARGEMENT possible without loss of detail.

GRAFFITI

Photographers' interest in graffiti (an Italian word designating inscriptions scribbled or scratched on walls—a practice that dates back to antiquity) pre-dates a similar interest by fine artists like Jean Dubuffet in France and Antoni Tàpies in Spain, as well as by the untrained "graffiti artists" whose work on walls and subway trains enjoyed a brief, if controversial, vogue in the United States during the late 1970s and early 1980s.

Beginning in the 1920s, Walker Evans and Berenice Abbott systematically photographed graffiti, which Evans considered part of a vernacular art that also included signs, posters, and billboards—a view perfectly expressed in his famous image *License Photo Studio* (1934). Helen Levitt, who photographed graffiti in New York's streets during the late 1930s, approached it from a more social perspective, stressing its sexual content and its qualities as the rough poetry of street kids. The urban photographers of the 1950s and 1960s, such as Lee Friedlander, William Klein, and Garry Winogrand, were also attracted to graffiti.

But it was the Rumanian-born Gyula Halász, known as Brassaï after he settled in France, who photographed graffiti most seriously and made them the subject of a book, *Graffiti* (1960). He had begun to shoot these images in the early 1930s, mostly in the streets of Paris. Brassaï's graffiti include faces, animals carved in the walls, and childish scribbles, offering the viewer a

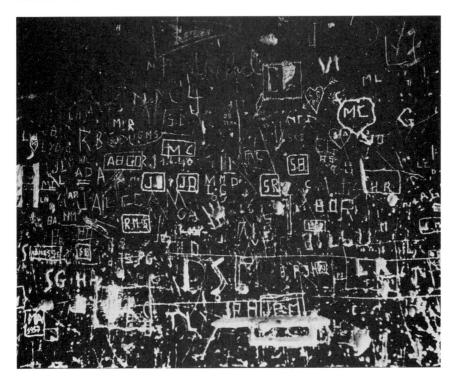

BRASSAÏ (1899–1984).
Graffiti from Lutèce, Wall in the Arênes de Lutèce, 1950–60.
Gelatin silver print, 9¼ x 12 in. (23.5 x 30.5 cm). Gilberte Brassaï.

veritable human comedy as well as a fascinating collection of SURREALIST found objects.

GROUP F/64

▷ **WHO** Ansel ADAMS, Imogen CUNNINGHAM, John Paul Edwards, Preston Holder, Consuelo Kanaga, Alma Lavenson, Sonya Noskowiak, Henry Swift, Willard Van Dyke, Brett Weston, Edward WESTON

▷ **WHEN** 1932 to 1935

▷ **WHERE** California

▷ **WHAT** In 1932, at the prompting of the photographer (and later filmmaker) Willard Van Dyke, a group of young California photographers, who had been strongly influenced by the work of Edward Weston and the German NEUE SACHLICHKEIT photographers, banded together under the name Group f/64. The name was taken from the technical description of the smallest possible lens opening, which assured maximum CLARITY and definition.

In reaction against PICTORIALISM, which remained fashionable, the group favored STRAIGHT PHOTOGRAPHY. MANIPULATION, whether before or after exposure, was disparaged, and all the members of the group were preoccupied with clarity of detail almost to the point of obsession. They also advocated strict respect for the medium's characteristics, stressing what was unique to it. In several statements for exhibitions and in articles, they expressed their aesthetic credo: no cropping of original negatives, no use of glossy paper for prints, and so on. The preferred subject was landscape, in the tradition of earlier California photography. Ansel Adams was the group's most outspoken theorist, Edward Weston its most reticent.

In November 1932 the group's first collective exhibition was held at the M. H. de Young Memorial Museum in San Francisco. In September 1933 a second exhibition was mounted at the Ansel Adams Gallery, also in San Francisco. Several articles by or about the group's members appeared in the periodical *Camera Craft,* always at the instigation of Adams. The group disbanded in 1935, but its impact on American photography was considerable and long-lived—despite its dogmatic excesses, which occasioned much criticism. For example, the photographer William Mortensen wrote in *Camera Craft* (June 1934): "Especially fallacious is their assumption that artistic truth lies in a complete rendering of literal details. Truth in art lies in the rendering of the experience,...not with facts, but with ideas and emotions.... The Purists insist

emphatically that their finger exercises merit artistic consideration. Such consideration cannot be given them until they are through with ostentatiously playing scales in the key of C."

GUM BICHROMATE PROCESS

Based on the CARBON printing process invented by Alphonse-Louis Poitevin, the gum bichromate process was introduced in 1858 by John Pouncy, but it did not become popular until the 1890s.

Pouncy's innovation was to replace the gelatin that was used to coat the paper in the carbon process with a solution of gum arabic, pigment, colloid, and a dichromate. The sheet was brushed with this mixture, dried, and then covered by a negative, exposed to sunlight, and developed in warm water, which washed away the pigment in proportion to the amount of light each area received (least-exposed areas retained the most pigment). The pigmented surface could be manipulated to produce various painterly effects; it could be brushed to alter the print's tonality, remove unwanted details, or add texture. After these interventions, the print could be resensitized and then exposed again to deepen the dark tones and enrich the tonal range. The most prominent devotees of the gum bichromate process were the French PICTORIALISTS Robert Demachy, E. J. Constant Puyo, and René Le Bègue; the American Edward Steichen; and the Austrian Heinrich Kühn. The process is occasionally used even today, but it had its moment of greatest glory in their hands.

HISTORIES OF PHOTOGRAPHY

Until quite recently, histories of photography were modeled after those documenting other branches of art history and thus failed to address the medium's unique characteristics. The earliest histories either limited themselves to accounts of photography's technical evolution (as in *Geschichte der Photographie* [History of photography] by the Austrian Josef Maria Eder, definitive edition, 1932) or viewed it from a purely aesthetic angle, adopting an approach like that applied to the other visual arts, particularly painting. Beaumont Newhall's *History of Photography 1839–1937* (first edition, 1937) was conceived in conjunction with an exhibition he organized at the Museum of Modern Art in New York, where he had been a librarian since 1935 (he became a curator there in 1940). Downplaying the importance of the medium's nonartistic uses, Newhall opened the way

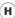

toward an aestheticizing approach to photography that now seems reductive, but his text also legitimized the medium by anchoring it firmly in the world of art. Alison and Helmut Gernsheim's book *The History of Photography, from the Camera Obscura to the Beginning of the Modern Era* (1955) proceeds along similar lines.

Recently, attempts have been made to treat the history of photography in more expansive ways. The sociocultural perspective has been influenced by Gisèle Freund, who, in addition to producing a considerable body of photographic work in the interwar period, drew on her training as a sociologist to write *Photographie et société,* 1974 (published in English in 1980 as *Photography and Society*), a book stressing the medium's close ties to its social uses. Jean-Claude Lemagny and André Rouillé also favored this approach in their *Histoire de la photographie,* 1986 (translated as *History of Photography: Social and Cultural Perspectives,* 1987). Others, even more ambitious—particularly Naomi Rosenblum's *World History of Photography* (first edition, 1984)—have attempted to recapitulate the medium's technical history alongside its many parallel evolutions in the domains of the documentary, photojournalism, fashion, and advertising, as well as in the realm of personal expression. The monumental *Nouvelle Histoire de la photographie* (New history of photography, 1994), edited by Michel Frizot and including contributions by many eminent scholars, focuses on the medium's inherent properties—designated as *le photographique,* or "the photographic"—which are said to be in play in all of its many guises, whether for private, fine-art, or media uses.

HUMANIST PHOTOGRAPHY

▷ **WHO** Werner BISCHOF, Edouard BOUBAT, Marcel Bovis, Bill Brandt, BRASSAÏ, Cornell Capa, Robert Capa, Henri Cartier-Bresson, Chim, Denise Colomb, Roy DeCarava, Jean Dieuzaide, Robert DOISNEAU, photographers of the FARM SECURITY ADMINISTRATION, GROUPE DES XV, Izis, André Kertész, François Kollar, Marc Riboud, George Rodger, Willy RONIS, the Seeberger brothers, W. Eugene SMITH, Louis STETTNER

▷ **WHEN** 1930s to early 1960s

▷ **WHERE** Europe and the United States

▷ **WHAT** Any photographer whose images celebrate humanity can be called "humanist." Humanism is a current of thought, pervasive in Western philosophy since the Renaissance, whose principal article of faith is the existence of

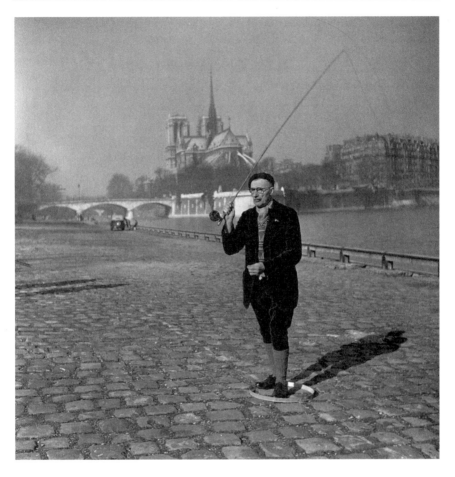

ROBERT DOISNEAU (1912–1994).
*Fly-casting Lessons on the Pont de la Tournelle, Paris, Fifth
Arrondissement*, 1951. Gelatin silver print, dimensions variable.
Rapho, Paris.

an eternal human essence. This mind-set has had a significant impact on how photography has borne witness to humankind, especially from the 1930s—years of grave economic crisis—to the early 1960s.

In the decades following World War I, a concern with sympathetically documenting social reality became a preoccupation of many PHOTOJOURNALISTS working in Europe, including François Kollar, André Kertész, and two of the future founders of the Magnum photo agency, Robert Capa and Henri Cartier-Bresson. The approach to documentation adopted by the FARM SECURITY ADMINISTRATION team in the United States was a more militant though ultimately optimistic brand of humanism intended to dignify the individuals they photographed. That tradition was carried on in America most strikingly by W. Eugene Smith's PHOTO-ESSAYS for *Life* magazine from the late 1930s to the mid-1950s.

Beginning in the late 1940s, the tone of French humanist photography was set by the poetic realism of the filmmaker Marcel Carné and the poet Jacques Prévert. Edouard Boubat, Jean Dieuzaide, Robert Doisneau, and Willy Ronis (most of whom belonged to the Groupe des XV, established in 1946, and were more concerned with the content than the form of their photographs) continued the tradition of a social poetry wonderfully exemplified by Brassaï's interwar images of Paris by day and by night. These photographers adhered to the optimistic descriptive approach that had been encouraged by the Popular Front of 1936 (a leftist French government), but their work was also infused with the dark poetry associated with the outskirts of Paris in films by Carné such as *Quai des Brumes* and *Hôtel du Nord* (both 1938).

In 1955 the American photographer Edward Steichen, then curator of photography at the Museum of Modern Art in New York, organized a hugely successful exhibition there entitled *The Family of Man*, which paid homage to humanist photography, presenting it as a language of universal brotherhood. This brand of photographic idealism has often been denounced, notably by the critic Roland Barthes. Such criticism encouraged a new approach to DOCUMENTARY PHOTOGRAPHY, beginning in the 1960s, which aims to describe the world as opposed to interpreting it through a filter of reassuring optimism.

INSTALLATION AND PHOTOGRAPHY

Installation art designates an arrangement of objects intended for public viewing, which the artist or photographer has configured in a way deter-

mined by the specific space and which is dependent for its effect on the interaction of all the elements.

Increasingly, curators are paying heed to the way a photograph's meaning can be altered by the context in which it is presented. The first photographic installations were straightforward displays of prints hung in rows along the wall—a traditional linear approach to installation that has changed very little, although modifications have been gradually introduced since the 1940s. Herbert Bayer's installation of the 1942 exhibition *Road to Victory,* for example, organized at the Museum of Modern Art by Edward Steichen, made highly theatrical use of novel formats and wall configurations: some pictures had a "widescreen" format, others were suspended from the ceiling.

Since the 1980s photographers and artists have begun to make increasingly inventive use of photographic images. They have employed large formats, diptychs or triptychs (as in some of the PHOTOMONTAGES by Gilbert and George), and composite objects (as in Pascal Kern's life-size Cibachrome still lifes of industrial detritus, which maintain their identity as photographs while also approximating the monumental presence of sculpture). Mixed materials have also been used (as in the Equilibres series, 1984, by Peter Fischli and David Weiss and in Sandy Skoglund's surreal tableaux incorporating brightly colored geometric motifs, paper cutouts, food, and animals, which she creates to be photographed). And images have been suspended or scattered in ways that transform the entire exhibition space (as in works by Annette Messager and Christian Boltanski).

JAPONISME

Japanese art—particularly woodcuts—had a profound influence on Western art from the mid-1860s through the early twentieth century, and this influence is known as *japonisme.* Photographers, too, responded to Japanese art's simplicity, its asymmetrical compositions and unusual points of view, its tendency toward abstraction and flatness, its decorative qualities. Among photographers, it was the PICTORIALISTS and the SYMBOLISTS who were most receptive to *japonisme.* Exemplifying the artisanal approach they favored, it helped reinforce their desire to resist the mechanical aspects of the photographic process. In 1909 Alfred Stieglitz mounted an exhibition of Japanese prints at his gallery, 291. The ideas of the American painter and teacher Arthur Wesley Dow, an advocate of the Japanese approach to composition, had a significant effect on the CLARENCE H. WHITE SCHOOL OF PHOTOGRAPHY as well as on artists of the PHOTO-SECESSION.

In the 1920s and 1930s many important Japanese photographers—including Toyo Miyatake, Kaye Shimojima, and Shigemi Uyeda—were active in southern California, especially in the Los Angeles area. Many were members of the Japanese Camera Pictorialists of America, and all of them took an approach to structuring photographic space that reflected their native traditions. The California photographers Anne W. Brigman, Imogen Cunningham, Johan Hagemeyer, and Edward Weston also emulated the Japanese visual syntax and emphasis on decorative elements, which eased their passage to a MODERNIST idiom.

JUDICIAL PHOTOGRAPHY

At the end of the nineteenth century, as cities became ever-larger conglomerations of strangers, a growing need for reliable proof of individual identity led to the establishment of photographic files of suspects and criminals. They were organized along lines that are still followed today. It was Alphonse Bertillon (working for the Paris prefecture of police) who, in 1885, first combined body measurements, photographic portraits, and systematic written descriptions to create comprehensive files of personal information. The resulting dossiers included two photographs of the suspect, one frontal and one in profile (a practice still current throughout the world). By 1890 a file of some ninety thousand "mugshots," as they are known, had been compiled in Paris. In perfecting this file, Bertillon was building on the work of two predecessors: the Belgian scientist Berthelet, who first applied to the human body the anthropometric principles devised by zoologists, and Eugène Appert, who had used portrait photographs for prosecutorial purposes after the Paris Commune in 1871.

Bertillon's work soon influenced British policing. The wealthy English amateur Francis Galton invented a preliminary version of the "composite photograph," based on the principle of visual fusion, which occurs when portraits of two different people are viewed through a stereoscope. Galton's procedure, intended to reveal the facial types of specific families and social groups, was taken up by ethnographers, notably the Frenchman Arthur Batut, and then by the British police. A related effect has been achieved by the contemporary Polish photographer Krzysztov Pruszkowski in his "photosynthesis" portraits and by the American Nancy Burson in her series of computer-merged faces.

The modern police portrait is another judicial tool. Intended to serve as an image of an unidentified suspect in the absence of a photograph, it results

from the combination, either sketched by hand or generated by computer, of generic facial elements selected on the basis of eyewitness accounts. It is by no means infallible.

The frontal lighting (to eliminate shadows), uniform poses, and rigorous artlessness of the mugshot left their mark on some subsequent PORTRAITURE, as can be seen in the work of such photographers as August Sander, who made documentary portraits of specific types within the German population during the interwar period, and Richard Avedon, particularly in his American West series of the 1980s. Thomas Ruff has produced Aperto, a 1988 series of large color images of young people's faces, all frontally lit, that intentionally evoke ID photos.

LANDSCAPE PHOTOGRAPHY

Landscape photography performed a documentary function before it assumed an aesthetic one. The commercial success of ALBUMEN PRINTS and STEREOGRAPHS encouraged nineteenth-century photographers to embark upon photographic expeditions throughout the world to supply this new market with countless touristic images. Landscape had emerged as an independent genre of painting in the late eighteenth century. With the advent of photography, two different approaches to the subject became prevalent: a European one, focusing on the cultivated and inhabited landscape, and an American one, preoccupied with savage, unspoiled nature.

Until the 1970s, the painting tradition exerted far greater influence over European than over American landscape photography. Early French photographers such as Eugène Cuvelier, Gustave Le Gray, Henri Le Secq, and Charles Marville, for example, associated with painters of the Barbizon School, including Jean-François Millet and Narcisse-Virgile Diaz de La Peña, who was a close friend of Le Secq. The painters' desire to capture something eternal in nature is also characteristic of landscapes produced by Le Gray, Le Secq, and the other photographers participating in the government's Mission Héliographique (1851). (All of them also shared a preoccupation with creating effective images of the sky, which was difficult to record photographically due to limitations in the available materials.) In the wake of the success of Impressionism later in the century, European photographers and then American ones abandoned straightforward documentary landscape as insufficiently aesthetic, in favor of the more coded, painterly mode favored by the PICTORIALISTS, who specialized in landscapes with limited topographical content.

CARLETON E. WATKINS (1829–1916).
Rock Formation, Utah, c. 1874. Albumen silver print, 6 x 8 in.
(15.3 x 18.6 cm). Amon Carter Museum, Fort Worth.

The great contribution made by the American photographers participating in documentary and exploratory expeditions into the American West (William Henry Jackson, Timothy H. O'Sullivan, Carleton E. Watkins, and others) was to avoid a conventionally artistic approach to landscape, which would have been at odds with the purpose of their mission as well as with their training. They saw themselves as technicians, geologists, and adventurers, and their complex images showcase nature in all its power, suggesting also the potential chaos in its looming forms. Their work was to exercise considerable influence on subsequent American landscape photographers, from Walker Evans to those espousing the NEW TOPOGRAPHICS.

One line of American MODERNISTS extending from Alvin Langdon Coburn through Paul Strand and Edward Weston had difficulty assimilating this nature-focused heritage, preferring a more rigorously formalist approach to a landscape that Weston, at the beginning of his career, described as "too chaotic...too crude and lacking in arrangement." ABSTRACTION was their great temptation, as it was that of modernists in general. The desire to give meaning to landscape led to lyrical images by Ansel Adams as well as mysterious ones by Minor White. In modernist photography, the close-up or detail was a viable response to nature's chaos, a means of organizing it into structured compositions. The Czech photographer Josef Sudek, for example, reduced landscape to simple, intimate scenes recorded from a fixed point of view, as in his series Windows from My Studio (1940–54).

Environmental art, which emerged in the 1960s, transformed the relationship between photography and the landscape. Artists began to act on the land: reshaping it (Robert Smithson and Michael Heizer moved earth and rocks in the American West, John Pfahl inscribed perspective lines on land and water, and Georges Rousse made trompe l'oeil configurations), traversing it (Hamish Fulton took precisely defined and precisely documented walks), or appropriating parts of it into the gallery (Richard Long made circles of mud or stone). Many of these artists then took photographs to document their interventions.

LATENT IMAGE

The obtaining of a latent (that is, invisible until developed) image on a sensitized surface was the first important step in the invention of photography. After Nicéphore Niepce's initial unsuccessful attempts, it was Louis-Jacques-Mandé Daguerre who was the first to resolve the problem effectively, in 1839. The latent image remains invisible on the exposed plate or paper until it is made visible by chemical DEVELOPMENT.

LENS

The lens in a CAMERA directs the light rays emanating from or reflecting off the object being photographed through the shutter (see LIGHT) to the light-sensitive surface being exposed (usually FILM). The lens consists of superimposed layers of glass or plastic whose surfaces have been treated to compensate for the distortion that results from the bending of light rays as they pass from one material (air) through another (the glass of the lens). Lenses are classified according to their focal length (the distance from the lens to the point where the light rays converge on the film—in a 35 mm camera, this is a distance of 2 inches [50 mm]) and their relative aperture, which is the relationship, expressed in the form $1/n$, between the diameter of the lens opening and the focal length of this lens. A lens with a focal length of 50 mm, open to f.4, has an aperture diameter of one-half inch (12.5 mm) and an "opening" of 4.

The standard lens types are normal (close to human vision), wide-angle, telephoto, and zoom (providing variable focal lengths that bring distant objects into closer view). There are also more specialized varieties, including fish-eye, soft-focus, macro- and micro-, enlarging, and decentering lenses. A photographer's choice of lens type can determine the look of the resulting work, as in the distorted nudes that Bill Brandt produced in the 1960s by using a wide-angle lens.

LIGHT

Light is a basic element in every photograph. The amount of it that reaches the SENSITIZED SURFACE is controlled by the camera shutter, or diaphragm, which opens and shuts at a precisely defined speed—1/125th of a second, 1/1000th, and so on. The diaphragm, a mechanical device that controls the diameter of the light beam penetrating the lens, is numbered according to an international scale, in geometric progression, as follows: 1.4, 2, 2.8, and so on, up to 256. Each step to a higher number reduces the amount of light admitted by one half. In the photographic process, light undergoes a reversal: bright light registers as black on the negative but, once the negative has been developed into a positive print (see DEVELOPMENT), the light is recorded in proportion to its brightness in the subject being photographed. Too much light striking the sensitized surface—called "overexposure"—results in a too-dark negative that yields a washed-out positive image, lacking shadows and definition.

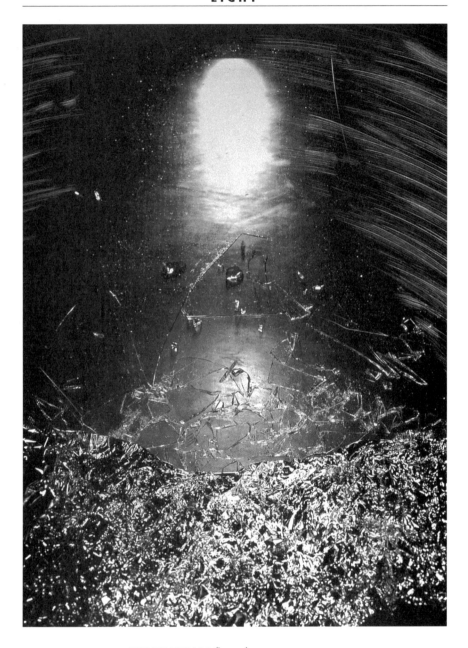

KEIICHI TAHARA (b. 1951).
Polaroid, 1984. Polaroid print, 20 x 25 in. (50.8 x 63.5 cm).
Collection of the photographer.

In 1857 the first artificial light for photography became available in the form of inflammable powder, which was burned to provide illumination. Nadar was the first to use electricity (in the form of Bunsen batteries) as a source of artificial light, which he used to photograph the catacombs and sewers of Paris in 1861. Magnesium had first been used for illumination two years earlier; it provided a vivid white light that made it possible for Timothy H. O'Sullivan to photograph miners at work in Nevada in 1867. Magnesium flash powder (late 1880s), flashbulbs (early 1900s), and the electronic flash (1925) have been the most important subsequent developments in the history of artificial light.

László Moholy-Nagy, who believed that photography was primarily the result of manipulating light, took literally the German word for photography (*Lichtbild,* "light image") and described himself as a *lichtner,* or "one who works with light." Many photographers have produced PHOTOGRAMS by directing light to record the silhouettes of objects positioned on light-sensitive paper or by manipulating light into abstract patterns captured on sensitized paper. In 1928–29 Willy Zielke made a specialty of photographing plates of transparent glass and the effects produced by light as it passed through them. In Zielke's words, "Thanks to [light] one can make something important appear in objects without importance." In the 1940s Carlotta M. Corpron (working under the influence of Moholy-Nagy) projected light through perforated-cardboard "light boxes" and then photographed the abstractions created by the play of the light on objects and on plain white paper forms arranged within the box.

LITERATURE AND PHOTOGRAPHY

Like every other art, photography has links with different forms of expression. It has most often been considered in terms of its contentious relationship to painting, while its extensive ties to literary activity have been neglected. These ties have been manifest in photographers' fascination with the literary world, with literary subject matter, and—most interesting of all—with experimental practices, an interest often shared by their writing colleagues.

As early as the 1840s William Henry Fox Talbot photographed a bookish subject—*A Scene in a Library,* for his own book, *The Pencil of Nature* (1844–46). Throughout the nineteenth century, writers were the favorite models of photographers such as Nadar and Etienne Carjat. Portraits of famous authors have remained a photographic staple, including celebrated images by Alvin

Langdon Coburn (*Ezra Pound,* 1917), Berenice Abbott (*James Joyce,* 1928), Henri Cartier-Bresson (*William Faulkner* and *Truman Capote,* both 1947), Madame D'Ora (*The Writer Colette,* c. 1953), Richard Avedon (*Norman Mailer,* 1960s), and so on. Conversely, many writers have dealt with photography in their fiction—for example, Thomas Hardy, Marcel Proust, Ezra Pound, Vladimir Nabokov, and Alain Robbe-Grillet. Many writers have also tried their hands at photography, among them Emile Zola and George Bernard Shaw. On occasion, the quality of their photographic work has equaled that of their literary output, as with Lewis Carroll, author of *Alice's Adventures in Wonderland* (1865), and the southern writer Eudora Welty, who became a sensitive photographer of her native Mississippi during the Depression.

The most successful collaboration between a writer and a photographer is undoubtedly *Let Us Now Praise Famous Men* (1941), in which the text (by James Agee) and the photographs (by Walker Evans) reinforce each other to yield a moving account of the daily life of Alabama sharecroppers in 1936. There have been many other writer-photographer collaborations, but few have produced such powerful results; in most cases the author has merely provided an introduction to the photographer's work (Lawrence Durrell on Bill Brandt, Yukio Mishima on Eikoh Hosoe, Truman Capote on Richard Avedon, Marguerite Duras on Ralph Gibson).

Contemporary photographers have turned their attention to the affinities and differences between literary and photographic practice. Since the 1970s Duane Michals has been producing narrative photographic sequences, annotated with his own wry titles and commentary. Others—including Christian Boltanski, Raymond Depardon, Robert Frank, Nan Goldin, Emmet Gowin, Bernard Plossu, and many others—have taken up a form of narrative photographic autobiography. Photography's ability to isolate moments from the continuum of time as well as the possibility of photographing oneself has led Denis Roche—who is also an author—to explore the concept of "photographic writing," especially through his self-portraits in his series Photolalies (1988). Parallels between narrative and photographic fiction (including the popular "photo-novel" form) have also been explored in inventive ways by Boyd Webb, who photographs bizarre storytelling scenes filled with exotic animals and oddly eclectic objects (as in *Asylum,* 1988), and William Wegman, whose exclusively canine universe has recently expanded to include fairy tales such as *Cinderella* (1993) and *Little Red Riding Hood* (1993).

LUMINISM

▷ **WHO** John Batho, William Christenberry, Mark Cohen, Marie Cosindas, William EGGLESTON, Mitch Epstein, Barnaby Evans, Franco Fontana, Ralph Gibson, David Gregory, Jan Groover, Frank Horvat, Joel MEYEROWITZ, Grant Mudford, Ruth Orkin, Alfred Seiland, Kishin Shinoyama, Stephen SHORE, Neal SLAVIN, Reinhart Wolf

▷ **WHEN** 1970s

▷ **WHERE** Primarily the United States, but also Europe and Japan

▷ **WHAT** The term *Luminism* was first applied to a school of mid-nineteenth-century American landscape painters devoted to the precise rendering of chromatic and atmospheric effects. In the 1970s an approach to color photography emerged in the United States that was indebted both to this pictorial tradition and to the black-and-white STRAIGHT PHOTOGRAPHY of the 1920s. Sometimes called "New Color Photography," this approach had been anticipated by the Kodachrome color prints taken in the late 1940s by Walker Evans (intended for publication in *Fortune* magazine) as well as by color work by some of the FARM SECURITY ADMINISTRATION photographers—for instance, Jack Delano. The photographic historian Jonathan Green—who first dubbed these photographers Luminists in his book *American Photography* (1984)—has observed that their photographic exploration of the world of color was also influenced by the abstract paintings of Mark Rothko and Barnett Newman.

Members of the 1970s generation of color photographers, such as Joel Meyerowitz and Stephen Shore, were indebted to the descriptive tradition of Ansel Adams, Eliot Porter, and Edward Weston. They were drawn to large formats and landscape subjects (in certain respects paralleling the concerns of those espousing the NEW TOPOGRAPHICS), but by no means did they neglect urban subjects—such as Shore's work in El Paso, Texas, in 1975 and Meyerowitz's studies of the Gateway Arch in Saint Louis—or social themes, such as Neal Slavin's quirky group portraits of various associations. The lessons of Walker Evans's vernacular documentary work were absorbed by William Eggleston (whose photographs of Mississippi were the subject of a retrospective at the Museum of Modern Art in New York in 1976) and by William Christenberry (who consciously emulated Evans). As Allan Porter noted (in a special issue of *Camera* magazine, July 1977), the Luminists set out to capture not only situations but "the color of these situations."

Profiting from advances in color EMULSIONS (especially Kodak film, but also the Polaroid SX-70 system), many Luminist photographers in the United States and Europe (Franco Fontana in Italy, John Batho in France, Reinhart Wolf in Germany) made a case for color as a legitimate form of "fine-art photography," a critical accolade previously reserved for black-and-white work.

MANIPULATION

The etymology of this term, based on the Latin word for *hand,* suggests what it designates—namely, any postexposure manual intervention in the photographic process (now including technical processes like digitization).

Such hands-on interventions are seemingly at odds with what was originally perceived as the mechanical and reliably objective nature of photography. Toward the end of the nineteenth century, as PHOTOJOURNALISM was emerging, manipulations began to be used to modify the reality depicted in photographic documents, to serve either political purposes (for example, retouching to obscure or delete unwanted information) or social mores (such as blanking out models' sexual organs). Manipulations were also favored to augment photography's artisanal and artistic character, as in the work of many commercial portraitists and, beginning in the 1880s, that of PICTORIAL-ISTS like Robert Demachy and Heinrich Kühn. As Pictorialism progressed, the range of options expanded to include the use of overpainting to unify backgrounds and intervention at the negative stage, a practice also facilitated by the GUM BICHROMATE PROCESS. In the late nineteenth century Frank Eugene used an engraver's burin to remove details and clarify graphic effects (as in *Horse,* c. 1901), thereby obtaining what he called "non-photographic photographs." Manipulation of both negatives and prints is still practiced today by photographers who might be called "neo-Pictorialists"—Jerry N. Uelsmann, who superimposes negatives to produce new composite images; Lucas Samaras, who manipulates the uncongealed surfaces of his Polaroids; Arnulf Rainer, who scratches and paints the surfaces of his prints.

Photographers affiliated with NEW VISION and SURREALISM regarded DOUBLE EXPOSURE and PHOTOMONTAGE as viable tools of visual expression, but the tradition of STRAIGHT PHOTOGRAPHY called for avoiding changes to the negative or alterations during the printing process; especially scorned were cropping and retouching. Since the 1980s, new DIGITAL technologies have made it possible to manipulate photographic images with far greater ease and effectiveness. Once a photograph has been digitized, it becomes possible to modify it through the use of specialized software, thereby altering the original image.

Such operations facilitate manipulations that, undetectable by the viewer, make it easier and easier to falsify data. Recently, in France, a commemorative stamp was issued using Gisèle Freund's famous 1930s photograph of the novelist André Malraux, which was electronically retouched to eliminate the cigarette in his hand, bringing it into line with the government's anti-smoking campaign.

METAPHOR

In language, a metaphor is a figure of speech that suggests an often-poetic analogy between two elements by using one to stand in for the other. The same could be said of photographic metaphor, which offers a reading of reality that transcends exterior appearances—a goal very much at odds with the presumably objective nature of photography, which is anchored in precisely such appearances.

SYMBOLIST photographers borrowed an arsenal of visual devices from painting, attempting to communicate poetic ideas by means of technical artifice (BLURRING, light MANIPULATION, coded academic poses). That Edward Steichen excelled at this can be seen in his photograph *Moonrise, Mamaroneck, New York, Autumn, 1904*. This idea of using elements from the visible world as metaphors for personal sensations and emotions was explored by Alfred Stieglitz in his EQUIVALENTS series of cloud photographs, begun in 1922. In 1927 Edward Weston started producing rigorously formalist close-up studies of vegetables, shells, and rocks that also have strong metaphorical overtones. Perceiving their organic forms as metaphors for the primal forces of nature, he transformed specific objects into essences by isolating them from any recognizable context. In the 1940s and 1950s Clarence John Laughlin used a quasi-SURREALIST language—featuring mirrors, superimposed negatives, rays of light, ghosts, and masks—to evoke the past of his native Louisiana, creating images that serve as metaphors for the Old South's morbid sensuality.

In the work of Minor White after World War II, metaphors became a link to mysticism. Influenced by Eastern philosophy, the teachings of G. I. Gurdjieff, and gestalt theory, all of which figured in his magazine *Aperture,* White conceived of his black-and-white photographs of objects and landscapes as metaphors for essential human experiences. "The rocks and the photographs are only objects upon which significance is spread like sheets on the ground to dry," he wrote in the introduction to his book *Rites and Passages* (1978). Harry Callahan, Paul Caponigro, Walter Chappell, Jean Dieuzaide, and Aaron Siskind have all worked in this metaphorical mode, which persists in

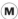
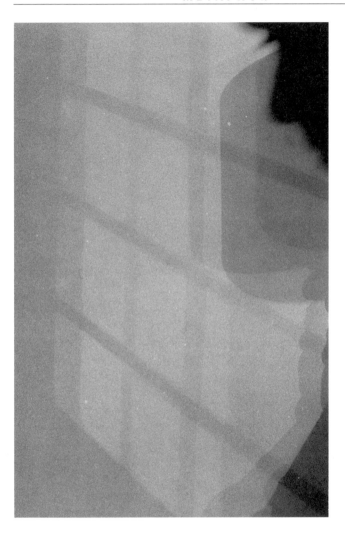

JORGE MOLDER (b. 1947).
Lisbon, 1986. Gelatin silver print, 15⅝ x 11¾ in. (40 x 30 cm).
Collection of the photographer.

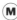

contemporary photography in a poetic rather than a mystical vein, as in the work of Debbie Fleming Caffery, Arnaud Claass, Otmar Thormann, and Jorge Molder.

MODERNISM AND PHOTOGRAPHY

In aesthetics, the term *modernity* has a wide range of meanings. It was used by Charles Baudelaire in the mid–nineteenth century to designate a new field of action for the artist—namely, the modern world (by which he meant bourgeois industrial society). In Baudelaire's view, modernity consisted of what was new in one's own culture and implied an obligation to be of one's own time, especially in terms of artistic expression. Modernity pushed the artist to reflect on his own status and tools of expression, with the aim of devising new and perhaps disruptive tools better suited to his period.

In art history, the related term *modernism* is used to designate a period extending from the 1860s through the 1970s, during which time the term's meaning was repeatedly called into question and redefined. *Photographic modernism* is generally understood to designate a period beginning at the end of World War I, in Europe and the United States, with the passage from PICTORIALISM to STRAIGHT PHOTOGRAPHY. Confronted with the new values of the industrial world, with avant-garde challenges to established modes of repre-sentation, and with a growing awareness of the potentials and limitations of their medium, photographers continued to reassess their approaches to the medium until the outbreak of World War II and beyond. Robert Frank's *The Americans* (1958) is generally understood as both the culmination and the endpoint of photographic modernism. After Frank—who thereafter stopped making photographs regularly—it seemed that the photographic language perfected since the beginning of the century had been exhausted and was no longer suited to comment on contemporary society.

Photographic modernism can be summed up as a series of technical and the-matic choices. In each case, the first alternative in the list that follows is identified with the photographic modernism advocated by participants in the NEUE SACHLICHKEIT, NEW VISION, and SURREALISM, as well as by the partisans of DOCUMENTARY and straight photography. Some of these opposing alternatives were technical and formal: clear/blurry, close-up/distant, pure/impure, experimentation/tradition. Others were more thematic: document/art, pres-ent/past, culture/nature, objective/subjective, and so on. These options were embodied in different ways by different photographers. Weston, for example, always preferred nature to culture, systematically excluding from

his work the modernist subjects of the city and the machine. The Surrealists managed to combine objectivity and subjectivity, as in Brassaï's depictions of Paris. American photographers have been less attracted to experimentation (the use of countercomposition, ABSTRACTION, PHOTOMONTAGE, and so on) than their European counterparts, preferring a more straight approach to photographic modernism.

MONTAGE—*see* PHOTOMONTAGE

MOVEMENT AND PHOTOGRAPHY

From the moment of photography's invention it was clear that the extended time required to make an exposure severely limited photography's ability to record movement. Until the technical limitations were resolved, photographs were often inhabited by the puzzling blurs and ghosts left by imperfectly rendered human and animal motion, as in the pictures of Paris streets taken by Charles Nègre during the 1850s. Only after the development of the GELATIN SILVER PROCESS in 1880 did life at its most active and instantaneous become a viable photographic subject.

It was work carried out by the American Eadweard Muybridge and the Frenchman Etienne-Jules Marey that placed the photographic analysis of movement on a solid scientific footing. Their research was to transform how humans perceived the world. Muybridge initially set out, in 1872, to elucidate the movement of a galloping horse by producing a sequence of images taken at split-second intervals. Beginning in 1883, he shot over 200,000 more sequential photographs of human and animal motion, using batteries of twelve to twenty-four cameras taking exposures at precisely timed and staggered intervals. In 1887 Muybridge published the results of his work in a series of volumes entitled *Animal Locomotion.*

In 1883, having learned of Muybridge's photographic studies, Marey perfected the *fusil photographique* (photographic gun), which he noted made possible "the production of successive images taken at set time intervals." This is a precise definition of chronophotography (literally, "photography of time"), which facilitates the study of animal and human motion. At first Marey shot individual images of successive motions on a series of plates; the black backgrounds he used made these difficult to read. In 1888 he began to use moving film to produce sequential images of a single action shot in real time. In 1931 Harold Edgerton developed technology making it possible to

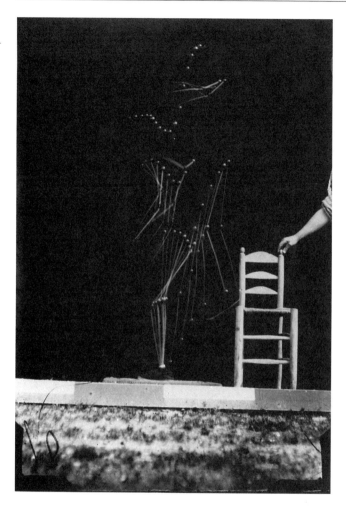

ETIENNE-JULES MAREY (1830–1904).
Man in Black Jumps from a Chair. Modern print from a plate,
11⅝ x 8⅜ in. (29.7 x 21.5 cm). Musée des Beaux-Arts et Marey,
Beaune, France.

photograph frozen movements—a splash of milk, a speeding bullet—imperceptible to the naked eye, with the aid of stroboscopic electronic flashes emitted at the rate of several hundred per second.

Chronophotography was originally designed to advance scientific research, but it had considerable aesthetic impact. The American artist Thomas Eakins, for example, performed photographic experiments inspired by Muybridge's work and incorporated the results in his paintings, such as *A May Morning in the Park: The Fairman Rogers Four-in-Hand* (1879–80). Several Europeans turned their attention to photographic studies of movement at the end of the century, including Ottomar Anschütz, A. M. Worthington, and Albert Lalonde (whose analytic photographs of a man walking down stairs, 1895, were to inspire Marcel Duchamp's notorious *Nude Descending a Staircase,* 1911–12). At the end of 1895 the Lumière brothers took the logical next step of projecting the images onto a screen and thereby invented cinematography.

The arrival of the twentieth century brought the automobile and the telephone, which condensed society's perceptions of time and distance. Thereafter, the depiction of time began to play an increasingly important role in art. Embracing a radical view of life as perpetual change and holding that art should convey the agitated energy of the modern world, the Italian FUTURISTS considered a movement's trajectory over time to be its most essential quality, and they were the first to focus on it self-consciously as a subject for painting and photography. Photographic MODERNISM assimilated the depiction of movement into its visual vocabulary in various ways—for example, by rendering it immobile, as in Edward Weston's *Galvàn Shooting* (1924), or by accepting and exploiting the blur as an indicator of speed, as in images of New York by photographers ranging from Walker Evans (1928–30) to Robert Frank (1950s) and Frédéric Gallier (1980s).

NATURALISTIC PHOTOGRAPHY

▷ **WHO** James Craig Annan, George Davison, Peter Henry EMERSON, Frank Eugene, Alfred Horsley Hinton, Gustave Marissiaux, Leonard Misonne, Alfred Stieglitz, Frank M. Sutcliffe

▷ **WHEN** 1886 to the end of the nineteenth century

▷ **WHERE** Principally Great Britain

▷ **WHAT** Enthusiastic about the optical discoveries made by Hermann von Helmholtz, in 1889 the English photographer Peter Henry Emerson published

NATURALISTIC PHOTOGRAPHY

PETER HENRY EMERSON (1856–1936).
The First Frost, from the book *Life and Landscape on the Norfolk Broads,* 1886. Platinum print, 8⅛ x 11⅜ in. (20.6 x 28.9 cm).
The Art Museum, Princeton University, Princeton, New Jersey;
Museum purchase, gift of David H. McAlpin.

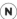

the handbook *Naturalistic Photography for Students of the Art.* In it he posited that in order to best resemble normal human vision, photographs should not be uniformly clear but rather selectively focused on one principal object, with the rest of the image slightly blurred. Opting for this new approach to realism that approximated human vision instead of being limited to the mechanical objectivity of the camera, Naturalist photography presented itself as the first aesthetic vision of reality to be justified by a scientific theory. In this, Emerson's thinking had much in common with that of the Impressionists, whose paintings were also influenced by optical theories—those of the chemist Eugène Chevreul concerning the perception of color. However, in January 1891, Emerson violently rejected his own approach to photography, taking himself to task for having made photographers think they could transform themselves into artists. He concluded his "Epitaph" as follows: "In short, I throw my lot in with those who say that photography is a very limited art."

But other "Naturalists" continued Emerson's original approach, which was greatly at odds with the self-consciously artistic composition of scenes by Henry Peach Robinson and others. During his Naturalist phase, Emerson himself produced a series of photographic volumes devoted to the English countryside, including *Life and Landscape on the Norfolk Broads* (1886), inspired by English Naturalist landscape painters such as T. F. Goodhall as well as by James McNeill Whistler. His emphasis on idyllic rural subjects was subsequently taken up by other English Naturalists, including George Davison, who worked with a PINHOLE CAMERA, and Frank M. Sutcliffe.

The main contribution of Naturalist photography was to make clear that there are various types of vision. Naturalism also linked photography with painting by encouraging photographers to intervene manually on their negatives; Frank Eugene, for example, scratched his negatives to eliminate superfluous details and to obtain etchinglike prints. PICTORIALISM was the next step in photography's self-conscious emulation of painting.

NEGATIVE-POSITIVE PROCESS

In the 1830s William Henry Fox Talbot discovered that silver salts would darken proportionally when exposed to light (the more light, the darker the result) and that light directed through a LENS onto a sheet of paper coated with a solution of silver salts would produce a negative image, in which the light areas in the subject became dark, and vice versa. Talbot also determined that these negatives could then be CONTACT PRINTED to yield positive

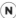

ROGER PARRY (1905–1977).
Locomotive, 1929. Gelatin silver print, 8⁷/₁₆ x 6⁷/₁₆ in. (21.5 x 16.3 cm).
The Metropolitan Museum of Art, New York; Ford Motor Company
Collection, Gift of the Ford Motor Company and John C. Waddell, 1987.

images, whose tonal values matched those of the subject. For aesthetic reasons, some photographers (notably NEW VISION photographers working between the wars) have preferred negative prints to positive ones.

NEUE SACHLICHKEIT

▷ **WHO** Ladislav Berka, Karl BLOSSFELDT, Fritz Brill, Hans Finsler, Hein Gorny, François KOLLAR, Werner Mantz, Yasuzo Nojima, Albert RENGER-PATZSCH, August SANDER, Emmanuel Sougez, Willy ZIELKE, Steef Zoetmulder, Piet Zwart

▷ **WHEN** Mid-1920s

▷ **WHERE** Europe (primarily Germany)

▷ **WHAT** The term Neue Sachlichkeit (New Objectivity) was coined in 1923 to describe the work of several German artists painting in a realistic figurative mode. Although there was never an organized group of Neue Sachlichkeit photographers, the painters' work had a crucial influence on MODERNIST photography in Germany during the years following World War I, prompting a new emphasis on technical perfection and the precise rendering of contemporary subject matter. The result was a shift from the earlier subjective, aestheticizing approach identified with PICTORIALISM to one that discouraged MANIPULATION and favored objectivity, stressing the medium's inherent qualities: CLARITY of definition, the structuring role of light, the importance of chemical processes and optical laws. Neue Sachlichkeit was distinct from but complementary to the NEW VISION, which was contemporaneous with it. Both contributed to what came to be called the "New Photography."

In 1929 the critic Wilhelm Kästner summed up the originality of Neue Sachlichkeit photography as follows: "In photography, this realism is characterized by extremely clear prints, strongly described objects, insistent light banishing all shadow and producing sharp contours, and above all by the choice of tangible objects with well-defined forms as subject matter." This description points up the similarities between work produced by these photographers and that by American STRAIGHT PHOTOGRAPHERS from the same period.

The most active Neue Sachlichkeit photographers—Karl Blossfeldt, Hans Finsler, Albert Renger-Patzsch, and August Sander—favored subjects from industry, nature, and contemporary society. Often working in SERIES (Blossfeldt's photographs of vegetation, Sander's portraits in his book *Antlitz*

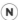
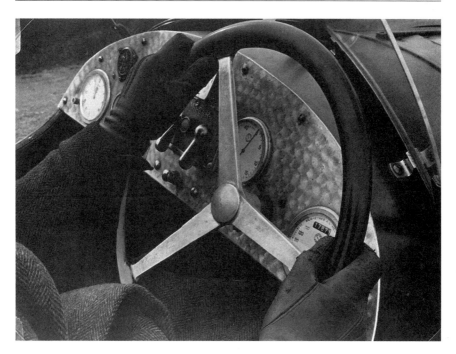

ALBERT RENGER-PATZSCH (1897–1966).
Untitled, n.d. Gelatin silver print, 6⅝ x 9 in. (16.8 x 22.7 cm), image;
6¾ x 9⅛ in. (17.2 x 23.1 cm), sheet. The Minneapolis Institute of Arts;
John R. Van Derlip Fund.

der Zeit [Faces of our time], 1928), they recorded an iconography of urban modernity and isolated objects. Their photographs, which have much in common with paintings by Neue Sachlichkeit painters such as Leo Breuer and Carl Grossberg, deliberately blur the line between the documentary and the aesthetic. Their work was to influence American photographers like Charles Sheeler, Ralph Steiner, Karl Struss, and, in certain respects, Edward Weston, who imitated their use of the close-up. In the 1930s even Japanese photographers like Yasuzo Nojima fell under the spell of this precisionist vision.

NEW BAUHAUS—*see* BAUHAUS

NEW COLOR PHOTOGRAPHY—*see* LUMINISM

NEW OBJECTIVITY—*see* NEUE SACHLICHKEIT

NEW PHOTOGRAPHY—*see* NEUE SACHLICHKEIT

NEW TOPOGRAPHICS

▷ **WHO** Robert ADAMS, Lewis BALTZ, Bernd and Hilla BECHER, Joe Deal, Frank GOHLKE, Nicholas Nixon, John Schott, Stephen Shore, Henry Vessel Jr.

▷ **WHEN** 1970s and early 1980s

▷ **WHERE** Primarily the United States

▷ **WHAT** In 1975 George Eastman organized an exhibition at his museum in Rochester, New York, showcasing several landscape photographers—notably, Robert Adams, Lewis Baltz, Bernd and Hilla Becher, Frank Gohlke, and Stephen Shore. The exhibition's title, *New Topographics: Photographs of a Man-Altered Landscape,* was meant to suggest that their work differed from that of earlier landscapists in taking a quasi-scientific, almost cartographic approach, which was also informed by social and ecological concerns.

Building on the great nineteenth-century tradition of photographic expeditions into the American West (as in Robert Adams's book *The New West,* 1974), these new photographers set out to record the often harmful impact of civilization on the natural world: brutal urbanization (as in Lewis Baltz's book *Park City,* 1981), topographical modification, and so on. They advocated a

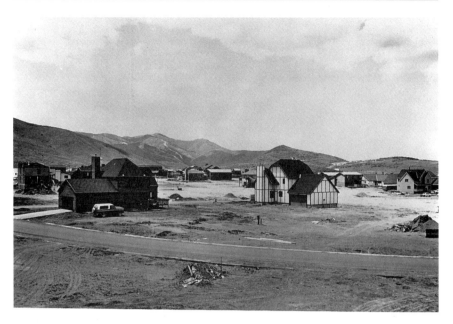

LEWIS BALTZ (b. 1945).
Prospector Park, Subdivision Phase 3, Lot 55, Looking West, from the book *Park City,* 1980. Gelatin silver print, 8 x 10 in. (20.3 x 25.4 cm). Janet Borden, Inc., New York.

clinical objectivity purged of sentimentality, as exemplified by Walker Evans's famous *Corrugated Tin Façade, Moundville* (1936). Steering clear of the monumental and lyrical approach to landscape exploited by Ansel Adams, they produced work that nonetheless had its own ideological agenda. Influenced by Charles Sheeler and the Precisionist painters (such as Charles Demuth) as well as by Conceptual art of the 1960s, they favored nondescript points of view and often worked in SERIES. Abandoning the often picturesque approach favored by such predecessors as Ansel Adams, they deliberately chose banal subjects.

The New Topographic photographers had considerable influence on their European colleagues, notably in the style favored by participants in France's DATAR (Délégation à l'Amenagement du Territoire et à l'Action Régionale) project (1982), which commissioned photographers to produce a record of the contemporary French landscape.

NEW VISION

▷ **WHO** Herbert Bayer, Ilse Bing, Paul Citroen, Erich Consemüller, Horacio Coppola, Pierre Dubreuil, Andreas Feininger, T. Lux Feininger, Werner Graef, John Gutmann, Toni von Haken-Schrammen, Florence Henri, Hannah Höch, Lotte Jacobi, André Kertész, Germaine Krull, El LISSITZKY, Eli Lotar, Lucia Moholy, László Moholy-Nagy, Yasuzo Nojima, Roger Parry, Walter Peterhans, Man RAY, Alexander Rodchenko, Franz ROH, Ellen Rosenberg (later Auerbach), Christian Schad, Hannes Schmidt, Vilho Setälä, Grete Stern, Josef Sudek, Maurice Tabard, Elsa Thiemann, Jan Tschichold, Umbo

▷ **WHEN** 1920s to 1940s

▷ **WHERE** First the Soviet Union and Germany, then Europe and the United States, and eventually worldwide

▷ **WHAT** During the 1920s, photography in Europe (especially the Soviet Union and Germany) was touched by the same transformation and efferves-cence that affected all forms of art as a result of such avant-garde move-ments as Dadaism, SURREALISM, Constructivism, and so on. Photography during this period was marked by experimentation with various new forms, including ABSTRACTION, COLLAGE, PHOTOGRAMS, PHOTOMONTAGE, and unusual points of view.

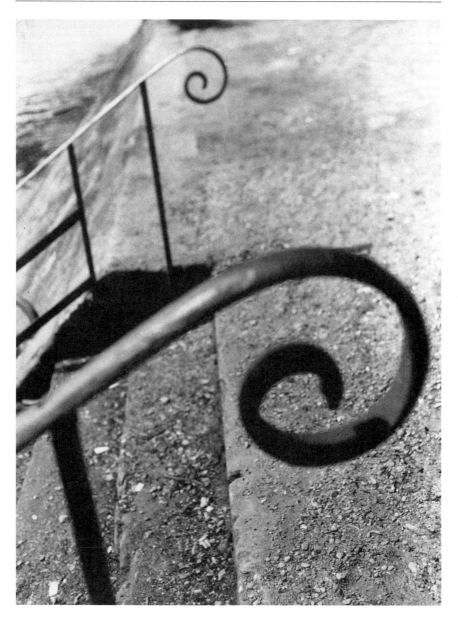

FLORENCE HENRI (1893–1982).
Abstract Composition (Handrail), c. 1930. Gelatin silver print,
15 x 11³/₈ in. (38.2 x 28.8 cm). J. Paul Getty Museum, Los Angeles.

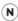

Such changes were not politically innocent: photographers, like artists, wanted to put their art at the service of a new society. Participants at the BAUHAUS in Germany and the Constructivists in the Soviet Union all sought to make art that would be more than just a decorative and subjective form appreciated only by those in the know. In their efforts to create a new visual language accessible to everyone, they incorporated the latest scientific research and technical discoveries, calling on the new spirit of rationality prevailing in Europe.

In photography this movement, which was both experimental and didactic, is known as the New Vision. It developed largely in prewar Europe (with less success in the United States), creating an international style with its own characteristic features—plunging views, dizzying upward perspectives, close-ups, and emphasis on photographic materials. It is complementary to NEUE SACHLICHKEIT, which took a new approach to photographic realism. The New Vision had its theoreticians—for example, Franz Roh, who, on the occasion of the 1929 FILM UND FOTO exhibition (which presented a vast overview of these new possibilities of photographic vision), published the book *Foto-Auge/Oeil et photo/Photo-Eye*. In his introduction, "Mechanism and Expression," Roh discussed the new possibilities opened by photography, from photograms to unusual perspectives—"the audacious sight from above and below, which new technical achievement has brought about by sudden change of level—lift, aeroplane, etc."

In the Soviet Union, El Lissitzky, like many artists of his generation, had been trained in other fields (in his case, architecture, typography, graphic arts, and engineering, which he also taught). From the beginning of the 1920s, Lissitzky was interested in photography, seeing in it a tool for exploring vision. Much the same could be said of the Soviet photographer Alexander Rodchenko, who stressed the technical aspect of the medium, declaring that how one photographed was more important than what one photographed. "Taking life by surprise" was how the critic and filmmaker Dziga Vertov characterized Rodchenko's experiments with multiple perspectives beginning in 1923. In an article for the magazine *Novy Lief* in 1928, Rodchenko said: "Given its possibilities, photography should concern itself with showing the world different points of view, it should teach how to look from every side." By this stage Rodchenko was no longer talking about "images" but about "realizations"—constructions that often served the ends of Soviet propaganda. The same militantly didactic intent to change vision by photography characterized the artists of the Bauhaus. László Moholy-Nagy approached photography

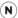

there experimentally, exploiting the potentials of light and chemistry in his inventive photograms.

NEW YORK SCHOOL

▷ **WHO** Diane Arbus, Richard Avedon, Alexey BRODOVITCH, Ted Croner, Bruce Davidson, Don Donaghy, Louis FAURER, Robert FRANK, Sid GROSSMAN, William Klein, Saul Leiter, Leon LEVINSTEIN, Helen Levitt, Lisette MODEL, David Vestal, Weegee

▷ **WHEN** Late 1930s to early 1960s

▷ **WHERE** New York City

▷ **WHAT** Starting in the late 1930s, a group of photographers, all living and working independently in New York, often freelancing for fashion magazines *(Harper's Bazaar, Vogue,* and *Flair)* or news magazines *(Fortune, PM),* shared certain aesthetic and stylistic influences and a taste for violating the contemporary conventions of PHOTOJOURNALISM—particularly the photojournalist's use of anecdotal description and avoidance of subjectivity. Known collectively as the New York School (which was never a formal group and was distinct from the postwar Abstract Expressionist painters sometimes also identified by that name), they worked with small cameras in natural light, producing grainy, out-of-focus but strongly expressive images—sometimes made by swinging their cameras or by shooting at random without aiming—that broke with prevailing strictures regarding FRAMING and composition. Their subjects came from the visual chaos of contemporary urban life—its dramas (murders and fires, as in Weegee's unflinching shots) and its distractions (the beaches of Coney Island, children at play).

Advocating a HUMANIST, subjective approach, the New York School photographers absorbed ideas from French existentialist philosophers such as Jean-Paul Sartre and Albert Camus and from the Beat Generation (in the case of Robert Frank). Also influenced by Abstract Expressionist painting, jazz, and the movies, they enlarged upon the heritage of Lewis Hine, Walker Evans, and Henri Cartier-Bresson, opening the way to a subjective DOCUMENTARY mode stripped of grandiloquence. Their unblinking readiness to record urban realities led directly to the new STREET PHOTOGRAPHY instigated by Lee Friedlander and, above all, Garry Winogrand at the end of the 1950s.

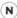

LISETTE MODEL (1906–1983).
Sammy's, New York, between 1940 and 1944. Gelatin silver print,
13⅞ x 10½ in. (34.8 x 26.9 cm). National Gallery of Canada, Ottawa;
Collection of the Estate of Lisette Model.

NUEVA LENTE

▷ **WHO** Juan Pedro Clemente, Manuel ESCLUSA, Manuel Falces, Joan FONTCUBERTA, Pere Formiguera, Ferran Freixa, Antonio Galvez, Cristina García Rodero, José Gomez Redondo, Rafael Navarro, José Miguel Oriola, Ouka Lele, Montserrat de Pablo, Luis PÉREZ-MINGUEZ, Pablo PÉREZ-MINGUEZ, Carlos PÉREZ SIQUIER, Bernard Plossu, Josep Rigol, Jorge Rueda, Carlos Serrano, Ramón Zabalza

▷ **WHEN** 1971 to 1983

▷ **WHERE** Spain

▷ **WHAT** In the 1960s Spain's cultural horizons were blocked by the oppressive Franco regime, but the country was nevertheless touched by the rebellious energy then spreading across Europe and the United States, which culminated in the American antiwar movement and the May '68 "revolution" in France. In 1971 the artist-photographers Pablo Pérez-Minguez and Carlos Serrano founded the journal *Nueva Lente* (New lens) to serve as a visual laboratory as well as a base of operations for an anarchism-tinged counterculture. It published not only photography but also comic strips—indeed, anything art-related that would challenge Franco's repression. In its fourth issue (October 1971) the journal proclaimed its intention to break with traditional photographic forms that stifled the imagination. Promoting photography primarily for its potential as an easily reproduced mass medium, it called for a revival of PHOTOMONTAGE and MANIPULATION and encouraged the combination of photography with other forms of communication, such as painting, drawing, writing, and so on. The generation of new photographers that developed around *Nueva Lente* also adopted elements from Dadaism and SURREALISM and mined the vein of grotesque fantasy that has been central to Spanish art since Francisco de Goya. In a sense, the *Nueva Lente* program anticipated the "anything goes" approach of POSTMODERNISM.

Nueva Lente proved to be a catalyst in the encouragement and expansion of photography in Spain during the 1970s, exemplified by the opening of the first Spanish galleries devoted to the medium (Spectrum in Barcelona, El Photocentro in Madrid). In 1978 Jorge Rueda became editor of the journal (though the editorship reverted to the magazine's two founders the next year), placing a new emphasis on accessibility and social content while honoring the publication's commitment to diversity. He allied himself with the Catalan photographer and theorist Joan Fontcuberta, who became one of the leaders of the new Spanish photography, along with Manuel Falces, Pere

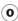

Formiguera, and Josep Rigol. By 1983 the magazine had lost its radical spirit, becoming simply a professional journal. However, the experimental mode established by *Nueva Lente* has been continued by many contemporary Spanish photographers, including Rafael Navarro, Ouka Lele, Manuel Esclusa, and Carlos Villasante.

OBJECTS AND PHOTOGRAPHY

Because at first photography was technically capable of recording only motionless subjects and because of the popularity of painted still lifes, the photographing of objects began as soon as the medium was invented. William Henry Fox Talbot made PHOTOGENIC DRAWINGS of plants in 1839; Louis-Jacques-Mandé Daguerre recorded fossils and shells that same year.

The status of object photographs has evolved in tandem with the object's increasing importance to other arts (especially painting) and to industrial consumer society from the mid–nineteenth century to the present. Early photographs of objects, taken in the context of nineteenth-century positivism, helped satisfy curiosity in the fields of archaeology, anthropology, and medical science. The documentation of objects continues unabated today, particularly in mail-order catalogs and other ADVERTISING.

Photographing objects in the style of painted still lifes resulted in a wide variety of PICTORIALIST compositions, from Baron Adolph de Meyer's *Waterlilies* of 1906 to the neo-Pictorialist still lifes by contemporary photographers including Toni Catany and Jan Groover. The industrial object—and even plant life—was favored by MODERNIST photographers such as Charles Sheeler and Albert Renger-Patzsch. The formal autonomy of decontextualized objects became a central preoccupation of Edward Weston, who also used his close-ups of shells, peppers, and other objects as sexual METAPHORS.

For NEUE SACHLICHKEIT photographers, objects served neither as documents nor as symbols but as an opportunity to study the visual effects of light as recorded through the camera lens. They enlarged, distorted, and combined objects by means of COLLAGE and PHOTOMONTAGE, emptying them of all functional associations, as did the SURREALISTS, though for different reasons. Many Surrealist photographers focused new attention on objects, emphasizing their strangeness either by transforming them through light (as in Man Ray's RAYOGRAMS) or by isolating them from their contexts and exaggerating their scale (as in Jacques-André Boiffard's Big Toe series of 1929). Brassaï created bizarre forms with his crumpled papers, which he photographed to look like monumental sculptures.

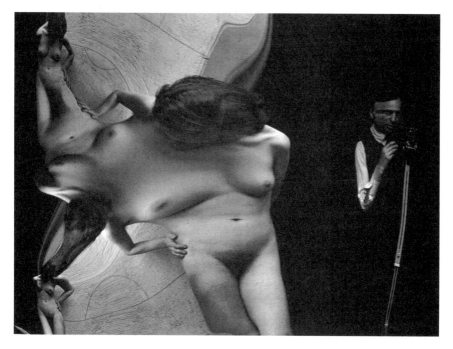

ANDRÉ KERTÉSZ (1894–1985).
Self-Portrait with Distortion 91, Paris, 1933 (printed later).
Gelatin silver print, 7¼ x 9⅝ in. (18.4 x 24.4 cm), image, 8 x 10 in.
(20.3 x 25.4 cm), paper. Estate of André Kertész.

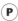

POP ARTISTS like Andy Warhol photographed popular commodities (Campbell's soup cans, Brillo packages, and so on) to underscore their ambiguous status as potential "readymades." In Warhol's work, multiple industrial objects are themselves multiplied through reproductive processes such as silk-screening, thereby acquiring status both as works of art and as icons of contemporary society. Recently, many photographers—including Hanna Collins, Pascal Kern, and Patrick Tosani—have returned to photographing objects, concentrating on effects related to surface, texture, depth, and scale, and producing work that is almost sculptural.

OPTICAL DISTORTION

In photography, we speak of "distortion" when an image recorded by a camera's LENS does not accurately represent the real object. Such discrepancies usually result from a flaw in the lens or from effects caused intentionally by modifying the focal length (compression of depth by telephoto lenses, wide-angle distortions produced by fish-eye lenses). Distortion is generally regarded as foreign to the medium's objective character, but it can be put to good effect, as in certain works by André Kertész (such as his Distortions series, made in 1933 with the aid of a funhouse mirror) and Bill Brandt (his nudes shot in the 1950s with a fish-eye lens).

OVERPRINTING—*see* DOUBLE EXPOSURE

PALLADIUM PRINT—*see* PLATINUM PRINT

PANORAMIC PHOTOGRAPHY

Panoramic views present an angle of vision wider than that encompassed by the human eye, extending from 100 degrees to as much as 360 degrees. They can be produced either by juxtaposing several contiguous images of the same vista taken in sequence with a conventional camera or by using wide-format film in a special panoramic camera, some versions of which pivot during one continuous exposure.

The first panoramic photographs appeared as early as 1845, when Friederich von Martens (a German printer settled in Paris) solved daunting technical problems to make a DAGUERREOTYPE panorama of Paris. The genre continued to evolve throughout the nineteenth century, proving suitable for recording

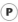

both urban development and landscapes, such as Eadweard Muybridge's 1878 panoramas of San Francisco and the Bisson brothers' views of the Alps. The format has occasionally been put to more intimate use in the twentieth century, as in the panoramic still lifes by the Czech photographer Josef Sudek. Closely associated with the epic experience of "Cinemascope" movies in the 1950s and '60s, panoramas have recently become popular with amateurs, due to the availability of disposable panoramic cameras.

PHOTO AGENCIES

Photo agencies have two principal functions. First, they oversee the sale and exhibition of work by the photographers they represent and manage their archives. Second, they serve as a source of pictures for use by the media. This double role can give an agency considerable influence over the photographers affiliated with it, and it may urge them to photograph certain types of subjects with an eye toward their potential salability.

The establishment of photo agencies is intertwined with the development of the picture press after World War I. In 1920 the Keystone agency was founded in Paris, focusing on both current events and fashion; André Kertész was among its photographers. In Berlin, the agencies Weltrundschau (early 1920s) and especially Dephot (Deutscher Photodienst; 1928–34) soon began to specialize in photographic stories that they sold to newspapers and magazines; their efforts helped establish reportage as a narrative told in a self-contained series of photographs. Functioning midway between capitalist and cooperative enterprises, they brought together some of the most creative photographers of the period, including Walter Bosshard, Endre Friedmann (who later took the name Robert Capa), Kurt Hübschmann, Felix H. Man, and Umbo. Dephot developed a new approach to photographic reportage, concentrating not on the usual mix of political milestones, royal weddings, and so on, but rather on heartwarming or hair-raising moments from daily life, social events, and other subjects of general interest. This innovation helped give rise to the image of the fast-talking, hard-boiled modern reporter, as immortalized in films like *His Girl Friday* (1940). The rise of Nazism prompted the directors of many German magazines to move abroad, where they launched several new agencies, such as Black Star, established in New York in the late 1930s. Nippon-Kobo, the first Japanese photo agency, was created in 1933.

After 1945 several agencies became cooperatives through which photographers (who were being increasingly threatened by television's dissemination

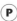

of images and the resulting demise of numerous newspapers and picture magazines) tried to strengthen their role as conveyors of information. In 1947 Robert Capa, George Rodger, Chim, and Henri Cartier-Bresson created the cooperative agency Magnum Photos, with offices in New York and Paris. In addition to its full-time members (including W. Eugene Smith, who had worked for Black Star before joining Magnum in 1957), it also represented several freelancers, including Richard Avedon and Gisèle Freund. Magnum gave its photographers total freedom to choose their own subjects.

Several new agencies—Gamma, Sygma, Sypa, Vu—appeared in France in the wake of the 1968 social upheaval, and all of them benefited from the example of the agency Viva (established in 1972), which focused on everyday subject matter. Contact Press Images, established in the United States by Robert Pledge in 1976, has tried to maintain the tradition of true PHOTO-JOURNALISM, which has been seriously threatened by the ever-increasing dominance of television news.

PHOTO-ESSAY

The photo-essay is a specific type of European and American PHOTOJOURNAL-ISM, characterized by a close association between a text and a group of photographs, often in a narrative sequence, concentrated on a given subject. A photo-essay—in which the factual exposition provided by images is complemented by the commentary and analysis supplied in the text—can be as complex and multilayered as a sophisticated literary essay. Photo-essays are quite different from "picture stories," in which photographs are organized into simple narratives and accompanied by brief descriptive captions. Picture stories, which predate the photo-essay, first appeared in the press in the 1880s, with the birth of photomechanical reproduction.

The photo-essay, which originated in news magazines such as *Life, Fortune,* and *Look* during the interwar years, is deliberately open ended, focusing on an individual, a place, or a situation in ways that invite variant readings, both ideological and aesthetic, although most of its practitioners have adopted a resolutely HUMANIST perspective. Photo-essays are usually the result of a collaboration between a photographer, a writer, and a publication's editorial board, but a few photographers have managed to assume all three roles successfully, making them the true authors of the results. Walker Evans and Margaret Bourke-White created notable photo-essays, but the genre reached its apogee in W. Eugene Smith's work for *Life,* such as "Country Doctor" (1948); "Spanish Village" (1951); and "A Man of Mercy" (1954).

PHOTOGENIC DRAWING

This process, invented by William Henry Fox Talbot in 1834, produces photographs without the use of a camera. Talbot first immersed a sheet of writing paper in a saline solution and then brushed it with a silver nitrate solution, which sensitized it to light. Next he placed an object such as a leaf or flower on top of the paper and exposed the ensemble to daylight. The areas struck by light darkened, while those protected by the objects remained light, producing silhouettes. Once the image was formed, it was necessary to fix it in order to prevent it from darkening completely as a result of ongoing exposure to light. This was accomplished by immersing the paper once more in a saline solution, which dissolved the residual silver salts and kept them from turning black. It was the scientist John Herschel, a friend of Talbot's, who first had the idea of fixing images with sodium hyposulfite, which is more efficient than a table-salt solution.

PHOTOGRAM

Photograms are images obtained without the intervention of a camera or other photographic apparatus, simply by placing objects on a SENSITIZED SURFACE, exposing it to light, and then developing and fixing it. The photogram technique predates the invention of photography itself. In 1802 Thomas Wedgwood and Humphrey Davy published *An Account of a Method of Copying Paintings upon Glass and of Making Profiles by the Agency of Light*, which explained how to make photograms. The PHOTOGENIC DRAWINGS made by William Henry Fox Talbot starting in 1834 can be considered the first real photograms; soon after his experiments, making photograms of various objects became a popular pastime for ladies in Victorian and American society. Beginning in 1843, Anna Atkins used the related cyanotype process to make comprehensive records of British algae and ferns; Bertha Evelyn Jaques made over a thousand botanical cyanotypes in turn-of-the-century America.

In the early years of the twentieth century this cameraless technique was taken up by members of the European avant-garde. The Dadaist Christian Schad produced "Schadographs" beginning in the late 1910s and again in the 1960s, and the Surrealist Man Ray made "Rayograms" that record ghostly images of everything from nails to parts of the human body. These were sometimes rephotographed to reverse the values, as in *Les Champs délicieux* (Delicious fields), an album of Rayograms published in 1922. It was the Hungarian László Moholy-Nagy who, in collaboration with students at the BAUHAUS, undertook the most radical exploration of this technique's

PHOTOGRAM

ARTHUR SIEGEL (1913–1978).
Photogram, 1948. Gelatin silver print, 19³/₈ x 15⁵/₈ in. (49.2 x 39.6 cm).
Museum of Fine Arts, Boston; Sophie M. Friedman Fund.

potential, using it to study the relations of color, light, and form. He regarded photograms as "the most perfect way of representing luminous flux." Some of the results, such as Moholy-Nagy's *Photogram No. 1: The Mirror* (1922–23), recall abstract paintings by the Russian artist Kasimir Malevich. This rapprochement with painting should be seen as an attempt to enrich human vision, which was Moholy-Nagy's intent in all of his photographic practice. In the 1920s and 1930s many other artists also made use of photograms, including Francis Bruguière, Raoul Hausmann, and Maurice Tabard.

The revival of experimental photography during the 1950s (especially in Europe, with SUBJEKTIVE FOTOGRAFIE, but also in the United States, in the work of photographers like Arthur Siegel) favored a renewal of the practice. In 1983, in Kassel, Germany, Floris M. Neusüss (himself the creator of many photograms) organized the first exhibition devoted to the process.

PHOTOGRAPHIC ACT

The expression "photographic act" seems to have been introduced by the French sociologist Pierre Bourdieu in his book *Un Art moyen* (1965; English translation, *Photography: A Middle-Brow Art,* 1990), in which it is used to designate the basic act of taking a photograph. In the 1980s French theorists made a concerted effort to define the nature of the photographic act, concentrating on its difference from other creative acts (painting and writing, for example) and stressing the unusually interdependent relationship it establishes among the operator, the photographic image, and the physical world.

According to these theorists, a photograph is not just an image but an "image-act" encompassing not only its production but also its reception and contemplation. In the words of the photographer-writer Denis Roche, "What one photographs is the act of taking a photo." Discussed in the pages of *Les Cahiers de la photographie* by scholars like Philippe Dubois and philosophers like Henri Van Lier, this concept encouraged many French photographers (including Sophie Calle, Raymond Depardon, Bernard Plossu, and Roche) to practice "photobiography." They set out to recast photographic autobiography in light of the peculiar SEMIOTIC status of the *dispositif photographique* (photographic apparatus and configuration), paying special attention to it as an imprint of the real, to its disruption of spatial and temporal continuities, and to the automatic nature of the process, which meant that the operator was supplanted by the machine at the moment of shooting. These theories

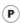

must be understood in the context of French intellectual thought of the 1970s, in which ongoing linguistic and SEMIOLOGICAL reflection by Roland Barthes, Emile Benveniste, Umberto Eco, and others prompted a redefinition of photography as a medium unlike other forms of aesthetic expression.

PHOTOGRAPHIC PAPER

The term *photographic paper* usually designates papers—or today, sheets of plastic—that have been coated with a light-sensitive EMULSION to serve as the support for images developed from black-and-white or color negatives. Images can be produced on "printing-out" paper by direct exposure to light through a negative, without the use of any chemicals. Gelatin–silver chloride papers (also known as "aristotypes" and sometimes called "gaslight papers" because they were developed by gaslight) were the first coated papers marketed at the end of the nineteenth century; they were less sensitive to light but produced brown contact images that were very detailed. They have not been used since the beginning of the twentieth century.

LATENT IMAGES are developed through the action of chemicals on "developing-out paper," first available in 1873. Their composition consists of several coats of silver bromochloride (silver-bromochloride paper) or of silver bromide (silver-bromide paper). Color papers comprise three layers that are sensitive to blue, green, or red, respectively. In the 1970s supports known as RC (resin-, or plastic-, coated) paper became available; these are easy to process and dry. Many gradations are available, from soft grade (better suited to overexposed negatives) to hard grade (useful for thin negatives lacking detail).

PHOTOGRAPHY INDUSTRY

The international photography industry has stagnated since about 1990, largely as a result of overcompetition but also due to the development of DIGITAL IMAGING and easy-to-use amateur video technology such as camcorders. These factors have precipitated an ongoing crisis in the sales of film, the sales of conventional cameras, and the market for film developing. But even with growth in these areas at a standstill, in 1995 their combined annual international sales, including both the professional and the amateur sectors, amounted to approximately $490 billion. More than 54 million cameras were sold worldwide, and 2.4 billion rolls of film. Labwork of various kinds brought in $23 billion. Kodak dominates the film market, commanding

42 percent of world sales. At present, more than 6 percent of its income is earmarked for research and development—now most notably in digital imaging. The number-two spot is held by Fuji of Japan, which controls 33 percent of the international market.

PHOTOJOURNALISM

▷ **WHO** Max Alpert, Werner Bischof, Edouard Boubat, Margaret BOURKE-WHITE, Mathew BRADY, Bill Brandt, René Burri, Romano Cagnoni, Cornell Capa, Robert CAPA, Gilles Caron, Henri CARTIER-BRESSON, Agustín-Victor Casasola, CHIM, Raymond Depardon, Robert Doisneau, David Douglas Duncan, Alfred EISENSTAEDT, Martine Franck, Philip Jones Griffiths, Ernst Haas, André Kertész, Chris Killip, Ihei KIMURA, Josef Koudelka, Guy Le Querrec, Don McCULLIN, Hans Malmberg, Felix H. Man, Constantin Manos, Mary Ellen MARK, Susan Meiselas, Lee Miller, Martin Munkacsi, Lennart Nilsson, Martin PARR, Gilles PERESS, Tony Ray-Jones, Marc Riboud, George Rodger, Alexander Rodchenko, Sebastião SALGADO, Erich SALOMON, W. Eugene SMITH, Umbo, WEEGEE

▷ **WHEN** 1850s to the present

▷ **WHERE** International

▷ **WHAT** *Photojournalism* designates photographic activity linked to news coverage, especially in print. The emergence of popular newspapers in the late 1830s coincided with the invention of photography, and photographs were soon being used for informational purposes. Initially they served only as the basis for gravures and lithographs, but beginning in the 1880s, when the photogravure process was fully developed, they could be printed directly. In 1880 the *New York Daily Graphic* became the first newspaper to publish a photograph on its front page.

Modern photojournalism became possible thanks to the development of the small-format camera—most notably, the Leica 35 mm, invented in 1914 and made commercially available in 1925. Its mobility and inconspicuousness made it possible for photographers to snap images from daily life that were more realistic and less static. With a market provided by European magazines and newspapers like *Berliner Illustrierte* (Germany) and *Vu* (France), a new kind of photographic storytelling began to emerge that encompassed a broad range of subjects. Work by artists affiliated with the NEW VISION—for example, Alexander Rodchenko's PHOTOMONTAGES for the magazine *LEF*—

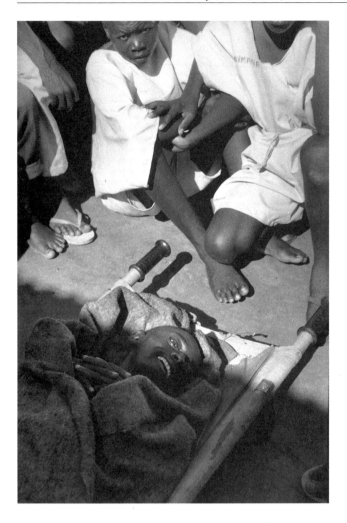

RAYMOND DEPARDON (b. 1942).
Rwanda, 1994. Gelatin silver print, dimensions variable.
Magnum Photos, New York.

had a considerable influence on photojournalism of the 1920s and 1930s. In the United States, illustrated newsmagazines like *Fortune* (established 1930) and *Life* (established 1936) fostered the development of the PHOTO-ESSAY.

Erich Salomon and Alfred Eisenstaedt were the first real "photo reporters," a type that was to be romanticized as a new kind of hero (or heroine) for modern times. Later examples include Henri Cartier-Bresson, Felix H. Man, and Susan Meiselas, whose experiences in Nicaragua inspired the Mel Gibson role in the film *The Year of Living Dangerously.*

Television, which progressively became the dominant source of news for most people, eventually supplanted most of the weekly news publications. With the assassination of President John F. Kennedy on November 22, 1963, television established its superiority over all other news sources: close to 170 million viewers spent three days watching the sequence of events, from the motorcade to the funeral. Throughout the 1960s it was television that most vividly conveyed the great moments of American history, reporting the civil rights struggle, the Vietnam War, and so on. Such powerful competition prompted newspapers and magazines to compete with television's scoops by publishing especially spectacular photographs—for example, Eddie Adams's *General Loan Executing a Vietcong Suspect,* which the *New York Times* put on its front page on February 1, 1968.

As television took over, photojournalists had to find new approaches. Some adopted a more subjective and aestheticized style, exemplified by the work of Bill Brandt, Josef Koudelka, and Sebastião Salgado. Others produced images that satirize contemporary middle-class mores, as in the new British school of reporting associated with Martin Parr. Photojournalism is now going through an identity crisis—is it documentary or self-expressive?— partly because of growing doubts about the very notion of photographic objectivity but also because of the scarcity of significant commissions. A few institutions remain committed to the survival and preservation of photojournalism, notably the International Center of Photography in New York and the annual festival of photojournalism held in Perpignan, France.

PHOTO LEAGUE

▷ **WHO** Jack Delano, Morris Engel, Sid GROSSMAN, Lewis HINE, Consuelo Kanaga, Sol Libsohn, Jerome Liebling, Lisette Model, Ruth Orkin, Walter Rosenblum, Aaron Siskind, W. Eugene Smith, Ralph STEINER, Louis Stettner, Paul Strand

▷ **WHEN** 1936 to 1951

▷ **WHERE** United States

▷ **WHAT** The Photo League had its origins in a collective of filmmakers and photographers known as the Worker's Film and Photo League, which was established in New York in 1928. Its members, which included Paul Strand and Berenice Abbott, were inspired by Germany's Communist worker-photographers of the 1920s. In 1936, under the direction of Sid Grossman and Sol Libsohn, the group jettisoned its film wing to become simply the Photo League, an organization committed to socially conscious photography in the tradition of Lewis Hine. Hine himself was a member in its early years, and he left his archives to the organization.

The photographers (both amateur and professional) of the Photo League displayed a rare degree of social engagement in their work, which was particularly evident in the group's bulletin, *Photo-Notes.* They were especially attentive to urban problems caused by the Depression. Beginning in 1935, Aaron Siskind used the league as a base of operations for his Feature Group, which produced remarkable photographs of Harlem. Accusations that the group was a subversive Communist organization, made during the McCarthy era, led to the group's dissolution in 1951.

The Photo League provided an alternative, more trenchant model of socially engaged photography during an era when PHOTOJOURNALISM was dominated by mainstream magazines like *Life.* It also served an important educational function, offering courses in photographic technique and history in its school (directed by Sid Grossman between 1941 and 1947) as well as organizing many exhibitions and conferences.

PHOTOMACROGRAPHY/PHOTOMICROGRAPHY

Photomacrography is the photographing of objects of small dimensions at life size or larger, requiring an opening of the camera's aperture equal or superior to 1. Such work requires either a special lens known as a "macro lens" and extension rings between the lens and the camera or the addition of an extra lens. An excellent example is a photograph by Willy Zielke entitled *Agfa Variation 1* (c. 1930), which depicts the cap of a container of a roll of Agfa film.

Photomicrography is the photography of objects of very small dimensions, often invisible to the naked eye, by using a microscope to which a camera is affixed. This technique is most often used in SCIENTIFIC PHOTOGRAPHY.

PHOTOMONTAGE

The term *montage*—from the French verb *monter,* "to put together"—is used to describe a broad range of creative practices that flourished early in the twentieth century, encompassing not only photography but also the work of writers (Alfred Döblin, John Dos Passos), filmmakers (Sergei Eisenstein), Dada and SURREALIST artists (Max Ernst, George Grosz), and so on. In photography, a montage is made by cutting up and then reassembling photographic negatives or prints from various sources (either scavenged or newly made), which are "recycled" in ways at odds with their original function; the final result is developed or rephotographed to yield a seamless print, which can then be photomechanically reproduced. Text and color are sometimes added to these compositions, stretching the limits of accepted definitions of what a photograph can be.

Photomontage should be distinguished both from COLLAGE (in which photographs are combined with nonphotographic materials on a canvas, wood, or paper support) and from the Surrealist *Fotoplastiks* by Herbert Bayer (for which he would photograph a composition of sculptural elements, develop and retouch the prints, and then rephotograph them). The idea of photomontage dates back to the nineteenth century, when Henry Peach Robinson and Oscar Gustav Rejlander combined multiple exposures to produce complex narrative images. In the first decade of the twentieth century, postcards were published in the United States and Europe that featured amusing hybrid images, such as photomontages of fur-covered trout.

Photomontage as an art form was nurtured by the European avant-garde, most notably in Germany and the Soviet Union. It was the Berlin Dadaists (Raoul Hausmann, John Heartfield, Hannah Höch), followed by those based in Cologne (Max Ernst), who first took up the technique after World War I and gave it its name. They were attracted by its adaptability for social and political critique, especially because it could be reproduced in large quantities—as posters, in magazines or newspapers—which set it apart from the unique collages being made by the Cubists and by Kurt Schwitters. Heartfield, who was not himself a photographer, used this medium to produce vitriolic images denouncing Nazism. In the Soviet Union during the 1920s, artists including Gustav Klucis, the October group, Alexander

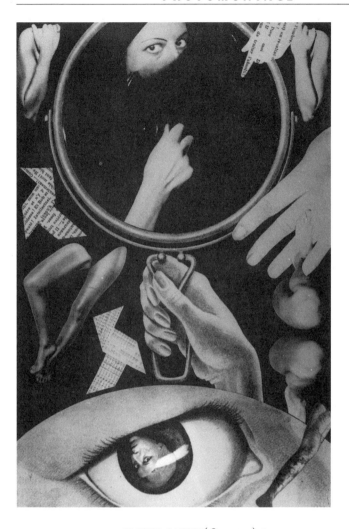

CLAUDE CAHUN (1894–1954).
Plate 3, from the book *Cancelled Confessions,* 1929–30. Photomontage,
6 x 4⁷/₈ in. (15.4 x 10.4 cm). Zabriskie Gallery, New York.

Rodchenko, the Stenberg brothers, and El Lissitzky put photomontage to work as propaganda in support of the new Soviet state. Toward the end of the 1920s, photomontage took root in the BAUHAUS as a constructed, often geometric visual language, as seen in work by Bayer, Lissitzky, and László Moholy-Nagy, as well as Paul Citroen's *Metropolis* (1925). Photomontage was often mixed with new typefaces to produce posters and images in the illustrated press that were evocative of the modern world, particularly under the influence of the Neu Werbegestalter group (New advertising designers), or NWG, which engaged Bauhaus artists like Bayer, Moholy-Nagy, and Joost Schmidt. In the same period, artists of the Czech avant-garde, such as Jaroslave Rössler, Karel Teige, and Jindrch Štyrský (all members of the group Devětsil), used photomontage extensively in creating their "image-poems," which portrayed various aspects of the modern world. In 1931 an exhibition entitled *Fotomontage* was mounted in Berlin.

Photomontage also related to Purism, an art movement that flourished in Paris from 1918 to 1925, led by Le Corbusier and Amédée Ozenfant. Through their magazine *L'Esprit nouveau* (The new spirit), they advocated a mechanical approach to making images (see *The Constructor,* an emblematic photomontage by El Lissitzky that is also a self-portrait). It was in France that the poetic potential of photomontage was most fully realized, in surprising juxtapositions made by the Surrealists Max Ernst, Léo Malet, and Man Ray. The tradition of Surrealist montage was continued into the 1970s by the Americans Clarence John Laughlin and Jerry N. Uelsmann, masters of evocatively dreamlike superimposed images. Other American photographers had been surprisingly resistant to photomontage in the years between the wars, retaining an unswerving commitment to STRAIGHT PHOTOGRAPHY. The photomontage aesthetic prevailed only in contemporary advertising and among a few photographers, notably Barbara Morgan, who were trained at the Institute of Design in Chicago. Its popularity increased beginning in the 1970s, when Robert Heinecken and then Barbara Kruger used montage in a POSTMODERNIST spirit, as did some of the NUEVA LENTE photographers in Spain.

PHOTO-REALISM

▷ **WHO** Robert Bechtle, Gianni Bertini, Chuck CLOSE, Tibor Csernus, Richard Estes, Jean-Olivier Hucleux, Malcolm Morley, Gérard Schlosser

▷ **WHEN** Mid-1960s to mid-1970s

▷ **WHERE** Primarily the United States, but also Europe

▷ **WHAT** Photo-Realism translates the objective qualities and descriptive precision of photography into painting. It is, in a sense, the obverse of PICTORIALISM. Born in the 1960s alongside POP ART, with which it shared a chilly objectivity and obsession with consumer culture as well as a predilection for urban subject matter, this school of painting was so fixated on the photographic quality of its representations that the resulting illusion was all but perfect, in large part due to the skillful adoption of codes associated with photographic prints: perspectival distortion, spatial flattening, background blurring, selective focus, and so on.

Photo-Realist painters often worked from slides projected onto their canvases, and some, like Chuck Close, would occasionally exhibit the photographs along with their finished paintings.

PHOTO-SECESSION

▷ **WHO** John G. Bullock, Alvin Langdon Coburn, William B. Dyer, Dallett Fuguet, Gertrude KÄSEBIER, Joseph T. Keiley, Robert S. Redfield, Edward Steichen, Alfred STIEGLITZ, Edmund J. Stirling, John Francis Strauss, Eva Watson-Schütze, Clarence H. WHITE

▷ **WHEN** 1902 to 1917

▷ **WHERE** United States

▷ **WHAT** The Photo-Secession was a movement initiated by Alfred Stieglitz to signal a break with the tired, academic brand of PICTORIALISM that had become dominant in American photography. Providing a pivot between pictorialism and STRAIGHT PHOTOGRAPHY, it marked the beginning of photographic MODERNISM. The path blazed by Stieglitz was to be further explored by Alvin Langdon Coburn, Gertrude Käsebier, Edward Steichen, Clarence H. White, and a few other "secessionists" (a term borrowed from contemporary avant-garde art movements in Austria and Germany). Their work gave new prominence to aspects of modern life such as the city and the machine, while retaining the painterly visual devices of Pictorialism, with its intentional soft focus and its retouching used to underscore aesthetic effect. By making the forms of Pictorialism more aesthetically rigorous, the Photo-Secession created an innovative, even modernist, version of it.

In 1902 Stieglitz resigned from the New York Camera Club and from his post as editor of its journal, *Camera Notes* (1897–1903), then organized an exhibition called *The Photo-Secession* at the National Arts Club in New York. He

was determined to win professional status for Pictorialist photography, which had previously been dominated by amateurs, and to establish a new awareness of photography as an independent art form. He was convinced that the way to accomplish this was to strengthen the market for photography, in part by presenting exhibitions and in part by encouraging his colleagues to concentrate on specifically American themes, which he thought might be more salable. Stieglitz founded the review *Camera Work* (1902–17; first issue published in January 1903) and, in 1905, opened his Little Galleries of the Photo-Secession at 291 Fifth Avenue (known more familiarly as 291), where he began to exhibit work by European modern artists (Pablo Picasso, Henri Matisse, Auguste Rodin, and so on), in addition to photography. His efforts offered the first glimpse of a potential market for art photography.

The formal end of the Photo-Secessionist movement came in 1917, when 291 closed. From that point on, Stieglitz, who had come under the influence of Paul Strand, was a champion of STRAIGHT PHOTOGRAPHY.

PICTORIALISM

▷ **WHO** Anne W. BRIGMAN, Alvin Langdon Coburn, Robert DEMACHY, Peter Henry Emerson, Hugo ERFURTH, Frederick H. Evans, Johan Hagemayer, Theodor and Oscar Hofmeister, Gertrude KÄSEBIER, Heinrich KÜHN, Alfred Maskell, E. J. Constant PUYO, Alfred STIEGLITZ, EDWARD WESTON, Clarence H. WHITE

▷ **WHEN** 1886 to early 1920s

▷ **WHERE** Europe and the United States

▷ **WHAT** From the middle of the nineteenth century, members of the art world hotly debated whether photography was an art form comparable to painting. Early on, photographers in France and England tried to produce photographs that resembled academic paintings, often with unconvincing results, as in the soft-focus compositions by Julia Margaret Cameron.

In 1886 Peter Henry Emerson published a widely read article, "Photography: A Pictorial Art," defending the artistic legitimacy of photography by arguing its similarity to painting. That publication marked the birth of Pictorialism, which soon became virtually an international movement, with its own theorists (Heinrich Kühn, E. J. Constant Puyo, and others), exhibition venues (the Little Galleries of the Photo-Secession in New York), academies, and clubs

HEINRICH KÜHN (1866–1944).
Study of a Youth (Walter Kühn?), c. 1908. Gum bichromate and platinum print, 18⅝ x 14⅜ in. (47.7 x 36.5 cm). National Gallery of Canada, Ottawa.

(the Linked Ring in London, the Photo-Club in Paris). Pictorialism also developed a following in Japan, but not until much later, in the 1920s; Japanese Pictorialists produced landscapes that are consistent with the country's artistic traditions but also have an almost MODERNIST look, as in work by Shinzo Fukuhara.

MANIPULATION always played a central role in Pictorialism, for its adherents cited the diverse methods of manual intervention to justify their claim that photography could be as creative as painting. They scratched, drew on, and stripped things away from their original exposures, and they were especially partial to "artistic BLURRING" and tonal adjustment—effects that were particularly well served by the GUM BICHROMATE PROCESS (a specialty of Robert Demachy).

It is now clear that there was not one Pictorialism but many: not only NATURALISTIC and SYMBOLIST but also resolutely modernist, as in the PHOTO-SECESSION and California variants. All of them explored the full range of genres, from portraiture to landscape. The more conventionally pictorial varieties rapidly became formulaic but proved durable nonetheless, retaining their appeal with both amateurs and commercial photographers until well after World War I.

The Pictorialist movement had several positive effects. It advanced the debate over the aesthetic nature of photography, increased awareness of the qualities specific to the medium, and encouraged reflection on its relationship to the modern world. In addition, the Pictorialists' enthusiastic experimentation with photographic processes has made their work surprisingly relevant to current artists and photographers.

PINHOLE CAMERA

The simplest kind of CAMERA, the pinhole camera is a miniaturized CAMERA OBSCURA—a light-proof box, one side of which is pierced by a pinhole without a lens. Light rays enter through the hole and strike a SENSITIZED SURFACE on the opposite side of the box, producing an upside-down image. The limited amount of light necessitates extended exposure times, and the results are inevitably soft and relatively undetailed. Some contemporary artists—including Ruth Thorne-Thomsen and the Belgian photographer Felten Massinger—use this elementary setup to obtain prints with those rather charmingly primitive qualities.

PLATINUM PRINT

Invented by William Willis in 1873, the platinum printing process (called the Platinotype process in Great Britain) remained popular for a long time, due to its rich tonal range, its subtle grays, its crisp rendering of details, and its superior stability. In the platinum print process a sheet of paper coated with a solution of ferric oxalate and sodium chloroplatinate was covered with a negative and exposed for several minutes to bright light, usually the sun. It was then developed, rinsed, and fixed (see DEVELOPMENT). After the high price of platinum made its use prohibitively expensive in the 1920s, it was replaced with palladium in a process that produced very similar results.

The platinum process was used with particular skill by Peter Henry Emerson, a champion of NATURALISTIC photography; Frederick H. Evans, in his evocative photographs of English and European cathedrals; and Alfred Stieglitz. The switch from platinum prints to GELATIN SILVER prints in the 1920s—notably by Edward Weston, a champion of STRAIGHT PHOTOGRAPHY—also signaled an aesthetic shift; the glossy surfaces of silver bromide paper were better suited to supplying the crisp definition required by straight photography.

POLAROID

As early as the 1860s the COLLODION-plate Dubroni camera combined exposure and DEVELOPMENT into one continuous process. But it was not until 1947 that the quest for a truly instantaneous one-step process bore fruit with the American Edwin H. Land's invention of the Polaroid process.

Initially, the Polaroid camera produced monochromatic prints one minute after exposure by passing the exposed film between rollers that released the chemicals needed for development. The introduction of Polacolor film in 1962 made color instant photographs possible; ten years later Polaroid introduced its SX-70 system, which offered amateurs an inexpensive camera with integrated electronic flash, simplified focusing, automatic ejection of the developed print, and a ten-exposure roll of 8 x 8 cm film. Unfortunately, the resulting color prints have proved to be unstable. Other companies, notably Kodak, now offer instant cameras with a special adaptable back that permits the use of different film formats.

Polaroids were first widely used to produce instant identification photographs; they quickly prevailed over the Photomat (copyrighted 1928)— a booth equipped to turn out automatic, inexpensive portrait photos.

Polaroids soon also proved to be invaluable in medical and scientific contexts as well as in professional photography studios, where they are used as trial runs for final exposures. The creative potential of the Polaroid has been exploited by photographers from Walker Evans (whose candid SX-70 color portraits date from the end of his career) to André Kertész (From My Window is a series of Polaroids taken from his New York apartment in 1981). The speed and ease of making Polaroids has encouraged artists including David Hockney, Lucas Samaras, and Stefan de Jaeger to experiment with creating multi-Polaroid compositions from multiple points of view. Their portraits, self-portraits, and landscapes capture a sense of the fragmentary and constantly changing nature of vision.

POP ART AND PHOTOGRAPHY

▷ **WHO** Wallace Berman, Richard Hamilton, Robert HEINECKEN, Roy Lichtenstein, Robert RAUSCHENBERG, Ed RUSCHA, Andy Warhol

▷ **WHEN** Late 1950s through 1960s

▷ **WHERE** United States and Great Britain

▷ **WHAT** Pop art, born in the United States and Great Britain in the late 1950s, took as its raw material the visual icons of contemporary popular culture—advertisements and other forms of printed mass media—that had previously been ignored by traditional artists. Photography, both commercial and popular, played a key role in the movement. Walker Evans was unusual in having been fascinated by American vernacular artifacts; they figure prominently in many of his photographs from the interwar years, and he also collected street signs, billboards, and so on. As a result, Evans's work has been claimed as a precursor of Pop art.

Beginning in 1955, Robert Rauschenberg made what he called "combines" by mixing paintings, real photographs, and photographic reproductions with various objects and oddities, such as a stuffed goat wearing a tire. Seven years later he started silk-screening—a common method of mechanical reproduction—"found" photographic images from diverse sources onto large canvases. Richard Hamilton, in the mid-1950s, used photographs taken from the media (particularly advertisements) in COLLAGES that divert these images from their original function. In *My Marilyn* (1965), for example, Hamilton painted over illustrations of the actress Marilyn Monroe taken from movie magazines.

159

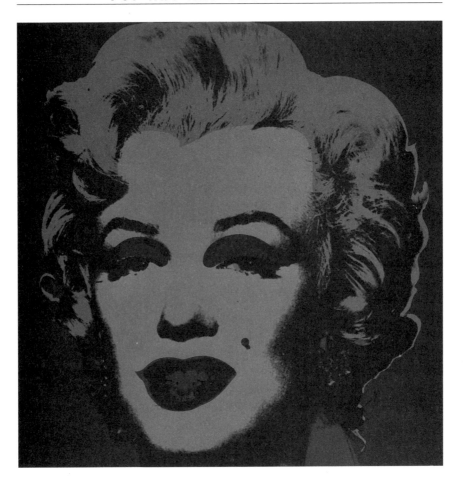

ANDY WARHOL (1928–1987).
Untitled, from the portfolio *Marilyn,* 1967. Serigraph, printed in color,
36 x 36 in. (91.5 x 91.5 cm). The Museum of Modern Art, New York;
Gift of Mr. David Whitney.

Roy Lichtenstein faithfully enlarged and transcribed the dots produced by modern print technologies in his paintings inspired by comic strips and advertisements. Andy Warhol used silk-screening to produce paintings based on mass-media images clipped from magazines. His Disaster Paintings series (1963) is based on grim black-and-white photographs of death and destruction—car crashes, plane crashes, electric chairs—published in tabloid newspapers. Ed Ruscha devised what he called an "antiphotographic" way of recording commonplace things and places, as in his deadpan series (published as an artist's book in 1963) called Twentysix Gasoline Stations.

It was the ubiquity of advertising, publicity, and other photographic images in the contemporary environment, as well as their mechanical character and easy reproducibility, that most intrigued Pop artists. None of them could be described as a fine-art photographer (though Rauschenberg is a master of photographic printing); their approach to photographs has been to recycle them in various ways, appropriating them to comment on the throwaway nature of consumer culture.

PORTRAITURE

Portraiture—a genre long associated with painting—figured prominently in photography from the very beginning. In the early nineteenth century, members of the middle class sought a technology that would make portraits widely and inexpensively available to them, and photography quickly satisfied that need. Soon after the invention of the DAGUERREOTYPE in 1839, the first portrait studios opened in the United States (Alexander Wolcott in New York, Southworth and Hawes in Boston) and in Scotland (David Octavius Hill). Amateur photographers soon began making portraits as well—notably Lewis Carroll's young girls and Julia Margaret Cameron's artist friends.

With the accelerated commercialization of portraiture, speeded by André-Adolphe-Eugène Disdéri's popular CARTES-DE-VISITE, certain famous studios came to dominate portraiture in the second half of the nineteenth century. Some—for example, Nadar and Etienne Carjat—produced psychologically penetrating portraits that were to prove influential. But, in general, the portrait studios produced predictable images imitative of academic painting, likenesses whose artificial qualities make the best, more natural portraits from the period seem that much more remarkable. The most frequent subjects were celebrities, but JUDICIAL PHOTOGRAPHY and medical photography (by Albert Londe, for example) also gained a foothold. In some cases, studies of anonymous human faces helped advance the pseudoscience of physiognomy, which posited that facial features betray aspects of individual character.

The photographic portrait was affected by aesthetic shifts. PICTORIALIST like-nesses by photographers such as Gertrude Käsebier, E. J. Constant Puyo, and Clarence H. White feature selective blurring and conventional setups, whereas MODERNIST examples are characterized by stark clarity, close-ups, and a formalist approach to light, as in works by Edward Weston. Between the two world wars Cecil Beaton, Yousuf Karsh, Baron Adolph de Meyer, Edward Steichen, the Harcourt Studio in Paris, the Japanese photographers Yasuzo Nojima and Shoji Ueda, and others situated portraiture halfway between the aesthetic and the commercial. Since World War II it has been photographers like Richard Avedon, Irving Penn, Helmut Newton, Jeanloup Sieff, and Annie Leibovitz who have kept portraiture original and vital.

By using a hidden camera to take candid images of unsuspecting passengers on New York subway trains (1938–41), Walker Evans rejected the psychologi-cal and aesthetic values of the studio photographic portrait. The results are a veritable deconstruction of the studio portrait tradition, a reflection of the optical unconscious discussed by Walter Benjamin in "A Short History of Photography" (1931). Benjamin maintained that photography revealed things that everyday vision tended to overlook: furtive gestures, fleeting postures, unselfconscious bodily and facial expressions. Evans's subway snapshots anticipate the work of many later artists. Their influence is detectable, for example, in Garry Winogrand's brutal images and Thomas Ruff's clinically neutral portraits. The ambiguity inherent in the portrait genre was explored to exemplary effect in various series (Le Bruit, L'Argent, La Chute [Noise, Money, Fall]) made by the French photographer Suzanne Lafont in 1990.

Early on, the documentary potential of photography led to the use of por-traits for social commentary, a trend reinforced by the rise of STRAIGHT PHO-TOGRAPHY. August Sander set out to produce a survey of the population types in Weimar Germany. Lewis Hine and Jacob Riis documented the plight of those worn down by poverty and the ruthless demands of American indus-try. In some cases—for example, Paul Strand's The Blind of 1916—the results yield genuine insight into the human condition. The way that faces reflect changing social forces has been a constant preoccupation of twentieth-century portraiture. Portraits of poverty-stricken victims of the Great Depression taken by FARM SECURITY ADMINISTRATION photographers during the 1930s are not unlike certain faces in Robert Frank's book The Americans (1958)—all seem to reveal their emotional or economic alienation. Diane Arbus and Larry Clark, in the 1970s, examined without flinching the faces of people on the margins of society, as did Nicholas Nixon in his portraits of people with AIDS, made in the 1980s.

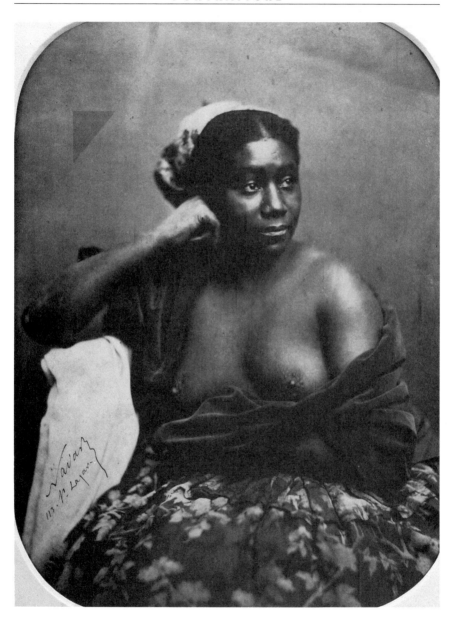

NADAR (1820–1910).
Maria, 1856–59. Salted-paper print, 9¾ x 7⅜ in. (24.9 x 18.9 cm).
Musée d'Orsay, Paris.

POSTMODERNISM

▷ **WHO** Ellen Brooks, Victor Burgin, Florence Chevallier, Clegg & Guttmann, Eileen Cowin, Joan Fontcuberta, Jeff Koons, Barbara KRUGER, Sherrie LEVINE, David Levinthal, Pierre et Gilles, Richard PRINCE, Cindy SHERMAN, James Welling

▷ **WHEN** Late 1970s to the present

▷ **WHERE** Primarily the United States but also Europe

▷ **WHAT** Given all the different definitions of postmodernism in use since the late 1970s, it is perhaps best to focus here on its ironic stance toward art, society, and above all, the high status that society confers on the image.

The role played by photography in postmodernism is much indebted to the SEMIOLOGICAL writings of Roland Barthes and Umberto Eco as well as to work by the French philosophers Jacques Derrida, Jean Baudrillard, and Jean-François Lyotard. The American Conceptual artist John Baldessari once observed that "we think of any unknown situation in terms of something we've seen in the movies"—to which might well be added the phrase "or in photographs." This rather cynical sense that everything has already been seen or done is the departure point for postmodern artists, who question the notion of novelty or originality in a society in which artistic images are so ceaselessly recycled that they have lost what Walter Benjamin called their "aura."

In an exemplary postmodern gesture, Sherrie Levine APPROPRIATED classic photographs by Edward Weston and Walker Evans by rephotographing them, thereby casting doubt—in both a legal and a conceptual sense—on the very idea of an "original" or a "masterpiece." The same approach is also encountered in work by Richard Prince, although he implements it differently, by appropriating visual documents from diverse origins (sensational press photographs, erotic advertisements), which he rephotographs without embellishment, simply reframing them as he sees fit.

Central to the work of Barbara Kruger and Cindy Sherman is the reuse of media and social archetypes to denounce their artificiality. In her PHOTOMON-TAGES, Kruger uses the language and graphic devices of advertising to ironically deconstruct it. For the past twenty-some years Sherman has photographed herself (and, more recently, mannequins and artificial body parts) in a variety of coded situations permeated by the influence of television and the movies, producing images that cast a harsh light on the status of

BARBARA KRUGER (b. 1945).
Untitled (You Get Away with Murder), 1987. Dye-coupler print with silkscreen lettering, 30⅛ x 30 in. (76.5 x 76.2 cm). The Hallmark Photographic Collection, Kansas City, Missouri; Courtesy Mary Boone Gallery, New York.

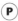

women in contemporary American society. For her series Family Docudramas (1980), Eileen Cowin staged and photographed scenes resembling situations from popular photographic romance comics in which she denounced the stereotypes of the Middle American family. Florence Chevallier, in her series of color photographs entitled Le Bonheur (Happiness, 1993), also staged the clichés of happiness promised by consumer society.

The quotation of classical art and mythology, and especially the ironic use of formulas derived from traditional painting, are typical of much postmodernist photography. Pierre et Gilles, for example, take provocative delight in commercial photography, producing kitsch fantasies for magazines and record jackets, sometimes by photographing themselves in various disguises, sometimes by photographing media celebrities as figures from popular and religious mythology. Clegg & Guttmann use official portrait formulas inherited from the Renaissance to point out the arbitrary relationship between aesthetic power and real power.

PRINTS

Since the 1960s the art market has imposed a hierarchy of values linked to a print's age, quality, scarcity, and proximity to the photographer.

Vintage prints are those made by the photographer himself or under his strict control, at a point more or less contemporary with the production of the original negative. These have the greatest value and constitute most of the images chosen by museums for exhibition.

Modern prints can be produced during the artist's lifetime by himself or under his control, but they are always made from an original negative considerably earlier in date than the print.

Posthumous prints are produced from an original negative after the photographer's death. They can vary considerably, depending on the degree to which the printer tries to imitate a vintage print from the same negative.

Copy prints (sometimes called "work prints") are made from a negative copied from a print. They have no artistic or commercial value.

Photographic books, journals, and popular magazines have played a crucial role in the history of the medium, particularly once the processes for reproducing photographs in print became relatively reliable and profitable.

The photographic book, which evolved in tandem with print technologies, has been used by photographers in very different ways. It was first employed as a means of presenting DOCUMENTARY PHOTOGRAPHY, especially TRAVEL PHOTOGRAPHY, with results ranging from Maxime Du Camp's *Egypt, Nubie, Palestine et Syrie* (1852)—the first book to be illustrated with original photographs—to today's tourist guidebooks. Important examples of the documentary mode are Margaret Bourke-White's *Eyes on Russia* (1931) and Albert Renger-Patzsch's industrial reportage in *Die Welt ist schön* (The world is beautiful, 1928). This documentary use of the book has also encompassed the photographic reproduction of works of art, which has profoundly affected our relationships to the originals. In addition, magazines and other popular publications have informed amateurs about photographic techniques (in publications such as *Camera Craft* and *Popular Photography*), disseminated information by photographic means (*Fortune, Time, Vu,* and so on), and familiarized readers with specific aspects of photography (the catalog of the 1955 exhibition *The Family of Man,* for example, served as a veritable manifesto of HUMANIST PHOTOGRAPHY).

Photographers have also used the book as a site for visual experimentation. Examples featuring audacious graphic and typographical design were produced by modernists affiliated with the BAUHAUS as well as by SURREALIST photographers and by members of the Czech avant-garde group known as Devětsil. El Lissitzky and Alexander Rodchenko, for instance, followed László Moholy-Nagy's lead in combining single images and PHOTOMONTAGES with type on the same page. A similarly experimental approach characterizes the 1970s work of Ralph Gibson, who was the first to approach the photographic book as an autonomous space, in his trilogy *The Somnambulist* (1973), *Déjà-Vu* (1973), and *Days at Sea* (1974). In this dreamworld Gibson, through page design as well as image sequencing and juxtaposition, created a new rhetoric of images with a rhythm similar to the chapters of a novel. Other photographers working in a similarly experimental spirit have sometimes used the photographic book as a tool of creative expression roughly equivalent to literary forms, as in Walker Evans's *American Photographs* (1938). In some cases they have worked with innovative art directors to achieve the desired results—for example, Henri Cartier-Bresson in collaboration with Tériade

(*The Decisive Moment,* 1952) and Robert Frank with Robert Delpire (*The Americans,* 1958).

Most of the great photography journals were founded by important figures in the field whose aesthetic preferences they were designed to promote. Such was the case with Alfred Stieglitz's two publications: *Camera Notes* (1897–1903), which helped photography attain the status of a legitimate art form, and *Camera Work* (1903–1917), which was launched as an organ of the PHOTO-SECESSION but was subsequently used to advance the cause of STRAIGHT PHOTOGRAPHY. *Camera Work* won new prestige for the photographic journal through its incisive critical writing and the admirable quality of its photogravure illustrations, which are now as sought after as the originals they reproduced. Other important photography journals have included *Arts et métiers graphiques* (founded by Charles Peignot, 1927–39), *Aperture* (founded by Minor White in 1952), and *Camera* (founded by C. J. Bucher in 1922 and subsequently edited by Allan Porter until closing in 1981).

RAYOGRAM—*see* PHOTOGRAM

REPRODUCTIVE PROCESSES

The increasing demand for images to illustrate the popular press made the invention of techniques for reproducing photographs a necessity. Until the introduction of screen-printing technologies in the late 1870s, photographs were reproduced by the same methods traditionally used for illustrations— namely, by transferring the image to a lithographic stone (the *phototypie* technique developed by the Frenchman Alphonse-Louis Poitevin) or to plates of various kinds of metal, including copper, zinc, and silver.

In order to reproduce the photograph in ink without losing the subtle nuances of the original image, these time-consuming photomechanical methods required the use of a sensitized support and a special type of ink. The WOODBURYTYPE is among the most faithful of these processes and the only one to produce continuous tonal gradations that make it difficult to distinguish the reproduction from the photographic original. In the late nineteenth century, Karl Klič in Vienna developed the photogravure (or heliogravure) process—also known as "grain gravure" due to the resin granules that were spread across the copper plate to translate the continuous tonalities of the image. This technique gave photographic reproduction a technical finesse that has never been surpassed.

The halftone process (a principle discovered in 1859 but mastered only much later) divides the image into a network of dots whose size and configuration can be manipulated in order to capture the subtle variations in tonal density of the photographic original. In duotone printing, two different plates—which can be printed in the same color of ink or in two different colors—of the same image are employed, one for lights and the other for darks. Color reproduction entails screening the image into four different plates, which are inked with the pigments of the printing spectrum (yellow, magenta, cyan, and black) and then printed simultaneously. Computer technology has recently made it possible to replace the screening process with the use of DIGITAL scans.

SABATTIER EFFECT—*see* SOLARIZATION

SALT-PAPER PROCESS

This primitive printing process, invented by William Henry Fox Talbot about 1840, made it possible to obtain a positive image from a paper negative or, less frequently, from a COLLODION negative on glass. A sheet of paper was treated with a solution of sodium chloride (table salt) and then floated on a silver nitrate solution, which formed a light-sensitive coating of silver chloride particles on one side. The paper was then dried, placed directly beneath a negative in a printing frame, and exposed to sunlight. The resulting CONTACT PRINT was rinsed, fixed, and sometimes TONED or varnished. Salt prints are mat and have a reddish brown color.

In 1844–46 Talbot produced *The Pencil of Nature,* an influential album consisting of original salt prints obtained from CALOTYPES. In 1851 Louis-Désiré Blanquart-Evrard improved the process, which was widely used in Europe over the following decade, especially in France by Gustave Le Gray, Henri Le Secq, and Charles Nègre.

SCHADOGRAPH—*see* PHOTOGRAM

SCIENTIFIC PHOTOGRAPHY

It was not an artist but the scientist François Arago who first announced the invention of photography to the public, in Paris in 1839, thus anticipating the close relationship that has linked science and photography ever since.

Microscopy and astronomy were the scientific fields in which the medium first played an important role. Microscopic photography—invented by the Frenchman René-Prudent Dagron in 1862—was initially used for decorating jewelry, but it soon served a more serious purpose. During the siege of Paris in 1871, eighteen thousand dispatches were recorded on just six pieces of microscopic film; weighing only a few grams, this vital cargo was transported out of the city by a single carrier pigeon.

In the early 1860s Hervé-Auguste Faye recorded the first photographic images of the sun; also, about this time a craze developed in both Europe and the United States for astronomical DAGUERREOTYPES. After technical progress made instantaneous exposures possible in the 1870s, the photographic documentation of MOVEMENT became a possibility. In the medical domain, Albert Londe delivered electric shocks to the facial muscles of mentally disturbed patients under his care in Paris and photographed the effects. Konrad von Röntgen's discovery of X rays in 1885 and Henri Becquerel's discovery of radio waves shortly thereafter established photography as an important tool in scientific detection and measurement, especially in medicine.

Advances in stop-action photography achieved early in this century at the Institut Marey in Paris made it possible, beginning in the 1920s, to expose up to twenty images per second. In 1931 the American Harold Edgerton developed stroboscopic flash equipment with which he produced remarkable stop-action images of a milk splash, a speeding bullet, and other now iconic images. In 1933 the electronic microscope was invented, which made it possible to enlarge images up to ten thousand times, followed a bit later by the "bubble chamber," an enormous photographic apparatus for registering atomic particles.

The development of color photography, coupled with the perfection of infrared film in 1935, made it possible to record information invisible to the naked eye. AERIAL PHOTOGRAPHY, cartography, and geology also benefited from these technological advances. Thanks to satellites flying outside the solar atmosphere, it is now possible to record images of other planets without distortion as well as to measure thermal fluctuations that reveal information about the origins of the universe. The use of sophisticated telescopes, optical adapters to correct atmospheric distortion, and collapsible mirrors that are deployable in subzero temperatures has also helped obtain undistorted images of space. DIGITAL IMAGING has vastly increased the number of possible applications for photography, especially in medicine.

Scientific photography has considerably altered the way we see the world. From galloping horses (depicted differently by painters after they saw the information revealed by chronophotography) to the interiors of our own bodies (revealed by endoscopic cameras composed of a hollow tube, a light source, and various miniature lenses), our vision of reality has been constantly affected by photography, and it has affected our aesthetic vision as well. Scientific photography was crucial to the NEW VISION of the 1920s, and some more recent photographers have made it the focus of their work, including Lennart Nilsson of Sweden, Mitsuhiko Imamori of Japan, and Claude Nuridsany and Marie Pérennou of France.

SCULPTURE AND PHOTOGRAPHY

▷ **WHO** Alinari brothers, Eugène Atget, Edouard Baldus, Herbert Bayer, Bernd and Hilla BECHER, Hans Bellmer, Bisson brothers, Louis-Désiré BLANQUART-EVRARD, Félix Bonfils, Constantin BRANCUSI, Francis Bruguière, Tom DRAHOS, Eugène Druet, Maxime Du Camp, Francis Frith, Naum Gabo, Pascal KERN, Henri Le Secq, Guglielmo Marconi, Charles MARVILLE, Pierre Mercier, Charles Nègre, Man Ray, Louis-Rémy Robert, Auguste Salzman, Edward Steichen

▷ **WHEN** 1840 to the present

▷ **WHERE** Europe and the United States

▷ **WHAT** In 1844 William Henry Fox Talbot remarked: "Statues, busts and other specimens of sculpture, are generally well rendered by the photographic art; and also very rapidly, in consequence of their whiteness." Photography *is* well suited to record sculpture, despite the fact that one medium is two-dimensional and the other, three-dimensional. It was particularly effective in recording and disseminating images of sculpture in the context of archaeology as that discipline evolved in the nineteenth century. Such documentation required methodical objectivity, and in 1859 the Frenchman François Willème invented a "photosculpture" process that made it possible to re-create a sculpture from multiple photographs, with the aid of a pantograph.

It was the Swiss art historian Heinrich Wölfflin who, in a series of articles entitled "How to Photograph Sculpture" (published in Leipzig in 1896–97), established the fundamental challenges of the genre—namely, the mastery of point of view and lighting. Throughout the second half of the nineteenth

171

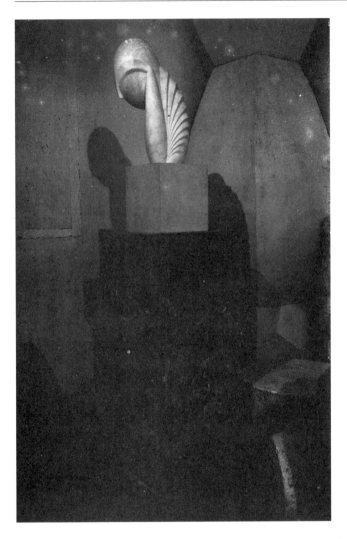

CONSTANTIN BRANCUSI (1876–1957).
Mademoiselle Pogany (III), 1931. Gelatin silver print, 11³/4 x 9³/8 in. (29.9 x 23.9 cm). Musée National d'Art Moderne, Centre Georges Pompidou, Paris; Brancusi Bequest, 1957.

century, photographing sculpture involved a tug-of-war between fidelity to the object's own aesthetic qualities (as exemplified by Maxime Du Camp's documentation of Egyptian sculptures) and the autonomous expressive power of the photograph (as exemplified by Charles Nègre's views of French monuments). Perhaps the most eloquent results of this ongoing struggle were produced in the twentieth century: Edward Steichen's brooding images of Auguste Rodin's *Balzac,* Brassaï's magnificent photographs of Pablo Picasso's sculpture, and even Alfred Stieglitz's evocative documentation of Marcel Duchamp's notorious *Fountain* (1917), which was destroyed soon after the photograph was made. Sculptors themselves may be the best photographic interpreters of their work, as epitomized by Constantin Brancusi, who began to photograph his own pieces in 1925. The resulting images explore the profound relationship between his sculpture and his studio, while also establishing the ideal viewpoint for viewers to take in order to best appreciate his sculpture.

Since Brancusi, many photographers have approached the relationship of photography and sculpture in a very different way, attempting to make photographs with sculptural characteristics. Concerning themselves with volume, texture, and space, they create photographic prints that can be considered a type of sculpture—especially when used in large formats, as by Jeff Wall, Craigie Horsfield, and Jean-Marc Bustamante. They also explore how such large photographs relate to the spectators who view them and the environments that contain them. In 1992 the Venice Biennale awarded its sculpture prize to Bernd and Hilla Becher for their photographic series depicting types of silos, water towers, blast furnaces, and other industrial monuments of the modern world, thereby reinforcing the close connections between photography and sculpture. Other photographers, such as John Coplans and Dieter Appelt, have documented their own bodies as if they were constructed of sculptural elements. (Hans Bellmer opened the way toward this approach in the 1930s with his disquieting photographs of dolls.)

SELECTION

The principle of selection is at the heart of photography. In his essay "The Decisive Moment" (1952), Henri Cartier-Bresson wrote, "For photographers, there are two kinds of selection to be made, and either of them can lead to eventual regrets. There is the selection we make when we look through the viewfinder at the subject, and there is the one we make after the films have been developed and printed, when you must go about separating the pictures which, though they are right, aren't the strongest."

This twofold process of selection takes place at two very different stages in the photographic process. At the moment of shooting, the operator selects a specific image from all the possibilities around him. That stage can be called "framing," at which point he establishes in the viewfinder what image will be recorded. The photographer makes his second selection at the editing stage, by choosing which images he wants to use, generally from a CONTACT SHEET or from study prints. Partisans of pure photography (Cartier-Bresson among them) consider trimming, or "cropping," the chosen image in the laboratory during the printing process to be a serious alteration of the authenticity of the original shot and adamantly forbid it.

SELF-PORTRAIT

The fact that a photographer can easily serve as his own model has encouraged experimentation with self-portraits from very early on. In Hippolyte Bayard's *Self-Portrait as a Drowned Man* (1840), for example, he approached photography as a stage on which dramas of the self could be played out and subjectivity explored. But it was with PICTORIALISM, which fostered the concept of the photographer as artist, that self-portraiture first acquired aesthetic significance, in works by Edward Steichen, Edward Weston, and others. Subsequently, NEW VISION photographers such as László Moholy-Nagy and Umbo focused on their own faces as objects for visual exploration as opposed to mirrors of subjectivity. From that point on, self-portraiture began to loom large in photographic practice.

Photographic self-portraiture often plays with shadows (Lee Friedlander, whose shadow falls on the back of the woman seen in *Self-Portrait, New York*, 1966) or mirrors (Florence Henri, in her Double Portrait series, 1927–28) to indicate the photographer's presence. Alternatively, a photographer may focus on physical fragments (Arno Rafael Minkkinen) or on the body's decline toward death (Dieter Appelt, Robert Mapplethorpe). Mapplethorpe, infected with the AIDS virus, produced a series of frank self-portraits, including one in which he photographed himself holding a cane topped by a skull, that record the stages in his physical deterioration. Some have photographed themselves in ways that evoke the search for a double (Duane Michals, in his Narcissus series, 1974) or that explore the pleasures of disguise and erotic fantasy (sexual tableaux by Pierre Molinier and by Urs Lüthi, erotic Polaroids by Lucas Samaras). Gilbert and George photograph themselves over and over in staged scenes, then incorporate those images as principal elements in their oversize PHOTOMONTAGES. Photographic self-portraits have also been used to expose and critically examine the

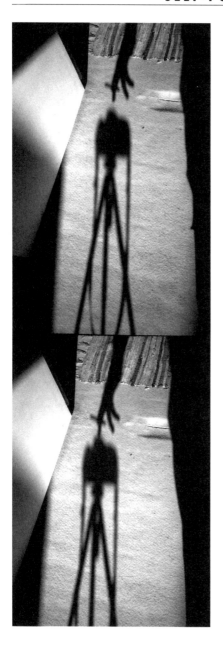

DENIS ROCHE (b. 1937).
Paris, 11 October 1987, Self-Portrait, 1987. Gelatin silver print,
11¾ x 4⅛ in. (30 x 10.5 cm). Collection of the photographer.

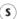

socially determined roles of the body—in particular, the female body. For example, between the wars Claude Cahun produced self-portraits (often COL-LAGES) that explore her obsession with the ambiguity of sexual identity.

Self-portraiture cannot be separated from other forms of photographic auto-biography. Some photographers (Denis Roche and Hervé Guibert in France, Nan Goldin in the United States) have given such projects a narrative dimension. Others (the painter Jean Le Gac in the 1970s; Christian Boltanski, with his "comic sketches" of 1974) have chosen to produce fictional autobiographies. Sophie Calle has created situations for herself to photograph, such as police investigations in which she played a role.

SEMIOLOGY

Semiology—which originated in the 1960s with the development of theories about the linguistic "sign" (based on work done by the Swiss linguist Ferdinand de Saussure in the early years of this century)—is the study of the circulation and social function of signs in general, both linguistic and visual. Semiologists have been particularly interested in photographic images because of their close relation to reality, of which they are said to be an "index" or "trace." Critics with a semiological bent have also had interesting things to say about the PHOTOGRAPHIC ACT.

In his book *La Chambre claire* (1980; English translation, *Camera Lucida,* 1981), Roland Barthes describes what is unique about the experience of viewing photographs, using the notion of the "trace" to discuss photographs as witnesses of "what has been" and thus intimately related to the experience of loss and death. The American art historian Rosalind Krauss and then the Belgian philosopher Henri Van Lier have rightly noted that photography's "indexical" status makes it the precursor of several aesthetic practices— from environmental art to body art, by way of gestural painting (from Jackson Pollock to Barnett Newman)—that use reality itself as a springboard to artistic production.

SENSITIZED SURFACE

This term designates any surface (glass or metal plate, paper, film) that has been sensitized to light in order to record a photographic exposure. Sensitization was achieved by various techniques throughout the nineteenth century—all based on the phenomenon that silver salts (a combination of sil-ver with chlorine, bromine, or iodine to produce silver chloride, silver bro-

mide, or silver iodide) darken when exposed to light. This phenomenon had been known since the sixteenth century, but the invention of photography required the discovery of ways to stabilize an image obtained by this procedure.

To sensitize a surface, it must be coated with a solution containing silver salts in suspension. Initially, the preparation of ALBUMEN paper and wet-COLLODION negatives proceeded in two steps: the surface was first coated with albumen or collodion (which served as binding agents) and then impregnated with light-sensitive silver salts. The invention of processes using EMULSIONS—which consist of a suspension of grains of silver halide, first in collodion (as in the dry-collodion process, invented in the 1850s) and then in gelatin (invented by Richard Leach Maddox in 1871)—simplified the sensitizing process and made possible the commercial production of sensitized surfaces. The GELATIN SILVER PROCESS invented by Maddox is still used today.

How sensitive the surface is (that is, how much and how quickly it will darken in response to light) depends on the composition of the emulsion containing the silver grains as well as on the size of the grains.

SERIAL PHOTOGRAPHY

More and more photographers conceive and present their work in series, in which images of a single subject are organized into a particular sequence and syntax. The use of a series format should be distinguished from other, related devices, such as the repetition of a motif, which can be seen in the COLLAGES and PHOTOMONTAGES made by experimental photographers working at the BAUHAUS in the 1920s. A frequent counterpart of repetition is accumulation, as in Paul Citroen's *Metropolis* (1925), a photomontage in which dozens of buildings are accumulated on a single surface.

Serialization, repetition, and accumulation evolved out of research by Bauhaus and NEUE SACHLICHKEIT photographers such as Albert Renger-Patzsch, who made photographs of industrial objects, and Karl Blossfeldt, who photographed close-ups of plant life. Such work reflected a positive response by photographers to the simplification and standardization brought about by industrialized mass production. In 1947 László Moholy-Nagy declared: "Repetition, which is to say the series, is an important aspect of contemporary technology. In it modern man recognizes, if at a certain remove, the beauty of technology." This notion was subsequently taken up by the POP ARTISTS of the 1960s, especially Andy Warhol.

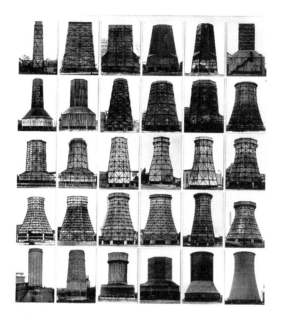

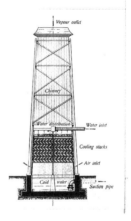

BERND and **HILLA BECHER** (b. 1934 and 1931).
Anonymous Sculpture, 1970. Thirty gelatin silver prints, 15⁷/8 x 11³/4 in. (40.3 x 29.8 cm), each; 85 x 78 in. (215.9 x 198.1 cm), overall.
The Museum of Modern Art, New York; Gertrude A. Mellon Fund.

Photographers interested in vernacular culture have tended to emphasize its serial character. In 1935, for example, Walker Evans produced a visual archive of certain building types—churches, antebellum mansions, store-fronts—in the American South, systematically using a dead-on frontal point of view. Evans's approach was later emulated by Lee Friedlander in his book *American Monuments* (1975). The potential variety of the series form is exemplified by Ed Ruscha's Conceptual books (*Various Small Fires and Milk,* 1964) and by Bernd and Hilla Becher's series depicting various types of industrial structures, which they display in groups related to mining, iron making, and so on. This typological approach, used by August Sander in his portraits of Germans made between the wars, has been taken up by many contemporary photographers, including Thomas Ruff, in Aperto, his 1988 series of portraits of young people; Thibaut Cuisset, in his architectural photographs; and Paul den Hollander, in his object photographs. The obsessional potential of the series format is driven home by *2,000 Photographs of a Woman's Sex,* made by the Frenchman Henri Maccheroni between 1969 and 1992.

SNAPSHOT/INSTANTANEITY

In general, the term *snapshot* designates photographs taken by amateurs with simple cameras to record family events such as vacations, weddings, and so on. Snapshots were made possible by a series of technical advances, notably the invention of rapid-shutter technology (which reduced posing time, beginning in the 1860s) and the development of increasingly light-sensitive and hence faster film. The introduction of the easy-to-use Kodak camera in the United States in 1888 made photography accessible to a much-expanded audience of snapshooters.

Many professional photographers adopted this direct and spontaneous approach, but the aesthetics of instantaneity and of the posed photograph have traditionally been understood as opposite and even antagonistic approaches. ("Innocence is the quintessence of the snapshot," declared the photographer Lisette Model.) Instantaneity was a feature in work made by several enlightened amateurs during the early years of the twentieth century, notably Jacques-Henri Lartigue. But it did not become truly established among professionals until the 1920s, after the appearance of small cameras such as the easily concealed Leica; at that point it was embraced by both PHOTOJOURNALISTS and STREET PHOTOGRAPHERS.

The aesthetic of instantaneity has taken different guises. One is the personal, intimist approach, which was adopted by even so deliberate an artist as

Alfred Stieglitz—notably, in his work at Lake George, New York, around 1920, in which he captured unstudied portraits of the servants, friends, and family close to him, swimming or otherwise engaged in everyday activities. Another is the rigorous approach to recording reality epitomized by Henri Cartier-Bresson's concept of the DECISIVE MOMENT. The casual snapshot aesthetic was also associated with the Beat Generation of the 1950s, whose members made a virtue of imperfection (John Cohen [who photographed the making of Robert Frank's movie *Pull My Daisy*, 1958], the poet Allen Ginsberg, and even the film actor Dennis Hopper were all occasional photographers). The origins of their approach can be found in the totally spontaneous use of the camera by the painter Ben Shahn in his work for the FARM SECURITY ADMINISTRATION in the 1930s. Instantaneity also infused the new street photography by William Klein, Garry Winogrand, and others, as well as a more poetic mode of urban photography in the HUMANIST tradition. Snapshots also lend themselves to diaristic and confessional modes of photography, as in work by Larry Clark, Nan Goldin, and others.

SOLARIZATION

Solarization is an effect accidentally produced by overexposure in the camera of part of the LATENT IMAGE, which results, after development, in a reversal of the light values. A related, but intentional, effect was discovered by the Frenchman Antoine Sabattier in 1862, and it is sometimes called the "Sabattier effect." In this case, the development of a negative or a paper print is briefly interrupted by a momentary reexposure to light; this too results in a partial reversal of positive and negative values in the final image. This process sometimes yields unpredictable results. It was taken up by a few European NEW VISION and SURREALIST photographers (in conjunction with other darkroom manipulations) as well as by the Americans Francis Bruguière and especially Man Ray, who used it in the interwar years to produce mysterious yet elegant portraits of fashionable sitters.

STAGED PHOTOGRAPHY

▷ **WHO** Herbert Bayer, Hans BELLMER, Arièle Bonzon, Ellen Brooks, Claude CAHUN, James Casebere, Florence Chevallier, Robert Cumming, F. Holland Day, John Divola, Tom Drahos, Bernard FAUCON, Fischli and Weiss, Alain Fleischer, Adam Füss, Joe Gantz, Jan Groover, Tim Head, Pascal Kern, Jeff Koons, Les KRIMS, David Levinthal, Joachim Mogarra, Pierre MOLINIER, Nic Nicosia, PIERRE ET GILLES, Oscar Gustav REJLANDER, Henry Peach Robinson,

SOLARIZATION

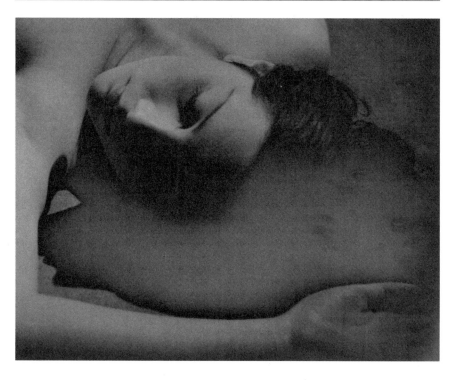

MAN RAY (1890–1976).
Untitled (Solarized Nude), 1929. Gelatin silver print, 9 x 11⅝ in.
(23 x 29.6 cm). Museum of Fine Arts, Boston; Graham Gund
Photography Fund.

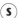

David Rosenthal, Jan Saudek, Cindy SHERMAN, Tjarda Sixma, Sandy Skoglund, Arthur Tress, Boyd Webb, William Wegman, Joel-Peter Witkin

▷ **WHEN** Primarily 1980s to the present

▷ **WHERE** United States and Europe

▷ **WHAT** When a photographer fabricates or alters the subject in front of the camera in order to obtain specific results, he becomes in effect a director, whether working with live models or inanimate props. The directorial approach emphasizes the fictional nature of the image, building on many earlier attempts in the history of photography to go beyond the limited notion of the medium as the passive recorder of objective reality and give the operator's imagination free play.

The carefully staged scenes that Oscar Gustav Rejlander and Henry Peach Robinson produced from multiple negatives during the second half of the nineteenth century are elaborately constructed photographic tableaux inspired by traditional genre paintings and allegories. Together with Hippolyte Bayard's famous *Self-Portrait as a Drowned Man* (1840), they established a new photographic genre that was explored at the end of the century by F. Holland Day, who played the role of Christ in a series of religious tableaux (1898). In the twentieth century, MODERNISTS (especially those affiliated with the NEW VISION, such as Herbert Bayer) and SURREALISTS (including Hans Bellmer, Claude Cahun, Pierre Molinier, and Man Ray) produced powerful examples of staged photography and served as progenitors of the directorial photographers who became known in the 1980s. The work created by the latter in response to growing skepticism about the possibility of photographic objectivity was also linked to Conceptual and performance-related art made during the 1970s. Many of those 1970s images star the artist in artificial, sometimes ludicrous narratives; see, for example, Real Dreams (1976) by Duane Michals (in this series of narrative sequences, Michals staged himself, with other figures, in often metaphysical fables), Luigi Ontani in Lede e Cigno (Leda and the Swan, 1975), and William Wegman's whimsical setups with his dogs.

Staged photography became more diverse as well as more firmly established in the 1980s, and it remains vigorous today. The critic Andreas Vowinckel has proposed four useful subcategories of the genre:

Staged self-portraits, in which the photographer casts him- or herself in different roles (Florence Chevallier, Jeff Koons, Pierre et Gilles, Cindy Sherman, Tjarda Sixma).

Narrative tableaux, in which live models or mannequins play roles inspired by social life, mythology, and fantasy as directed by the photographer (Bernard Faucon, Joe Gantz, Nic Nicosia, Jan Saudek, Sandy Skoglund, William Wegman, Joel-Peter Witkin).

Miniature theaters, which are conceived like narrative tableaux but on a reduced scale, with dolls, toys, and other miniature props (Ellen Brooks, James Casebere, Alain Fleischer, David Levinthal, Joachim Mogarra, Arthur Tress).

Installations and "photo-sculptures," which are large-format photographs of carefully arranged tableaux of objects (Arièle Bonzon, Tom Drahos, Fischli and Weiss, Jan Groover, Pascal Kern).

STEREOGRAPH—*see* THREE-DIMENSIONAL PHOTOGRAPHY

STRAIGHT PHOTOGRAPHY

▷ **WHO** Ansel Adams, Eugène ATGET, Karl Blossfeldt, Bill Brandt, Brassaï, Henri CARTIER-BRESSON, Imogen Cunningham, Walker EVANS, Lewis HINE, André Kertész, Dorothea Lange, Albert RENGER-PATZSCH, Erich Salomon, August Sander, Charles Sheeler, Edward Steichen, Alfred STIEGLITZ, Paul STRAND, Edward WESTON, Minor White

▷ **WHEN** Early 1900s to 1970

▷ **WHERE** Europe and the United States

▷ **WHAT** Tension between straight photography and the temptation to aestheticize has been a constant in the history of photography. "Straight" photography triumphed when photographers, reacting against the aestheticizing excesses of PICTORIALISM, rejected the other visual arts—especially painting—as a model and resolved to build upon the characteristics specific to photography: CLARITY in the rendering of detail, accurate and automatic recording of reality.

Alfred Stieglitz took a decisive step in this direction when he launched the PHOTO-SECESSION and began actively to support the view that photography was an independent art, a position reflected in his famous image *The Steerage* (1907). However, it wasn't until 1917 that the painter and photographer Charles Sheeler (influenced by Charles Demuth's Precisionist paintings)

183

made his series of photographs of his Doylestown, Pennsylvania, house, which signal the beginning of the straight aesthetic. These were strongly marked by the formal qualities of Cubist painting, in direct opposition to Pictorialist BLURRING. In a 1917 article in the journal *Seven Arts,* Paul Strand declared: "Unlike the other arts, which are really anti-photographic, objectivity is of the very essence of photography, its contribution and at the same time its limitation.... The full potential power of every medium is dependent upon the purity of its use."

Straight photography was long considered the essence of photographic MODERNISM by American historians of the medium, notably Beaumont Newhall. During the interwar period, members of the European avant-garde movements, especially NEUE SACHLICHKEIT and NEW VISION, embarked on a parallel exploration of the medium's inherent qualities, but they adopted a position that was less rigorously purist, favoring experimentation of a kind frowned upon by their American colleagues—including MANIPULATION, PHOTOGRAMS, PHOTOMONTAGE, and so on.

Beginning in the 1920s DOCUMENTARY PHOTOGRAPHY in both Europe and the United States was significantly influenced by straight photography. The California-based GROUP F/64 (particularly Edward Weston and Ansel Adams) pushed the straight-photography aesthetic to its limits by decreeing very strict rules: the use only of large-format cameras, the goal of absolute clarity, the refusal to crop images, and so on. The journal *Aperture,* founded by Minor White in 1952, showcased a mystical variant of it until the early 1960s.

The notion of straight photography began to fall apart when POP ARTISTS, installation artists, and others began to challenge the medium's autonomy by using it as merely one creative tool among many. Nonetheless, the art historian Rosalind Krauss, along with Roland Barthes and Henri Van Lier, has argued convincingly that, in its capacity as an "art of the trace," photography has served as an important model for a broad range of contemporary art. This status has made the medium a focus of ongoing debate and controversy in contemporary criticism.

STREET PHOTOGRAPHY

Traditionally, a "street photographer" is an itinerant who offers to take portraits of passersby for a modest fee. This longstanding practice was facilitated by the development of instant cameras but now seems to be disappearing.

CHARLES NÈGRE (1820–1880).
Chimney Sweeps Walking, 1851. Salted paper print, 5⅞ x 7⅝ in.
(15.2 x 19.8 cm). National Gallery of Canada, Ottawa.

"Street photography," on the other hand, is a genre practiced by photographers who make their primary subject modern urban life, much of which unfolds in the street. Street photographers pursue the fleeting instant, photographing their models either openly or surreptitiously, as casual passersby or as systematic observers. The first photographer who achieved the technical sophistication needed to register people's movements on the street was Charles Nègre, working in Paris in 1851. Eugène Atget, producing his own distinctive version of street photography later in the century, preferred to describe the inhabitants of Paris by showing the places in which they lived and worked rather than the inhabitants themselves.

Many photographers—for example, most of the participants in the FARM SECURITY ADMINISTRATION project—have practiced street photography as simple reportage. Others have made this subject the basis for more aesthetically rigorous images linked to various tendencies in contemporary art. Alexander Rodchenko, for example, formulated a Constructivist vision of street photography, and Henri Cartier-Bresson built his DECISIVE MOMENT theory by combining formal decisions with a simultaneous grasp of the spectacle of the street; he also found that street subjects were well suited to SURREALIST interpretation. The American photographers Harry Callahan (in his views of passersby taken all from the same vantage point in Detroit, 1943–45) and Walker Evans (in his treatment of the same subject in Chicago in 1946) used street photography to explore the PORTRAITURE of anonymous subjects as well as the role of chance and the possibilities inherent in SERIAL PHOTOGRAPHY.

Beginning in the 1950s Robert Frank and members of the NEW YORK SCHOOL made street photography the point of departure for a more subjective photography, couched in a more radical visual language. Through the freedom of their framing and the novelty of their points of view, they sought to convey the visual chaos of big-city streets. At the same time, Diane Arbus, Lee Friedlander, William Klein, and Garry Winogrand captured all the violence and visual complexity of the street, as well as some of its socially marginal inhabitants. Postwar French photographers working in the HUMANIST tradition, notably Robert Doisneau, used street photography to express their far more romantic visions of the city.

See THE CITY AND PHOTOGRAPHY

▷ **WHO** Pierre Cordier, Mario Giacomelli, Heinz Hajek-Halke, Arno Jansen, Lennart Olson, Françoise Saur, Otto STEINERT, Christer STRÖMHOLM, Rolf Winquist, Steef Zoetmulder

▷ **WHEN** 1950 to 1958

▷ **WHERE** Europe (primarily Germany)

▷ **WHAT** The group Fotoform, founded in Germany in 1949 to encourage formal explorations of abstraction, numbered among its ranks the theorist and photographer Otto Steinert. While a member of Fotoform, Steinert revived the experimental vein of German photography by mounting three exhibitions (in 1951, 1954, and 1958) promoting Subjektive Fotografie (Subjective photography)—a new international movement intended to encompass "all domains of personal photography from the abstract photogram to reportage." Its program (written in collaboration with Franz Roh, a key figure in NEUE SACHLICHKEIT photography) was comparatively unstructured, favoring individual expression of all kinds as long as it was in strictly photographic form. Especially praised were PHOTOGRAMS and reportage that were "visually well composed and psychologically profound."

Steinert thought that even though photography was an entirely objective medium, dominated by technique and differing profoundly from human vision, the only way for a photographer to express his own subjective perception of the world was to explore all the means specific to photography. It is exactly this paradox that would make it possible for photography, according to Steinert, to rival contemporary painting by offering new visual forms in which reality could be rendered with a more forceful originality.

In Europe, Subjektive Fotografie affected an entire generation of young photographers in search of a new artistic identity, and it also influenced the PHOTOJOURNALISTS associated with Magnum, members of the 30 x 40 Club in Paris, the Italian group La Bussola, and the Swedish scientific photographer Lennart Nilsson. Steinert's second exhibition, in 1954, brought together photographs from all over Europe, displaying the full range of creative possibilities inherent in the medium. In the catalog for this exhibition, Steinert proposed a three-part photographic typology: photography that only reproduces reality (documentary photography), photography that tries to represent reality by means of established aesthetic formulas

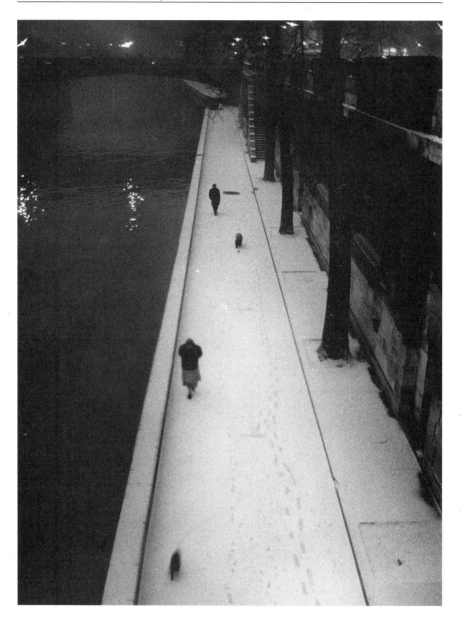

CHRISTER STRÖMHOLM (b. 1918).
Paris, 1949. Gelatin silver print, dimensions variable.
MIRA Bildarkiv, Stockholm.

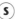

(aestheticizing photography), and finally, the most creative form, which is abstract photography.

American photographers were also much influenced by Subjektive Fotografie. In 1953 the George Eastman House in Rochester, New York, presented the Subjektive Fotografie exhibition that had been shown in Saarbrücken, Germany, in 1951. It had a considerable impact on Minor White as well as on photographers preoccupied with METAPHOR, such as Wynn Bullock, Aaron Siskind, and Frederick Sommer, encouraging them all toward ABSTRACTION.

SURREALISM

▷ **WHO** Manuel Alvarez Bravo, Herbert Bayer, Hans Bellmer, Ruth Bernhard, Jacques-André BOIFFARD, BRASSAÏ, Claude Cahun, Georges Hugnet, André Kertész, Clarence John LAUGHLIN, Fernando Lemos, Eli Lotar, Dora Maar, René Magritte, Marcel Mariën, Edouard L. T. Mesens, Lee Miller, Pierre Molinier, Paul Nougé, Roger Parry, Roland Penrose, Man RAY, John Riise, Frederick Sommer, Maurice Tabard, Val Telberg, Raoul UBAC, Kansuke Yamamoto

▷ **WHEN** 1924 to the 1960s

▷ **WHERE** Europe (primarily France), United States, Japan

▷ **WHAT** After the disaster of World War I, two radical movements arose in Europe to challenge the conventional bourgeois world. First were the Dadaists (1916–22), who declared war on traditional art and morality, and then came Surrealism, founded by André Breton in 1924, which (guided by Freudian psychology) set out to tap the powers of the unconscious by systematically unsettling established habits of perception. Photography played a crucial role in both of these movements, especially Surrealism.

Breton held that vision was far superior to the other senses, and beginning in 1925, he greatly favored photography: "When is it, then, that all important books will begin to be illustrated not by drawings but by photographs?" He carried out this preference in the Surrealist journals with which he was associated, illustrating them with work by innovative photographers (Man Ray in *La Révolution surréaliste,* Brassaï in *Minotaure*). The Surrealists regarded photography as a tool for exploring the optical unconscious, opposing the immediacy of vision to the reflective nature of thought.

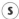

MANUEL ALVAREZ BRAVO (b. 1902).
Parabola Optica, 1931. Gelatin silver print, 10 x 8 in. (25.4 x 20.3 cm).
The Witkin Gallery, Inc., New York.

Two photographic modes were particularly apt for the Surrealists. The first was the straightforward documentation either of things created to be photographed or of found objects accidentally encountered; both could provide access to meanings hidden within reality, as in Brassaï's series Involuntary Sculptures (1933). Other examples of this type include photographs by Jacques-André Boiffard and Henri Cartier-Bresson that illustrate writings by André Breton, as well as images that capture places, things, and unexpected juxtapositions in unorthodox ways, as in work by the Mexican photographer Manuel Alvarez Bravo. The second mode was the use of MANIPULATION, as in PHOTOGRAMS of various kinds (particularly Man Ray's Rayograms), SOLARIZATION, Herbert Bayer's *Fotoplastiks* (see PHOTOMONTAGE), DOUBLE EXPOSURES by Maurice Tabard, burnt negatives by Raoul Ubac, and negative prints by Roger Parry. The Surrealists used manipulated photography not only as a new language tied to a new perception of reality (the same could be said of BAUHAUS manipulated photography) but also as a strategy to modify our too-simple relationship to reality and its conventions.

One of the major preoccupations of European Surrealist photography was the female body, presented as a site of eroticism (Brassaï's photomontage *Phenomenon of the Ecstasy of Salvador,* 1933, is a prime example) or as an occasion for sexual fetishism (as in Hans Bellmer, *Dolls,* 1932, and Pierre Molinier's self-portraits of the 1950s and 1960s). Another Surrealist preoccupation was the inherent strangeness of reality—a strangeness particularly evident in objects and the body. One Surrealist method of sabotaging normalcy consisted of making reality visually odd by photographing a city at night (as Brassaï did with Paris), by taking close-ups of faces (Man Ray and his *Tears,* c. 1930) and objects, by fragmenting and dislocating representations of the body (as in the sexually charged images by Claude Cahun and Bellmer), by bringing unexpected objects together (as Cartier-Bresson did in *Martigues,* 1932), or by using unusual lighting (Parry).

Surrealism had less impact in the United States than in Europe. European artists emigrating to the United States in the early 1940s to escape World War II influenced photographers like Val Telberg, Ruth Bernhard, and Carlotta M. Corpron, but the Americans' Surrealism is more formal than literary. It was the Louisiana native Clarence John Laughlin who most successfully extended the European Surrealist heritage, in a series of dreamlike, death-haunted images of the Deep South, which he began in 1935. Duane Michals's narrative sequences from the 1970s, Ralph Gibson's trilogy of 1973–74, and Jerry N. Uelsmann's double exposures are also indebted to the Surrealist tradition. In Japan, Surrealism had an enormous influence on

EDWARD STEICHEN (1879–1973).
The Pond—Moonrise, 1903. Platinum print toned with yellow and blue-green pigment, 15⅝ x 19 in. (39.7 x 48.2 cm). The Metropolitan Museum of Art, New York; Gift of Alfred Stieglitz, 1933. Reprinted with permission of Joanna T. Steichen.

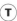

photography through the 1950s, spurring the establishment of many avant-garde clubs—for example, the Nagoya Photo Avant-Garde.

SYMBOLISM

Symbolism originated during the 1890s in France and Belgium as a literary movement founded on the principle of the equivalence of sensations and meanings, which Charles Baudelaire had proposed in the 1850s. The term *Symbolism* soon became a rather vague aesthetic concept loosely applied to painting (by Paul Gauguin and Gustav Klimt) and to music (by Claude Debussy). Its stylistic characteristics are difficult to pinpoint; Symbolist works generally avoid realistic depiction and evoke instead "eternal" ideas such as love, beauty, death, and nature. Symbolism can also be described as the opposite of the realism characteristic of the second half of the nineteenth century, of which photography represented the most up-to-date form.

When, at the end of the nineteenth century, photographers wanted to give themselves higher artistic status, they borrowed from Symbolist painters the elements that could confer on their photography an aesthetic character: first by refusing objective CLARITY in favor of soft, out-of-focus forms and then by borrowing Symbolist themes such as nature and love. American fin de siècle photographers including Baron Adolph de Meyer, Frank Eugene, Edward Steichen, Clarence H. White, and even Alfred Stieglitz, as well as European ones, produced "Symbolist" photographs that came close in theme and treatment to the dominant pictorial Symbolism and that constituted the first manifestations of PICTORIALISM. The rejection of specific reality in favor of aestheticizing generality through the subterfuge of the symbol often resulted in photographs that were insipid and academic.

Photographic Symbolism has recurred in different forms throughout the twentieth century. For example, in Edward Weston's mineral and plant studies of the 1920s and 1930s (such as *Shell,* 1927), each photographed object is intended as an equivalent, often sexual or at least sensual, of reality. In the 1950s and 1960s Minor White explored METAPHOR, using his camera to unveil emotions symbolized by objects from the real world.

THREE-DIMENSIONAL PHOTOGRAPHY

All three-dimensional photography is based on the principle of binary vision. The stereograph, for example, is an apparatus comprising two nearly identical photographic images taken by a special camera with a double lens that

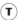

approximates the disparity in perspective between a viewer's own two eyes. Looking at the two images—mounted side by side—through a special viewer produces an illusion of depth, an effect that made the stereograph immensely popular from the 1850s into the twentieth century. Most stereoscopic views have topographical subjects, but erotic examples were also produced.

To create a three-dimensional effect in black-and-white images, the Frenchman Louis Ducos du Hauron used the anaglyph process (1891), in which two stereoscopic images are reproduced side by side, each having a different tint: blue-violet for the first, red for the second. If one looks at this double image through glasses equipped with lenses of the same color (a blue-violet lens, a red lens), each eye can perceive only the image intended for it, resulting in a three-dimensional impression. This principle was used beginning in the late 1930s to make 3-D movies. Among the other processes proposed throughout the early twentieth century to give the effect of three-dimensionality, the one used most frequently is that using polarizing glasses, created in 1934 by Edwin H. Land. The most convincing illusion of three-dimensionality currently available is produced by the hologram technique, which uses lasers to break up and reconfigure light.

TINTYPE

Invented by Hamilton Smith in 1856 or 1857, the tintype (also known as a "ferrotype") was an inexpensive alternative to the DAGUERREOTYPE. The image was prepared like an AMBROTYPE, using a variant of the wet-COLLODION process, but on a thin sheet of blackened iron instead of a glass plate. The resulting image is rather soft and somewhat inferior in quality to an ambrotype. Tintypes, often produced by street vendors, were popular from the 1850s to the early twentieth century, especially for portraits. Like daguerreotypes, tintypes are unique images.

TONING

Toning is a chemical treatment used to alter the appearance of a photograph—especially its color—and to improve its stability. To this end, during or after DEVELOPMENT silver is combined with another element: platinum, sulfur, gold (the one most frequently used in the nineteenth century after the invention of the DAGUERREOTYPE), or selenium. These various toners make it possible to add a large range of tonalities, from golden to sepia, to the pho-

tographic image. Toned photographs should not be confused with tinted photographs, which are obtained by using tinted photographic paper (which became available in the 1870s, especially as ALBUMEN paper).

Certain photographers color their works themselves by hand, by applying oil paint, gouache, or watercolor to part or all of the image. This technique originated with the daguerreotype and was initially intended to imitate oil paintings.

TRAVEL PHOTOGRAPHY

Traveler and photographer: these roles have been closely linked since the invention of photography, primarily in the context of archaeological or geographical expeditions but also in conjunction with a kind of colonial tourism by the European middle class. Exploiting a fashion for the exotic, wide-ranging photographers brought back images that made their contemporaries dream of faraway places (the Egypt of Maxime Du Camp and Francis Frith, the Orient of Felice Beato) and that also helped establish the aesthetic and commercial potential of landscape photography. Ethnographic research soon became another travel-related specialty—notably in Désiré Charnay's photographs of Mexican ruins and, from the 1860s to the 1870s, of Australian Aborigines and the inhabitants of Madagascar. The most ambitious of all ethnographic enterprises was that of Edward S. Curtis, who beginning in 1899 assembled more than forty thousand photographs of North American Indian tribes, shot both in situ and in the studio.

The DAGUERREOTYPE and then the CALOTYPE were not well suited to travel photography. The fact that plates and papers had to be treated immediately after exposure complicated still further the problems caused by having to transport unwieldy materials—glass plates, chemicals, heavy cameras, and light-proof development tents (sometimes weighing as much as 2,200 pounds [1,000 kg], as in Félix Moulin's 1856 trip to Algeria). And beginning in 1850, wet-COLLODION plates had to be prepared as well as treated on-site. It was not until the advent of dry-collodion plates (in the 1870s) and the GELATIN SILVER PROCESS (1880s) that travel photographers could lighten their baggage and simplify their procedures.

Americans photographing the westward expansion, starting about 1860, generally used the cumbersome wet-collodion process. Alexander Gardner, William Henry Jackson, Eadweard Muybridge, Timothy H. O'Sullivan, and Carleton E. Watkins were among the best-known participants in these large

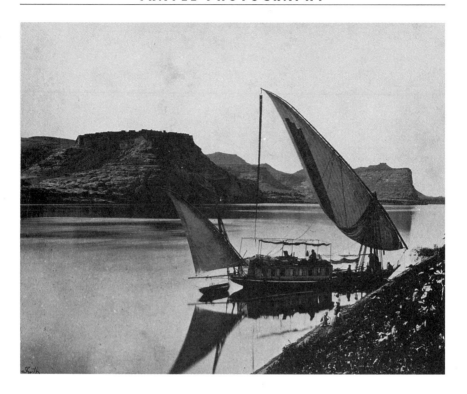

FRANCIS FRITH (1822–1898).
Travellers Boat at Ibrim, from the *Lower Egypt and Thebes Album*,
c. 1860. Albumen print with text, 5³/₈ x 7 in. (13.6 x 17 cm), image;
17 x 12³/₈ in. (43.2 x 31.4 cm), mount. The Minneapolis Institute of Arts;
David Draper Dayton Fund.

ALVIN LANGDON COBURN (1882–1966).
Vortograph, 1917. Gelatin silver print, 8⅝ x 10⅝ in. (22.1 x 27 cm).
The Art Institute of Chicago; Harold L. Stuart Endowment.

government survey expeditions that were exploring and recording the West. Their efforts became a veritable laboratory of American landscape photography. The glorifying images of the wilderness that they produced were often inspired by the geologist Clarence King (leader of many of these trips), who used their photographs to support his theories of "catastrophism" and "mechanical geology." Many of the sites documented by these expeditions were revisited in the 1970s by American photographers like Rick Dingus, who produced contemporary views of them in order to cast light on environmental and social changes.

In the twentieth century travel photography has generally been more intimate, more reflective of individual subjectivity. Projecting onto the landscape his own obsessions with sensuality and death, Edward Weston made two extended forays into the American West supported by Guggenheim fellowships, in 1938 and 1939, as well as another to illustrate Walt Whitman's *Leaves of Grass* (1940). More recently, photographers have revived the German Romantic tradition of the journey of initiation, turning toward the autobiographical travelogue. This may focus more on unfamiliar cultures (or subcultures) than on foreign places—a trend exemplified by Robert Frank's *Americans* (1958), Bernard Plossu's *Voyage mexicain* (1979), Larry Clark's exploration of the adolescent outskirts of society (*Tulsa,* 1971), and Nan Goldin's provocative sexual journeys of the 1980s. Travel photography documenting contemporary life in foreign countries also remains a major form of PHOTOJOURNALISM as well as a popular genre of amateur photography.

VORTOGRAPH

Vorticism was intended to be both a philosophy and an aesthetic theory. Established in England in 1914 by the poet Ezra Pound and the painter Wyndham Lewis (who were much influenced by Cubism), it claimed for the artist a place at the center—or vortex—of the energy of modern life. The visual and verbal language of the movement is often reminiscent of FUTURISM. Pound introduced the photographer Alvin Langdon Coburn to Vorticism shortly after Coburn arrived in London, and beginning in 1916 he produced prismatic abstract images taken through a kind of kaleidoscope incorporating three mirrors. Baptized "Vortographs" by Lewis, they anticipated German NEW VISION photography. Despite Pound's support, Coburn's innovative photographs were not well received when exhibited in London in 1917.

▷ **WHO** Eddie Adams, Felice BEATO, Margaret Bourke-White, Mathew Brady, Larry BURROWS, Romano Cagnoni, Robert CAPA, Gilles Caron, David Douglas DUNCAN, Roger FENTON, Alexander GARDNER, Philip Jones Griffiths, Don McCULLIN, Lee MILLER, Carl Mydans, James Natchway, Timothy H. O'Sullivan, Gilles Peress, James Robertson, George Rodger, Joe Rosenthal, Galina Sankova, W. Eugene SMITH

▷ **WHEN** 1850 to the present

▷ **WHERE** International

▷ **WHAT** The DOCUMENTARY potential of photography predestined it for war coverage from the moment that invention of the COLLODION plate made this practicable. In fact, it is fair to say that the entire genre of reportage was a child of warfare. The Crimean War was photographed by Roger Fenton as early as 1855. His example was soon followed by Felice Beato, who covered the second Chinese Opium War, and by the photographers of the American Civil War, the first conflict to be photographed extensively; Mathew Brady, Alexander Gardner, and Timothy H. O'Sullivan, among others, produced unflinching images of war's horror. War coverage appeared in publications around the world, including the *Illustrated American, Illustrated London News, London Times* (with articles on the Crimean War by William Howard Russell), and *Harper's Weekly*. Other conflicts, like the Boxer Rebellion (1900), were covered by Italy's *Corriere della sera*.

Technical limitations, which imposed extended exposure times, fostered a war imagery that was profoundly still, and hence contemplative. The photographic collections of the Musée de l'Armée in Paris (created 1896)—which include thousands of images, most of them by amateurs—make it possible to compare official images of combat with unofficial ones. The latter tend to be far more informative than the official record, for they were less restrained by censorship and the need to produce propaganda.

By the 1930s PHOTOJOURNALISM was in full sway, aided by the development of lighter cameras and faster film. All of the great picture magazines sent war correspondents to the front. Robert Capa covered the Spanish Civil War (1936–38) for *Vu* and *Picture Post;* his *Death of a Republican Soldier* (1936) has become an emblematic image of modern war. He also recorded the Allied invasion of Normandy for *Life,* while W. Eugene Smith covered the Pacific theater. (Capa died in 1954 after stepping on a land mine while

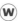

LEE MILLER (1907–1977).
Dead German SS, Dachau, 1945. Gelatin silver print, 6 x 6 in.
(15.2 x 15.2 cm). Lee Miller Archives, East Sussex, England.

covering the war in Indochina.) In 1945, the Associated Press photographer Joe Rosenthal won the Pulitzer Price for his photograph of marines raising the American flag on Iwo Jima, but *Life* magazine originally refused to run the picture, accusing him of having staged the scene. (This accusation, though essentially false, has haunted the photograph ever since.) It was Lee Miller who produced perhaps the most powerful images of World War II, beginning in 1944, when she accompanied the American forces as they swept across Europe, recording the widespread devastation as well as the liberation of the concentration camps in 1945.

The tragic effects of war were perhaps most vividly conveyed in photographs by Shomei Tomatsu and Hiromi Tsuchida documenting the aftermath, both immediate and lingering, of the bombing of Hiroshima and Nagasaki. In 1991 Robert Frank, Raymond Depardon, and a few others undertook a similarly wrenching documentation of war-torn Beirut, Lebanon. In the work of David Douglas Duncan, Philip Jones Griffiths, Don McCullin, and Gilles Caron (who died on the battlefield in 1970), the Korean and Vietnamese conflicts generated a wide range of responses, encompassing a HUMANIST universalism (Duncan) as well as outright horror (McCullin). In the wake of the Vietnam War there has been something of a crisis in photographic war coverage. In 1968 there were four hundred photographers in Vietnam; in 1981 the war between Argentina and Britain over the Falkland Islands was covered by only three. Live television images have largely supplanted the need for photographic coverage, as was made clear by the Persian Gulf War in 1992, when CNN provided most of the coverage.

WOMEN AND PHOTOGRAPHY

The role of women in photographic history was long downplayed by photographic historians, but that role is now being thoroughly reassessed, notably by Naomi Rosenblum. Women have, in fact, been active practitioners of the medium since the beginning, and their contribution should be reexamined in light of the economic, social, and cultural constraints that shaped it. By the end of the nineteenth century there were many female professional photographers (Geneviève-Elisabeth Francart Disdéri in France, Catharine Barnes Ward in the United States, Christina Broom in England), but most women who took pictures during these years did so as a leisure activity, though one that was sometimes coupled with aesthetic ambition (as was the case with Julia Margaret Cameron).

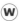
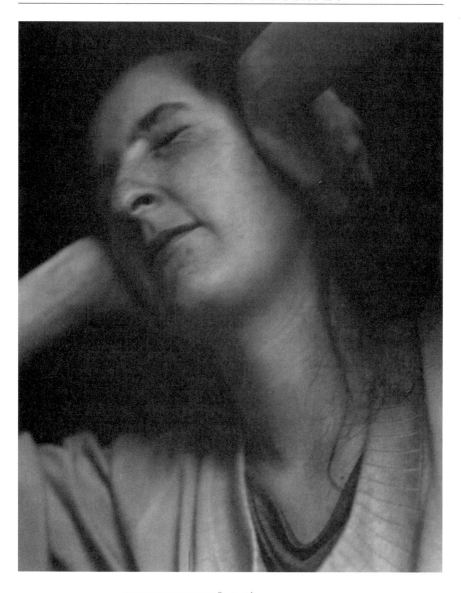

SUZANNE LAFONT (b. 1949).
Element No. 1, from the series Le Bruit (Noise), 1990.
Gelatin silver print, 8 elements, 47¼ x 39⅜ in. (120 x 100 cm), each.
Collection of the photographer.

During the period of PICTORIALISM and the PHOTO-SECESSION, portraiture was one of the genres to which women devoted themselves most successfully. Gertrude Käsebier—who had her first one-person exhibition at the New York Camera Club, under the aegis of Alfred Stieglitz, in 1899—became one of the best-known commercial portraitists in New York and was one of the founding members of the Photo-Secession in 1902. In California at the beginning of the century, the Pictorialist Anne W. Brigman produced a body of work—particularly depictions of female nudes in the wilds of California—that influenced both Edward Weston and Imogen Cunningham.

Women photographers actively participated in the blossoming of the European avant-gardes between the wars, and many women were part of the BAUHAUS circle (notably Florence Henri and Lucia Moholy-Nagy). Hannah Höch was a creator (in collaboration with Raoul Hausmann) of Dadaist COLLAGES and PHOTOMONTAGES. Gisèle Freund, Lotte Jacobi, and Germaine Krull produced a strong corpus of portraiture. As for Tina Modotti—photographer, political activist, and student and lover of Edward Weston—her body of work, though small, provided images of the Mexican Revolution that succeeded both formally and as social documents.

Women photographers' concentration on the problems of society, in conjunction with the emergence of PHOTOJOURNALISM between the two wars, led to a social reportage dominated by women photographers, including Berenice Abbott, Ilse Bing, Margaret Bourke-White, Dorothea Lange, Helen Levitt, Lee Miller, and Lisette Model. Women had considerably greater difficulty establishing themselves in the fields of FASHION PHOTOGRAPHY (Louise Dahl-Wolfe was a notable exception, becoming a central figure at *Harper's Bazaar* starting in 1936) and advertising. The options available to women increased considerably after World War II, however, when changing circumstances—notably the expansion of the photography market—favored the emergence of women artists of the first rank. Charlotte Brooks became the first female photographer for *Look* magazine, in 1945, and Eve Arnold was the first to join the Magnum agency, in 1951.

Since the 1950s women have become active in every genre of photography. In the 1960s Diane Arbus began to make portraits of those on the fringes of American society. A feminist vision began to emerge in work such as Abigail Heyman's book *Growing Up Female: A Personal Photo-Journal by Abigail Heyman* (1974) and assumed a central role in POSTMODERNIST photography of the 1980s, along with Cindy Sherman's explorations of SELF-PORTRAITURE. American photographers Marsha Burns, Judy Dater, Sally Mann, and Anne Noggle produced work investigating homosexuality, aging, and the family

from an autobiographical perspective. In France, INSTALLATIONS by Annette Messager and STAGED PHOTOGRAPHS by Florence Chevallier dealt with similar themes, though work focusing on issues of female identity from a feminist perspective is less common in Europe than in America. Annie Leibovitz is the reigning celebrity portraitist of the day.

WOODBURYTYPE

Invented in 1864 by Walter B. Woodbury, the Woodburytype is a photomechanical reproduction that so closely resembles a true GELATIN SILVER print that it is difficult to distinguish the two.

The process of making a Woodburytype began with the preparation of a special FILM by coating a sheet of glass first with COLLODION and then, after that had dried, with bichromated gelatin, which hardened in proportion to its exposure to light. The film was then removed from the glass, placed under a negative, and exposed. The image thus obtained was in low relief, the gelatin coating being thickest where the image was brightest. It was allowed to harden, placed under a hydraulic press, and imprinted on a sheet of soft lead. This produced a mold that was coated with pigmented gelatin and pressed against a sheet of paper (with the excess gelatin being squeezed out around the edges). The resulting image has a tonal richness comparable to that of CARBON prints.

Woodburytypes were often glued into luxury ALBUMS. The process was discontinued around 1900 due to its high cost.

Page numbers in **boldface** refer to main entries for terms, concepts, and movements.
Page numbers in *italics* refer to illustrations.

207

213

Front cover: E.B.H. Anthony & Company. *Lafayette Place, North from Great Jones Street,* c. 1866. The Lightfoot Collection, Greenport, New York.

Additional cover photography by Darrin Haddad (4 x 5 Camera Front, 4 x 5 Camera Back, Bellows, Film Reels) and Scott W. Santoro (35 mm Camera, Hand in Sand, Lightbulbs).

Half-title page: Charles Nègre. *Chimney Sweeps Walking,* 1851. See page 185.

Frontispiece: Man Ray. *Rayograph,* 1922. See page 83.

Editor: Nancy Grubb
Translator: John Goodman
Designer: Scott W. Santoro/WORKSIGHT
Typesetting/Layout: Emily L. Santoro/WORKSIGHT
Production Editor: Jeffrey Golick
Picture Editor: Elizabeth Boyle
Production Manager: Elizabeth Gaynor

First edition
10 9 8 7 6 5 4 3 2 1

Library of Congress Cataloging-in-Publication Data
Mora, Gilles, 1945–
PhotoSpeak : a guide to the ideas, movements, and techniques of photography,
1839 to the present / Gilles Mora.
p. cm.
Includes index.
ISBN 0-7892-0068-6 (pbk.)
ISBN 0-7892-0370-7 (cloth)
1. Photography—History—19th century. 2. Photography—History—20th century. I. Title.
TR15.M63 1998
770—dc21 96-44428